screenprinting

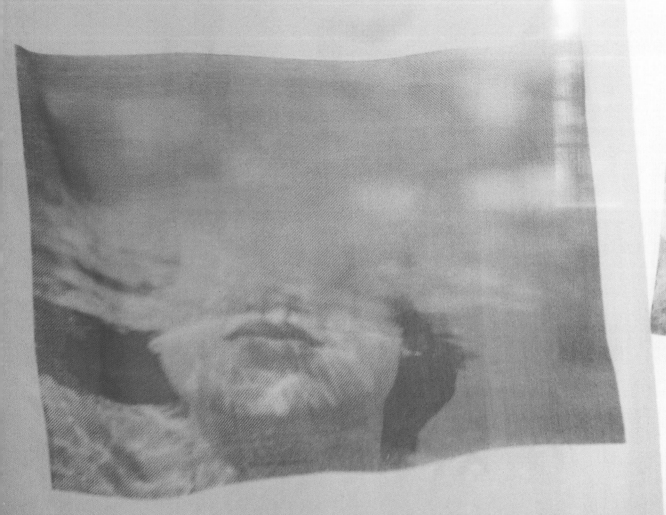

with 265 illustrations, 228 in colour

Thames & Hudson

Robert Adam
and Carol Robertson

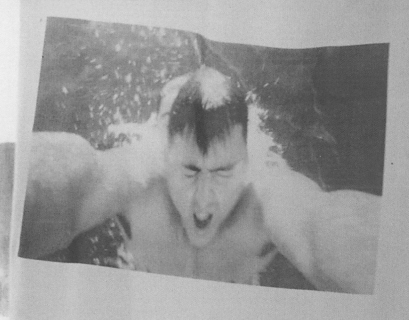

screenprinting
the complete water-based system

05 Nov 4
B+T
4000(2220)

All photographs courtesy of the authors except:
A. Balasubramaniam p. 10; Peter Mackertich (petermackertich.com)
pp. 2-3, 12, 35, 36, 42, 44, 51, 57, 58 top, 130, 132 all, 134, 135 all,
137, 139, 150 both, 151 all, 153, 154, 166, 167 both, 172, 173 both,
176 both, 177 all, 195 top left, top right and bottom left, 182,
183, 184 both, 191 all, 193 centre left, centre right and bottom right;
Rebecca Mayo pp. 7, 39; Elizabeth Ogilvie pp. 9, 29, 199; David Roche
pp. 20, 156, 200; Penny Stanford p. 21

pp. 2-3 Helena Henriquez, *Waves*, water-based screenprint
installation, 2001. Seven banners of Chinese Habutie silk,
measuring 3.5 m x 0.91 m (11 ft 6 in. x 3 ft), printed with Lascaux
Screenpaste, Varnish, Gouache and water. The text on one of the
banners comes from Henriquez's own notebook where she records
her thoughts and emotions. Underwater photographs of the artist
and her friends were manipulated using Adobe Photoshop to create
halftone positives, which were then used to generate photostencils.
Henriquez stretched the silk fabric, which is very thin and tricky to
work with on this large scale, and lightly glued it over flat
boards before screenprinting it.

© 2003 Robert Adam and Carol Robertson

First published in the United Kingdom in 2003 by
Thames & Hudson Ltd, 181A High Holborn,
London WC1V 7QX

www.thamesandhudson.com

First published in the United States of America in 2003 by
Thames & Hudson Inc., 500 Fifth Avenue,
New York, New York 10110

thamesandhudsonusa.com

A catalogue record for this book is available from the British Library
Library of Congress Catalog Card Number 2002116936

ISBN 0-500-51115-2 (hardback)
ISBN 0-500-28425-3 (paperback)

Printed and bound in Hong Kong by C&C Offset

CONTENTS

HOW SCREENPRINTING DEVELOPED

THE ORIGINS OF SCREENPRINTING

Screenprinting is a development of the process of stencilling. The word 'stencil' is derived from the medieval word *stanselen* ('to decorate with bright colours'), which in turn came from the old French *estencele*, meaning 'to sparkle'. One method of creating and repeating fine art images in this way is known as *pochoir*, which in French means 'stencil'. This involves cutting out a shape from a thin sheet of a paint-resistant material such as paper, plastic or metal, or from a flat leaf such as banana. The cut-out stencil is then laid on a piece of paper and gouache or watercolour paint is brushed over the open area. This forms the image, which can be seen on the paper when the stencil is lifted away.

Stencilling has been used over the centuries by many different cultures for a wide variety of functional and decorative purposes, and some of the earliest examples date back as far as 30,000 BC. During Paleolithic times, prints were made by people who used their hands as stencils when splattering pigment patterns onto cave walls. These are still clearly visible in the Cosquer Cave, one of the Lascaux Caves in France. The Chinese developed stencil printing in about AD 1000 for the mass reproduction of religious images. The Japanese decorated interiors, ceramics and fabrics with stencils, and by the eighteenth century they had solved the problem of printing intricate images which incorporated floating shapes by weaving these into position with human hair and silk.

Wallpaper, playing cards and other items decorated with stencilwork were very popular in France up until the nineteenth century, and at about this time European

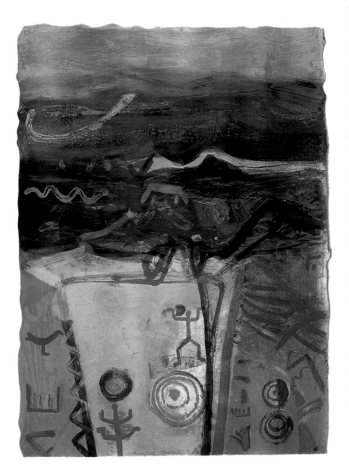

Barbara Rae, *Painted Desert 2*, water-based screenprint, 101 x 75 cm (39³/₄ x 29¹/₂ in.), edition of 40, 2000. The artist made a series of paintings of the landscape and of symbols left by an ancient civilization. To create this screenprint she painted thirty-four positives using Lascaux Tusches on smooth PVC sheet. The resulting stencils were printed with Lascaux products on Somerset Satin White 300 gsm paper.

immigrants brought their skills in decorative stencilling to the New World. Stencilwork is now considered to be an important element in the tradition of American folk art. Meanwhile in England the technique was used extensively by Arts and Crafts Movement designers, such as William Morris. This method of making patterns or repeat motifs is still popular today.

COMMERCIAL SCREENPRINTING

Handmade stencilwork was expensive and, as industry developed, there was a desire for cheaper and faster production methods. Towards the end of the nineteenth century, a stencilling technique which used a printing frame was patented in Michigan, USA. In 1907 a patent was granted in Manchester, England, for a printing process using a wooden frame stretched with silk on which a stencil was hand-painted with screen filler. The ink could not pass through the resulting stencil but was squeezed through the silk onto the paper below, making a print. This process of a fixed stencil on the mesh allowed intricate patterns to be printed, and became known as silkscreen printing or screenprinting.

Hand-painted stencils were replaced in commercial printing when the first photographic stencil was invented in the USA after the First World War. From that point onwards screenprinting became a widespread commercial printing technique, valued for its speed and flexibility in terms of the variety of surfaces on which an endless range of colours could be printed.

Screenprinted images have often been characterized by simplified forms made of flat, opaque colours with shiny ink surfaces – typified by much of the poster art produced in the first half of the twentieth century. The inks and stencils commonly used for screenprinting had particular qualities which determined this appearance.

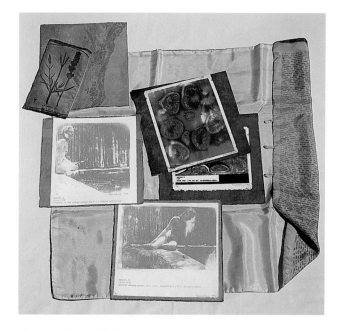

Rebecca Mayo, *Exhibits A-E Packaged*, water-based screenprint with etching, cyanotype, silk, paper and lavender, package size 25 x 30 cm (9$^7/_8$ x 11$^7/_8$ in.), 1997 (detail). Found imagery was transferred to various surfaces using direct photographic stencils.

The meshes and stencils were relatively crude, and the speed with which the ink would dry in the mesh meant that printers favoured bold and simple designs which were easier to print. Smooth, coated papers with cut edges were chosen to print on because the surface accepted the inks more readily and the straight edges were easier to register.

The development of synthetic materials such as nylon and polyester made it possible for the first time to manufacture hardwearing screen meshes made up of very fine threads. By the 1980s specialist light-sensitive emulsions for different types of ink had become widely available. These direct stencils can hold delicate and detailed images which withstand long runs. Automatic presses are now able to produce thousands of prints per hour, and the speed of these presses overcomes the problem of ink drying in the

mesh. Screenprinting is used today for a broad range of applications, from textile printing to precision printing of electronic circuit boards, and from all aspects of the packaging industry to specialized applications, such as braille books and lenticular graphics.

In the 1990s tightening health and safety legislation and an explosion of digital technology led to the introduction of many new printing techniques which began to displace screenprinting as a commercial printing method. Screenprinting companies started to adopt new processes such as electrostatic, inkjet, laser photo, thermal transfer and associated finishing techniques. These print methods are able to fulfil an enormous range of applications, from billboards, packaging, signs, number plates and wrap-around graphics for cars and buses to massive graphics which can be used to cover the entire side of a multi-storey building. This rapidly evolving technology is extensively documented on numerous Internet websites and in trade journals such as *Screenprinting*.

FINE ART SCREENPRINTING

A group of American artists enthusiastically embraced the new process of silkscreen printing in the 1920s and '30s, and their prints were exhibited in New York and elsewhere during that period. Carl Zigrosser, Curator of Prints at the Philadelphia Museum of Art, organized an exhibition of these silkscreen prints at the Weyhe Gallery in New York in the late 1930s. He described them as serigraphs (*sericum* is Latin for silk) in order to identify them as fine art prints made by artists painting stencils on a silk mesh. Rather than silk, artists now use meshes made of polyester, and they generate stencils in a variety of ways, so the technique is generally referred to as screenprinting.

Interest in the process as a fine art medium grew, especially in North America, and in the 1950s artists began to use light-sensitive stencils as a means of further exploiting the potential of screenprinting. This method of working allowed them to incorporate photographic elements in their images. This opened the way for building up images from components collected from a huge range of sources. These artists were interested in and stimulated by the use of commercial print in the consumer world around them. Prints created by artists such as Roy Lichtenstein, Robert Rauschenberg and Andy Warhol challenged and changed the established perception of the medium, although it took some time for screenprints to achieve wide acceptance in their own right.

Screenprinting is now accepted as a major expressive form and it is common practice for artists to work in collaboration with screenprinting specialists. It is taught as a fine art subject in most art colleges and institutes, and many secondary schools have screenprinting facilities.

There is a growing understanding of the versatility of the medium. Marks of any kind, including photographic, digital and autographic, can be translated easily into stencils. The printed results may resemble painted or drawn marks, stains or lithographic washes, text, and different mechanical and reproductive effects. Printing is straightforward and rapid, and the range of potential substrates is broad.

The practice of contemporary artists such as Eduardo Paolozzi, Barbara Kruger, Christo and Richard Prince demonstrates that the traditional boundaries of printed art are not as clearly defined as they once were, and artists have responded to political and social issues by devising print formats which communicate directly with the public.

Within this creative context, screenprinting offers a flexible and expressive tool. Artists involved in every kind of medium, including performance, installation, sculpture, digital, ceramics, textile and photography, can use screenprinting as part of their practice, both as a means of expressing ideas in a particular way and as a way of documenting and disseminating their work.

Elizabeth Ogilvie, *Into the Oceanic 2*, water-based screenprinted installation, Odapark, Netherlands, 3 x 16 x 12 m (9 ft 10 in. x 52 ft 6 in. x 39 ft 4 in.), 2000. The installation consisted of water, roofing materials, steel, timber, electric fans and water-based screenprinted text on Perspex. The artwork was created by Ogilvie in collaboration with the poet Douglas Dunn. The text was created and output digitally on clear acetate, and screenprinted using a standard mix and Lascaux Studio greens.

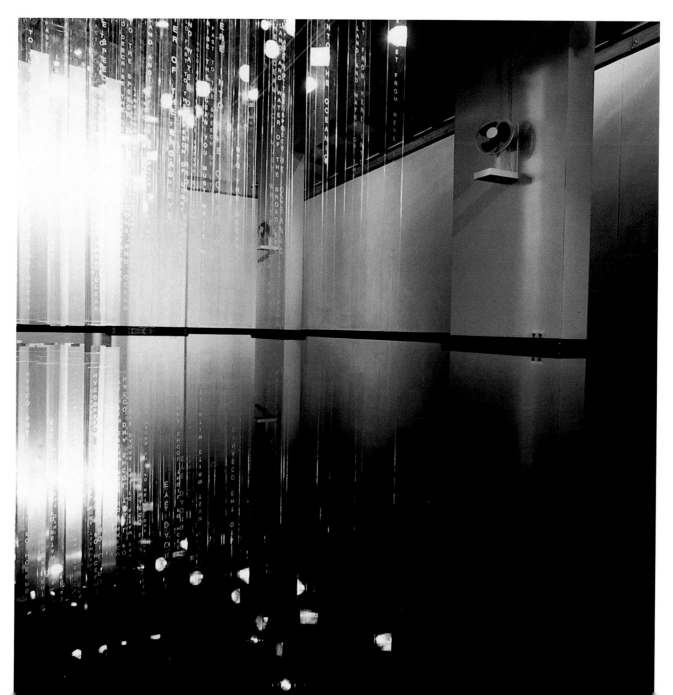

THE MOVE TOWARDS WATER-BASED SCREENPRINTING

TRADITIONAL SCREENPRINTING AND ITS IMPLICATIONS FOR HEALTH, SAFETY AND THE ENVIRONMENT

Health Issues

Screenprinting inks have until recently been solvent-based and have required solvents for cleaning up. In industry the term 'solvents' usually refers to 'organic solvents', which are widely used to dissolve organic chemicals such as oils and resins. 'Organic' in this context means belonging to the class of chemical compounds that are formed from carbon, and should not be confused with the use of the word to describe foods which are perceived as safe or wholesome.

There is a growing awareness that these materials, and many other products used in the screenprinting process, are not only inflammable and potentially explosive, but also toxic. New research from a number of countries is changing health and safety legislation for screenprinters, and governments are calling for substantial reductions in the use of solvents and other hazardous chemicals in order to comply with international agreements.

Solvent-induced brain damage is already a recognized occupational disease, and printers are one of the groups identified as being most at risk. In Great Britain substantial funding is being invested in research projects examining the relationship between exposure to solvents and neurological illnesses, such as Parkinson's disease, and other conditions such as deafness.

A recent study at the University of Boston, Massachusetts, USA, warns that brain damage linked to workplace solvent exposure may mimic multiple sclerosis or dementia, with loss of memory, inability to think clearly and depression. Recent German research has shown that a worker can inhale as much as 5.5 litres of volatile solvent during a single working shift. This is a direct result of solvents evaporating rapidly and becoming part of the air breathed within the workplace.

The first effects of solvent exposure can be similar to drinking too much alcohol – a light-headed feeling,

A. Balasubramaniam, *Untitled*, water-based screenprint, 1998 (detail). Safe screenprinting techniques were used with Lascaux materials and collage to create this edition.

slower reaction time, giddiness and nausea, and in extreme cases loss of consciousness. Solvents can cause damage to the liver and kidneys, and can affect the central nervous system, which consists of the brain and spinal cord. This can cause mood swings, tiredness, irritability, relationship and sexual problems, and depression. Exposure to solvent vapours can irritate respiratory mucous membranes. This can produce a burning sensation in the nose, throat and chest, and can lead to coughing. Inhalation of very high concentrations of solvents may result in severe irritation of the lungs and pulmonary oedema (fluid in the lungs). Symptoms of pulmonary oedema include coughing and difficulty in breathing, and require prompt medical attention.

Organic solvents also have a de-fatting, sensitizing and irritant action which can affect the internal organs and the skin. This can cause dermatitis (skin disease), of which the first symptoms are red, sore, cracked, blistered and bleeding skin. Once the skin has been sensitized in this way, it can become more permeable and reactive to other, seemingly innocuous substances. Chronic dermatitis is unpleasant and debilitating, and many printers are affected by it. In some cases the effects are so severe that individuals have had to give up their printing careers.

The Risk of Fire

Many of the materials used for traditional solvent-based screenprinting are flammable or explosive. Ignition sources in printmaking studios, such as sparks and equipment used for traditional etching, including matches, lit tapers, hot plates, pilot lights and bunsen burners, are high risk factors. In addition, some chemicals are incompatible with solvents and mixing them will produce toxic gases, heat or fire.

Oxidizers and strong acids should never be allowed to come into contact with solvents.

Good studio practice concerning rules about not smoking, solvent and chemical storage, decanting, and general chemical usage should be followed. Containers must be accurately labelled and need well-fitted lids to prevent evaporation. A fume cupboard is required for the safe storage of these materials. This cupboard must be maintained carefully in an organized way with any incompatible chemicals kept separate from each other. Containers of sand or other appropriate materials should also be stored close at hand to absorb or neutralize spills.

Rags and cloths used for cleaning up solvents are a risk, both in terms of fumes and fire, including the possibility of spontaneous combustion. Special fireproof containers with closing lids must be used to store soiled rags, and these should be emptied at the end of each working day into a lockable fireproof container kept outside the building. A similar system should operate for paper, film, PVC sheet and other flammable waste materials.

It is important that fire extinguishers are clearly visible and of the correct type for each hazard. This equipment has a limited lifespan and will need to be tested and replaced regularly. Fire officers will specify the number and type of extinguishers and other equipment required for a particular workspace. Conforming to these fire regulations can be expensive but is often a legal requirement. Premises may be inspected on a regular basis by safety officers who will monitor the systems which are in place.

The Environment

It is illegal in most countries to dispose of solvents or solvent-based products through domestic waste systems.

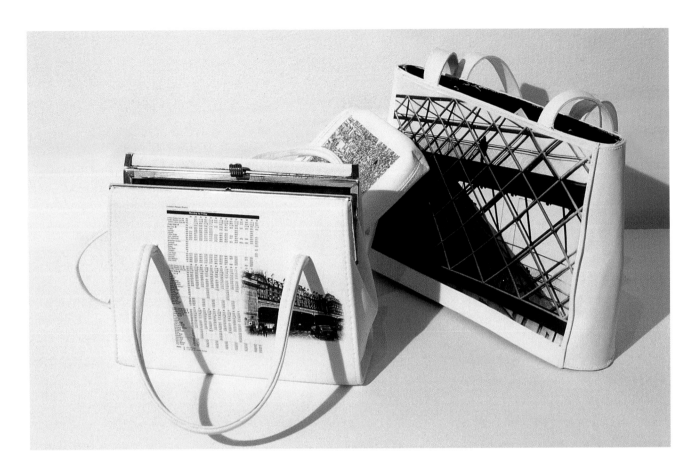

Solvent-soaked rags, waste inks, screen-cleaning chemicals, volatile fillers and waste photo-emulsion should be collected and processed by a specialist waste agency. Even when waste organic solvents are finally disposed of in landfill sites there is a strong risk that these will ultimately enter ground-water and soil, causing damage to the environment.

European Community research has shown that in the printing industry more than 50% of solvents used for cleaning up will evaporate into the atmosphere, making printing the second biggest industrial emitting source of volatile organic compounds (VOCs) in Europe. A separate study of air quality carried out recently in North America involved monitoring a large group of ordinary people in different locations going about their normal activities.

Susan Short, *08:05*, water-based screenprinting on handbags, installation, 2000. The artist used safe techniques and Lascaux products to print images and text onto handbags.

The results showed that hazardous chemicals could be measured consistently in samples of breath, outdoor air and indoor air. Many of the toxins detected are commonly used in solvent-based screenprinting. They included acetone, aromatic hydrocarbons, aliphatic hydrocarbons, xylene, 1,1,1-trichloroethane benzene, toluene, dichloromethane and ethyl acetate. This study is a cause for concern at a time when increasing numbers of people are suffering from asthma, allergies and multiple chemical sensitivity (MCS).

The emission of certain VOCs into the air also creates ground-level photochemical smog and is a

major health hazard. Some VOCs contribute to the rapid thinning of the world's ozone layer, which is linked to global warming.

Sourcing Information About Chemicals and their Correct Use

In order to discover the names of any hazardous chemicals in a product, a Material Safety Data Sheet (MSDS) must be sought. This will list the hazardous chemicals and specify minimum and maximum quantities in the product. Important practical information is provided about the chemical's routes of entry to the human body, necessary protective clothing and equipment, procedures for safe handling and storage, spillage control, adverse chemical reactions and fire-fighting. It will specify correct disposal methods, but local regulations must also be checked.

It is a legal requirement that manufacturers should provide product users with MSDSs. An MSDS should be obtained for each chemical used (or stored) in a studio so that any necessary precautionary or legal measures can be followed by the user. It is the responsibility of the person in charge of a workshop, studio or department to establish what these requirements are and to comply with them. This legislation relates to the transportation, storage, handling and disposal of chemicals which are classed as hazardous. The labelling on the container must (in some countries) indicate any hazards by showing a symbol or specifying whether a data sheet is necessary. Failing to comply with legislation can lead to heavy penalties and, increasingly, litigation. In countries or states which operate a right-to-know policy, students, staff and neighbours of the organization (or premises) have to be provided with access to full information about any hazardous chemicals in use. In the UK it is a legal stipulation that MSDSs relating to hazardous substances

are held for reference on the premises. The practical reason for this is that in the case of an accident, spillage or fire it is possible to refer rapidly to a data sheet for accurate guidance concerning the course of action. It is important to make sure the document is up to date, as regulations change.

Sometimes this chemical health and safety information can be time-consuming and difficult to obtain. Companies are often happy to provide product literature but less than willing to provide an actual MSDS, and it has to be noted that product information sheets can on occasion masquerade as MSDSs but fail to provide crucial chemical information. Some MSDSs give the minimum information but in these cases the chemical name, synonym or chemical number can be used to source the chemical's own MSDS from the Internet. When searching for information on a specific chemical it is important to use the correct and complete chemical name, although typing in an accurate synonym or a brand name may provide results. It is easy, however, to make a mistake by typing in an inaccurate or incomplete synonym which can be misleading. For instance, 'magnesium' is explosive whereas 'magnesium carbonate' is regularly used as an ink additive in relief printing.

Commonly used screenprinting products often have trade or generic names such as 'Screen Cleaner', 'General Purpose Cleaner' or 'White Spirit', and do not display either the names of any hazardous components or the proportions of these on the container label, which may vary considerably from one batch to another. For example, white spirit, which is a turpentine substitute, is formulated according to the commercial availability of its various components. The MSDS for a product may reveal that a chemical may be present in a proportion which can vary from, say, 2% to 20%.

The international symbols for flammable, corrosive or irritant materials

As a result the effects of a product on the user can vary significantly from one batch to another.

Useful guidance on reading and understanding MSDSs is available from government bodies. A wealth of up-to-date information about chemicals and health and safety issues can be obtained on the Internet. Key words to use in a web search are 'organic solvent', 'MSDS', 'toxic chemicals', 'printer health + safety', 'HSE' (Health and Safety Executive), 'GPMU' (Graphical, Paper and Media Union), 'COSHH' (Control of Substances Hazardous to Health) and 'environment + [name of chemical]'. Government agencies and local authorities publish printed information concerning health and safety and environmental issues. For instance, booklets and courses are available, covering topics including risk assessment (this is a required procedure concerning any activity, whether teaching or non-teaching, which may expose employees, students or any other person to any substance that is hazardous to health).

A recent directive from the European Community has resulted in the emergence of the CHIP 2000 regulations – The Chemicals (Hazard Information and Packaging for Supply) [Amendment] Regulations 2000. This legislation aims to provide a high standard of protection for people and the environment from the harmful effects of chemicals.

The toxic chemicals listed opposite are often included in screenprinting products, but should be avoided, as screenprints can be made successfully without their use.

How Traditional Screenprinting Chemicals Enter the Body

The routes of entry by which traditional screenprinting chemicals find their way into the body are through ingestion, eye and skin contact, and inhalation.

Ingestion

Ingestion is when chemicals enter the body by swallowing. Food should not be stored in the studio as it absorbs toxins from the air. Swallowing contaminated food will introduce these toxins to the digestive system and bloodstream. The same applies to beverages. Hand-washing before eating or smoking is important, as chemicals can be transferred to the lips by food or cigarettes. Studios and workshops should have a separate kitchen and eating and smoking area, and good hygiene is important.

Substances can also enter the stomach through indirect means. For instance, coughing pushes material out of the lungs, allowing it to be swallowed and to come into contact with the stomach and other internal organs.

Eye and skin contact

Eye protection, gloves and protective clothing can guard the user from obvious physical contact with toxic inks and cleaners. Goggles or visors should be worn by everyone working in areas where hazardous chemicals are in use because of the risk of splashes. Solvent vapours may produce eye irritation, which can lead to burning, painful and watering eyes. Contact lens wearers should take particular care.

CHEMICALS COMMONLY FOUND IN TRADITIONAL SCREENPRINTING MATERIALS

Screenprinting chemicals which are commonly used in the formulation of inks, ink remover, aerosol screen-opener, developers, fixer, light-sensitive emulsions, light-sensitive emulsion removers, screen fillers, screen filler removers, haze removers, parts-washer solvent and degreasers are listed below. All of these substances give cause for concern in one or more of these categories: hazardous to user, hazardous waste, air pollution and contamination of ground-water.

acetone
alcohols, C8-C10, ethoxylated
barbon tetrachloride
benzene
benzyl alcohol
2-butoxyethanol
butyl acetate
butyrolactone
byclohexanol
chlorobenzene
cyclohexanone
diacetone alcohol
dichloromethane
diethyl adipate
diethyl glutarate
diethylene glycol
diethylene glycol butyl ether
 acetate
diethylene glycol monobutyl ether
dimethyl adipate
dimethyl glutarate
dimethyl succinate
dipropylene glycol methyl ether
dipropylene glycol methyl ether
 acetate
2-ethosyethanol

ethoxylated nonylphenol
ethoxypropanol
ethoxypropyl acetate
ethyl acetate
ethyl lactate
ethyl oleate
furfuryl alcohol
isobutanol
isobutyl isobutyrate
isobutyl oleate
isopropanol
methanol
methoxypropanol acetate
methyl ethyl ketone (MEK)
methyl isobutyl ketone (MIBK)
methyl lactate
methylene chloride
mineral spirits (distillates,
 hydrotreated light)
mineral spirits (naphtha, heavy
 straight-run)
n-butyl alcohol
n-methylpyrrolidone
ortho-dichlorobenzene
phosphoric acid, mixed ester with
 isopropanol and ethoxylated
 tridecanol

potassium hydroxide
propylene carbonate
propylene glycol methyl ether
propylene glycol methyl ether
 acetate
pyridine
silica
silica, fumed (amorphous,
 crystalline-free)
sodium bisulfate
sodium hexametaphosphate
sodium hydroxide
sodium hypochlorite
sodium lauryl sulfate
sodium metasilicate
solvent naphtha, petroleum
terpineols
tetrachloroethylene
toluene
1,1,2-trichloroethane
trichlorofluoromethane
1,2,4-trimethyl benzene
tripropylene glycol methyl ether
trisodium phosphate
xylene

Skin is absorbent: examples of its permeable nature are the use of essential oils in aromatherapy massage, and nicotine patches which act as a substitute for smoking. In the same way harmful chemicals can pass through the skin into the body. Solvents can break down the skin's natural protective oils and fats, causing dermatitis and allowing toxins to be absorbed into the bloodstream. It is important to wear the appropriate type of glove as some are permeable to particular chemicals, and what may seem like perspiration can in fact be solvent migrating through the material onto the skin. Nitrile gloves should be used when working with solvents and chemicals.

Inhalation

Inks, fillers and cleaners often release chemicals into the air which are toxic. Many of these chemicals are classified as volatile organic compounds (VOCs) and hazardous air pollutants (HAPs). These fumes are released during ink-mixing, proofing, printing and cleaning up, and as editions dry. It has been documented that even dry prints made with solvent-based inks will outgas VOCs into the atmosphere. A serious danger lies in inhaling fumes and in absorbing these vapours through the skin. The insidious nature of VOCs and HAPs makes their toxicity difficult to manage. Protective breathing equipment should be worn by all studio users when these fumes are present but the appropriate protective breathing masks have a limited life and are expensive, bulky and uncomfortable.

In an attempt to alleviate this problem, extraction systems are used to remove toxic fumes from print studios. The fumes are heavier than air and the way they flow is affected by draughts, heating systems and the movement of people within the space. As a result, designing an efficient extraction system requires

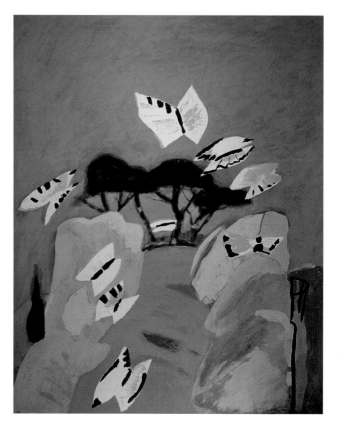

Mary Newcomb, *Butterfly Arena*, water-based screenprint, 70 x 56 cm (27½ x 22 in.), 1997. The artist painted positives with tusches on True-Grain, and the resulting photostencils were printed using safe techniques on Somerset Sand paper using Lascaux Screenprinting Paste, Acrylic Transparent Varnish and Studio Acrylics.

specialized knowledge, and the costs associated with installation and operation tend to be high. The use of limited-life filters on outlets is also expensive. These extraction systems may not comply with changing environmental legislation if they are merely redirecting the toxic fumes to another location where these may harm others who will not be aware that they are being exposed to hazardous chemicals.

THE DEVELOPMENT OF A SAFER SCREENPRINTING SYSTEM

By 1990 we had become seriously concerned about the dangers associated with solvent-based screenprinting and increasingly frustrated with the limitations of this system. We were making high-quality collaborative editions, and using screenprinting as part of an educational programme, in a large open-plan print studio. We found that we were encountering a number of difficulties. Artists and staff were experiencing discomfort in the studio, and suffering from headaches and allergies. Students required a high level of teaching support to master the technical skills needed to become competent. Time spent on essential health and safety training and on maintaining the studio was a drain on staff resources. The fast-drying inks, the use of unpleasant solvents and other chemicals, and the noise of a powerful extraction system combined to make an unsympathetic and unhealthy environment for teaching and learning.

Painters and sculptors visiting the studio to collaborate with printmakers on screenprint editions found the industrial nature of the environment unfamiliar. The materials available for image-making directly on meshes or on positives were crude and not designed for expressive use. Artists were dissatisfied with the colours and surface characteristics of the commercial inks, and were concerned that they were not of archival quality.

The system was expensive to run in terms of teaching and supervisory costs, and overheads for consumables such as solvents, rags and wasted inks were high. Hidden costs for running the fume extraction system, and compensating for central heating lost due to this, were considerable. Extra costs were also generated by the requirement to meet the demands of health and safety and environmental legislation.

Even with significant investment of time, money and expertise these problems could not be resolved within the solvent-based system. At this point in time, no comprehensive, integrated, water-based screenprinting system existed, but a number of interesting products were being marketed. We decided to invest our energies in researching and developing an alternative method of screenprinting especially designed for artists. Our ambitions were that the system should be safe, accessible, economic, free of mystique and able to satisfy the needs of fine artists. In order to do this we realized it was necessary to examine and assess every aspect of the process, including materials, methodology, specialized equipment, studio layout, teaching and studio practice, and health, safety and environmental issues.

This search for safer materials led us to evaluate state-of-the-art commercial screenprinting products and to consider using fine art materials for screenprinting rather than relying entirely on our usual industrial sources, with the unexpected discovery that some artist's paints, in combination with high-technology meshes and photo-emulsions, could be used to make successful screenprints on a range of substrates. This realization altered our perceptions and set us off in a new direction.

These paints, which can be adapted for screenprinting, are generally non-toxic and are clearly labelled with the US standard ASTM D 4236 'No health labelling required'; the European standard CH-BAGT T 'sans classe de toxicité'; or with the AP (Approved Product) Seal (validated in the US by the Art & Creative Materials Institute, Inc. [ACMI]). Unlike industrial screenprinting products, fine art materials have the advantage of offering artists a familiar and comprehensive selection of archival colours and a range of additives which allow a wide adjustment of the printing

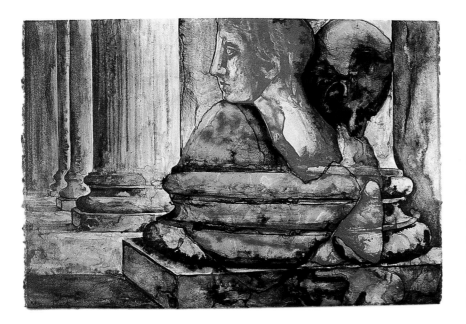

Graham Dean, *Trust* from *The Osterley Quartet*, water-based screenprint and lithograph, 38 x 57 cm [15 x 22⅜ in.], 1995. The blue wash (the head facing left) in this print was screenprinted using water-based techniques, and illustrates how similar the marks are to those characteristic of stone lithography. All other printings were made using traditional stone lithography techniques.

mix performance and the print surface. This control of drying time in the mesh is such that the most delicate stencil can be abandoned for as long as an hour during a print run, and when printing is resumed it will soon proof up perfectly. The characteristics of these materials allow an ease and delicacy of printing which was formerly impossible, and we found that the technical constraints which had previously hampered screenprinting no longer existed. Cleaning up paints, printing mixtures, screen fillers and painting fluids with soapy water is fast and safe. Dried materials can be cleaned away using household cleaners which are classed as safe so there is no longer any need for fume cupboards, unwieldy personal safety equipment or noisy and expensive extraction systems. This water-based system is easy and students are soon self-sufficient, requiring less teaching support. All of these factors contribute to a relaxed and pleasant working environment.

Many approaches to image-making can now be explored freely by professionals and novices alike, and fine art screenprints no longer need to be characterized by a particular range of marks. Curators and expert printmakers are astonished by the quality of the prints, which can be compared to (and are often mistaken for) paintings or lithographs.

Artists can choose to work directly on the mesh, using a range of creative methods, or with digital and photographic techniques, confident in the knowledge that the images they make will print accurately and without difficulty. The tusches manufactured by Lascaux have been specially designed to bring a new range of marks to screenprinting. These relate closely to the vocabulary of painting, monoprinting and intaglio techniques, such as sugarlift, aquatint and soft ground. Other tusches can be used to create marks which print with a tonal range and resemble watercolour, stone-litho or zinc-plate washes. As a result, water-based screenprinting is increasingly taking over the role of lithography in the fine art printmaking studio, as the most delicate drawings and washes can be created and printed faithfully within as little as two hours.

The range of water-based materials available is extensive and testing each of these thoroughly is a complex, expensive and time-consuming process. To help us define a system we established some broad criteria, which were as follows:

- the development of a harmonious, integrated system
- a system for fine artists which would provide a comprehensive range of colours and surface qualities; control of drying times in mesh; the ability not to warp printing paper; the ability to be cleaned up with soapy water
- excellent for educational purposes and for professional editioning
- VOC-free; no fume extraction needed; minimal use of chemicals
- non-hazardous to health or environment
- economical; mixed colours to have a long shelf-life.

Using these and more specific criteria, we identified a range of materials which are compatible and of the lowest toxicity available, and which can be brought together to make a balanced, reliable and complete screenprinting system.

A system will only remain balanced if all the components work harmoniously at every stage of the process. Some chemicals can interact and create technical problems for the printmaker. For instance, a screen filler which breaks down during a print run may have been weakened by chemicals present in the printing mix, whereas the same filler in combination with another printing mixture performs perfectly. Other unexpected problems can result when an ink or filler crosslinks with a photo-emulsion and causes printing and decoating difficulties.

We evaluated the economy of particular materials on the basis of their performance and total cost over a year. What we found was that an initial investment in high-quality products leads to long-term savings because these materials are easy to use, perform reliably, store well and produce good results. They allow a consistent degree of success and reduce frustration for the following reasons:

- Setting up, cleaning up and screen reclamation times are reduced.
- Photostencil failure is rare, which saves on photo-emulsion, decoating and degreasing chemicals.
- The printing performance is consistent, accurate and easy.
- Fewer mistakes during printing mean that wastage of proofing paper, editioning paper, ink and stencils is reduced.
- Staff and artists' time spent solving technical difficulties is minimized.
- The system is intrinsically efficient, so there are significant financial economies.

Looking ahead

The increasing range of environmentally friendly products available to the screenprinter nowadays means that it is realistic to operate a screenprinting studio on a basis that is responsible but still cost-effective. Changes in public attitudes and tightening legislation are leading to a continuing investment in the research and development of products which are more environmentally friendly, and it is therefore a good idea to remain aware of products which are coming onto the market. As new materials emerge, these are evaluated and incorporated into the system if they supersede an existing product or offer a new benefit.

A number of governmental, federal and regional environmental programmes have been established

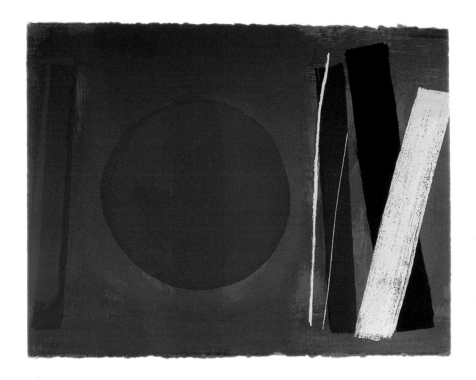

W. Barns-Graham, *Quiet Time*, water-based screenprint, 56 x 76 cm (22 x 30 in.), 1998. The artist painted eleven positives using Golden acrylics on True-Grain. The photostencils were screenprinted on Arches paper using standard mixes, a range of Lascaux paints and Kremer pigments.

worldwide to help the print industry incorporate environmental considerations into its practice. In Europe, Germany has taken a lead in reducing solvents and other hazardous chemicals, and schemes in the US include the United States Environmental Protection Agency's Common Sense Initiative and Great Printers Project.

Selecting materials

Screenprinting materials can be grouped in two distinct categories: fine art materials, and industrial and commercial products. The water-based system makes use of products from both groups. The following sections give broad overviews of the two categories and list a range of selected products and the criteria used to choose them. Details of manufacturers and suppliers are given on pp. 201-4. All the products listed are available internationally but if any are difficult to obtain the criteria can be used to source a replacement.

FINE ART MATERIALS FOR WATER-BASED SCREENPRINTING

Fine art materials manufacturers have led the way in developing safer products for artist-screenprinters to work with. In the 1970s the Swiss artist's materials manufacturers Lascaux Colours & Restauro developed and marketed Lascaux Screenprinting Paste, which is used in conjunction with their high-quality artist's materials. These products include Lascaux Artist's Acrylics, Studio Acrylics, Studio Bronze (metallics), Gouache, Resonance (gouache), Decora (tempera), Aquacryl (watercolour), Sirius Primary System, Perlacryl (iridescent acrylic colours) and a wide variety of painting aids. These painting aids can be used to alter and control the drying time of printing mixes and the surface quality of the finished prints (see 'Printing Mixtures', pp. 150-70). Lascaux paints are particularly suitable for screenprinting because their minute particle size allows them to pass through fine mesh

easily. Lascaux Colours products are made without solvents, are toxicologically tested and fulfil the Swiss standard CH-BAGT T 'sans classe de toxicité' and the US standard ASTM D 4236 ('no health labelling required'). (Cadmium colours should not be sprayed and are therefore appropriately labelled.) Lascaux also manufacture Lascaux Screen Filler and Painting Fluid, which are useful artist's tools and can be painted on the mesh to make stencils. These products are also water-based and non-toxic.

In the US, Golden Artist Colors, Inc. make Golden Silkscreen Medium and Golden Retarder, which can be used in conjunction with all Golden high-quality acrylic paints. These products are safe to use and have minimal odour. Their AP Seal certification attests that in a programme of toxicological evaluation by a medical expert, the product contains no material in sufficient quantities to be toxic or injurious to humans, or to cause acute or chronic health problems.

Speedball Art Products Company, also in the US, manufactures a full range of non-toxic water-based screenprinting inks, including trichromatic colours. Speedball Screen Drawing Fluid and Screen Filler are also useful non-toxic stencil-making products.

Daler-Rowney in the UK produce an inexpensive non-toxic water-based screenprinting system which consists of System 3 Acrylic Paints, Screenprinting Medium, Screen Filler and Screen Drawing Fluid.

Some of these types of water-based inks and retarders may include propylene glycol (synonym: 1,2-propanediol). In its pure state this is classed as relatively non-toxic, and the US Food and Drug Administration (FDA) has classified propylene glycol as an additive that is generally recognized as safe for use in food. The MSDS states that ingestion of a sizeable amount (over 100 ml) may cause some gastrointestinal upset and temporary central nervous system depression. Prolonged contact with the skin may cause mild irritation and de-fatting, and eye contact may cause transitory stinging and watering. There are no adverse health effects caused by inhalation, but it may aggravate pre-existing kidney disorders. Certain websites and an activist group in France are concerned about the widespread use of propylene glycol in many products, ranging from cosmetics and pharmaceuticals to flavour extracts, and are calling for more research.

Cleaning up fine art materials

Soapy water – rather than toxic flammable solvents – is used to wash up the printing mixes, fillers and screen painting fluids. Therefore cleaning up is inexpensive and no vapour extraction is required. Sponges for cleaning up last a long time, and cloths used to dry tools and surfaces can be washed and used again. Dried fillers can be removed from the mesh with household cleaners. These products are classed as suitable for domestic use but MSDSs are available

Penny Stanford, *Guide Book* series, water-based screenprint on bubblewrap and Arches noir paper, 1999 (detail). When printing on plastic surfaces, errors can be rectified by sponging away the printing mix, then degreasing, drying and reprinting.

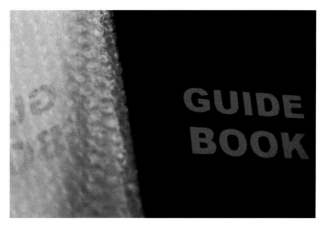

from manufacturers and should be obtained for reference. Protective clothing, gloves and eye protection should be worn when cleaning screens with household cleaners but, as no fumes are generally released, breathing masks or extraction systems are unnecessary. As airborne particles are easily inhaled, household cleaners and detergents should not be sprayed (even if they are supplied in a spray bottle). The cleaners should be decanted into flexible containers with nozzles (such as a recycled dishwashing liquid bottle or a Lascaux acrylic paint container) so that the liquid can be squirted onto the mesh. Containers should be clearly labelled. The cleaners should be rinsed from the mesh with a soft hose before the high-pressure hose is used.

A fume-free studio is a pleasant environment in which to work, but good studio practice should be followed, even when handling materials labelled non-toxic. This may include wearing gloves to prevent dermatitis. Artists who have previously worked with solvent-based materials may have sensitized skin.

Making professional printing mixtures using powder pigments

The range of Lascaux and Golden colours available is enormous but some professional artists may wish to work with pigments in powder form. These can be combined with Lascaux mediums, pastes and varnishes to make screenprinting mixes. Whether or not the pigments are toxic, handling these finely divided materials is a hazardous procedure and should only be undertaken by professional artists. Pigments should be stored in jars with lids to prevent dust escaping into the studio atmosphere. Standard dust masks will not provide adequate protection from these minute particles and so a particulate respirator,

available from a specialist supplier, is necessary. A hand-held electric liquidiser is required to unite pigments thoroughly to create a screenprinting mix.

It is worth bearing in mind that many finely divided powders mixed with air in a contained space can present an explosion risk. Some metallic powders, such as zinc and aluminium (aluminum), present particular hazards and should not be used or stored in a studio. Aluminium powder is highly flammable and can form an explosive mixture with air, especially when damp. It is harmful if inhaled, causes irritation to eyes, skin and respiratory tract, and may affect the lungs. Zinc powder is also potentially explosive and reacts with water. Metallic acrylic paints and gouaches are safe alternatives when silvery effects are required.

Cadmium and cobalt pigments are classified as toxic, and in some countries as carcinogenic. They are particularly dangerous when in powder form and should therefore be purchased as artist-quality acrylic paints or gouaches, which are classed as safe unless sprayed or used in an airbrush.

Manganese and lead white pigments are particularly poisonous and should not be used.

Fine art screenprinting materials, household cleaners and the environment

No VOCs are released into the atmosphere when working with non-toxic water-based screenprinting pastes, varnishes, paints, mediums, fillers, painting fluids and non-hazardous household cleaners. Cleaning up the printing mixtures with soapy water and sponges is environmentally friendly, and registering and proofing on a clear PVC (polyvinyl chloride) sheet, which can be wiped clean repeatedly using a sponge, saves wasting paper and rags. When printing is finished, these screenprinting mixtures can be lifted cleanly off the

mesh and stored indefinitely in sealed glass or plastic jars. As a result there is minimal waste of printing mixes. Colours are generally compatible so they can be altered subsequently for another edition, and an ink-recycling system is simple to establish and economic to use. Adding black powder pigment to stocks of dull unpopular mixes will mean these printing mixtures can become useful again. A particulate respirator should be worn when working with pigment, and a hand-held liquidizer will create a smooth consistency. Any unwanted printing mixtures can be used for painting, or can be given to a local school for use in art classes.

Soiled rags and cloths which have been used for cleaning and drying tools and surfaces can be washed in a domestic washing machine using ordinary household or 'green' washing powder. Cloths washed in this way seldom need replacing and this practice is economical and reduces landfill waste. If the cloths are to be washed in batches, they may be dampened and kept moist in a plastic container for a day or two.

The propylene glycol contained in many artists' water-based materials and household cleaners will readily biodegrade when released into the soil or air. Most household cleaners, including dishwashing liquids, also contain formaldehyde and surfactants which cause some environmental problems. 'Green' household cleaners are widely available and less damaging to the environment.

The amount of water required to clean the mesh is not excessive, which is important in areas where water is a scarce and valuable resource. Studios should install a filtration waste tank which will collect paint and filler residues. The resulting sediment can be gathered easily and disposed of along with other standard waste.

Companies specializing in the development and manufacture of non-toxic and environmentally friendly

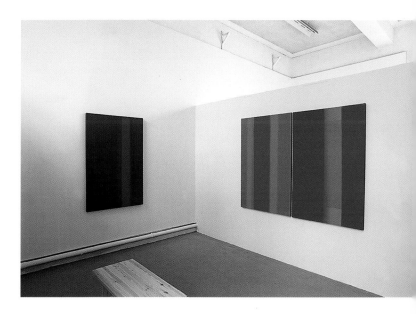

Peter Davey, *Reflections* series, water-based screenprints on canvas, 140 x 90 cm (55 x 35⅜ in.), 2000. The artist's series of canvases was based on research into Oriental philosophy. Davey explains his approach as follows: 'I wanted the work to have a meditative quality whilst allowing strong colours to maintain their presence. The screenprinting process allowed me to create the subtle layers the work required. The canvases were screenprinted with Lascaux products and then stretched.'

products take a positive and active approach to environmental care.

The modern manufacturing facilities of Lascaux in Switzerland operate to strict ecological conformance standards. Since its inception the company has specialized in water-based systems and all Lascaux Colours products are made without solvents and have undergone toxicological testing. In the production and cleaning processes, only water is used. This is then processed by the company's own water treatment plant, which has been specially designed to meet the company's needs and results in more than one million litres of clean water per year.

Golden Artist Colors, Inc. in the US recycles and meets the disposal requirements of Chenango County,

the New York State Department of Environmental Conservation (NYSDEC) and the Environmental Protection Agency (EPA). All products are evaluated toxicologically and meet the requirements of the Federal Hazardous Substances Act. This system allows the company to select the safest raw materials and formulations for the consumer.

Speedball Art Products in the US manufacture screen filler, screen drawing fluid and water-based screenprinting inks which are non-toxic. Some products are removed from mesh with household cleaners which are classed as non-hazardous, such as Greased Lightning, Mr Muscle Bathroom, Mystrol and Flash.

Daler-Rowney in the UK manufacture System 3, a non-toxic acrylic screenprinting system which conforms to ASTM standard D 4236 ('no health labelling required'). Soapy water is used to clean tools and benches, and household cleaners are useful for cleaning fine meshes. Printing mixtures made using this brand of acrylic paint tend not to have a long shelf life; however any excess printing mixture can be disposed of along with household waste.

Selecting Fine Art Materials for Water-Based Printing Mixtures

Screenprinting pastes and silkscreen mediums have been developed by a number of companies. These are designed to combine with paints to form printable mixes and they vary in their effectiveness. In some cases, when manufacturers' mixing instructions are followed exactly, a variety of problems may arise. For example, the printed paper may warp, prints may take hours to dry, and the surface of finished prints may remain

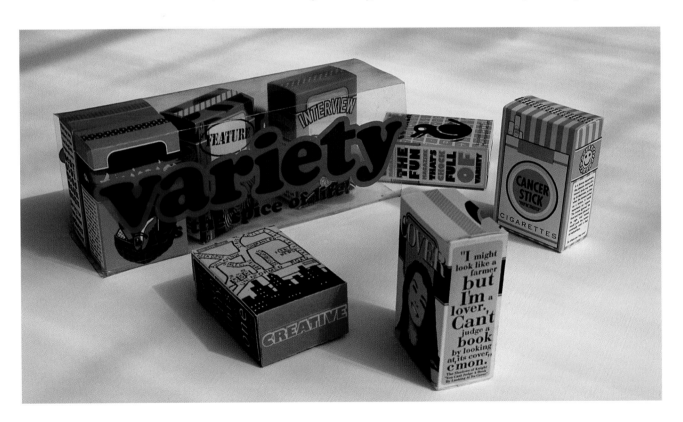

tacky. Prints made with one particular brand of screen medium can re-wet, even after framing or binding, with unfortunate consequences. Other products are so fast-drying in the mesh that manufacturers recommend that the mesh is frequently cleaned out with soapy water during editioning to prevent faulty printing. In their mixing advice manufacturers do not generally distinguish between the demands of a translucent as opposed to an opaque printing mix.

To overcome these difficulties and to improve the scope of these products, we researched the effect of using other additives. We discovered that certain painting aids which are used to thicken paint, slow down drying time, suspend powder pigments, alter surface quality or varnish finished paintings can be used to achieve fine control of screenprinting mixtures. As with the screenprinting pastes and mediums, they vary widely in their characteristics and suitability.

The products we found to be the most reliable and flexible are listed below, and recipes are given in 'Printing Mixtures' pp. 150-70. All the selected products share the following characteristics:

● archival quality
● economical
● consistent quality from batch to batch
● non-toxic to user and low toxicity to the environment (except cadmium paints and certain labelled Kremer powder pigments)
● individual materials have long shelf-life and are non-separating
● good container design which minimizes wastage and is recyclable
● combine easily to make printing mixtures
● printing mixtures have long shelf-life and are non-separating (except for metallic mixtures)
● control of surface quality, ranging from gloss to matt
● ability to make mix which will not warp printing paper
● ability to print fine dots, lines and open areas with good snap and without creep
● ability to sustain long print runs without decaying stencil or requiring re-wetting or washing out
● ability to print on plastic and other substrates
● ability to make mix which is durable and scratch-proof
● speed of drying in the mesh easily controlled
● easy to print with at novice level or for artists with special needs
● excellent for professional artists
● suitable for hand-printing

Fred Deakin, *Selection Box*, water-based screenprint, each of the eight boxes measures 7 x 10.5 x 4 cm (2³/₄ x 4¹/₈ x 1⁵/₈ in.), 1994. Printed with standard mixes and Lascaux Studio Acrylics on card and PVC, folded and shaped after printing. The artist explains his working method as follows: 'This cereal variety pack, based on the sections of a magazine, was created for my degree show ... and was one of my first attempts at screenprinting. I had previously done a lot of two- and three-colour work with a colour-cartridge photocopier, putting sheets of paper through several times and changing the toner from black to red, and so on. This gave me an understanding of how spot colours interact, but the registration was very bad, and I was severely limited in my choice of colours. The opportunity to use a wider palette, and to be more exact in my placing of areas, was mind-blowing after many years of working within these design restrictions. The positives were computer-generated by hand from an old PC: by that I mean that I designed the flat boxes in full colour and then painstakingly created single-colour separations by turning all objects of a specific colour black, sometimes outlining them further as appropriate, and then deleting or colouring white all other objects. This was the only way I could find to create separations that gave me as much room for manoeuvre as possible when it came to the printing.... I then printed them out on acetate from a laser printer. I concentrated on flat colour to try and take the designs as far from the computer as possible. Watching each one slowly take shape, colour by colour, was a revelation as they always looked completely different from the on-screen designs and seemed far more full of life.'

- easy to print with, as all the mixture is able to pass through very fine or coarse meshes (from 49 T to 165 T [125 T to 420 T in US])
- excellent for difficult and slow registration
- no crosslinking with screen fillers or with photo-emulsions
- fast-drying on paper
- non-tacky when dry
- wet mixtures can be removed easily from mesh and tools with sponges, soap and water.

Selecting screenprinting pastes, varnishes, thickeners, retarders and other painting aids

Choice: Lascaux Screenprinting Paste, Acrylic Transparent Varnish 575, Thickener, Retarder

- transparency truly pure and not chalky or cloudy
- not sticky or glue-like

Selecting colours

Choice: The full range of Lascaux paints
The following products are also useful: Golden acrylic paints, Speedball trichromatic colours, and Kremer organic pigment pastes and powder pigments when used in conjunction with Lascaux Screenprinting Paste and other products.

- complete range of high-quality artist's colours and types of paint, including gouaches, liquid watercolours and acrylics
- very intense colour/high percentage of quality pigment in paint
- paint of very fine pigment particle size/all of mix can pass through 120 T mesh (305 T in US)
- archival quality (except Speedball process colours and Golden fluorescent colours)
- excellent range of possible opacity (Lascaux Gouache) or translucency

- colour wheel (Lascaux Sirius Primary System)
- capable of four-colour process printing (Speedball process colours).

Selecting Screen Fillers and Screen Painting Fluids

There are relatively few screen fillers on the market for screenprinters working with water-based printing mixtures. Several commercial fillers are available but some of these have toxic components or poor handling qualities, and none have been found to suit the particular needs of the system. Specially designed fine art products are more suitable. At present there are no commercial painting fluids.

Screen filler

Choice: Lascaux Screen Filler

- non-toxic to user and low toxicity to environment
- product has consistent quality from batch to batch
- long shelf-life; non-separating mixture
- economical
- excellent for painting with a wide range of brushes
- excellent for mark-making with sponges and other textured materials
- bridges well on fine or coarse open meshes
- suitable for fine editing and compatible with photostencil
- can be applied with a squeegee
- can be applied to either side of mesh
- adheres well to photostencil for spotting out
- compatible with Lascaux Screen Painting Fluid and Speedball Screen Drawing Fluid
- accurate image reversals in conjunction with photo-emulsion
- errors can be corrected when filler is wet by washing away with soapy water

- fast drying time
- removal requires use of high-pressure hose in conjunction with Mystrol
- tough, durable, sustains long print runs

Speedball Screen Filler can be used but is not reliable when applied to a photostencil. This filler can often be removed with household cleaner and warm water but a high-pressure hose may be necessary in some cases.

Screen painting fluid

Choice: Lascaux Screen Painting Fluid
- good for image reversals in conjunction with screen filler
- easy to remove with water

Speedball Screen Drawing Fluid may be used but it is slower drying and less easy to see on the mesh, as it is pale blue.

INDUSTRIAL AND COMMERCIAL PRODUCTS FOR WATER-BASED SCREENPRINTING

Selecting Industrial and Commercial Water-Based Screenprinting Inks

The manufacturers who supplied artists and industrial printers with solvent-based screenprinting inks began in the 1980s to develop less toxic products in response to new health and safety requirements and changing environmental legislation. Commercial water-based screenprinting products are promoted as much less hazardous to the user and the environment than solvent-based screenprinting products. However, the MSDSs for many of these materials show that they do in fact contain some hazardous components.

These products vary considerably both in their chemical composition and in their performance. The inks are designed to be used primarily by commercial printers working with automated equipment and, for production reasons, to dry rapidly on the paper. This speed of drying creates technical difficulties for artist-printmakers who generally print by hand, with stage-by-stage decision making, who often wish to print on unusual substrates or to register slowly, and who are printing comparatively short runs.

In general, industrial screenprinting inks, mediums and additives have limited colour quality, range and surface control. Some brands have colours within their ranges which are incompatible and will not mix. These inks do not carry an AP Seal or have ASTM D 4236 ('no health labelling required') status, and some require fume extraction. Their handling and printing characteristics are similar to solvent-based inks and they require protective clothing to be worn. The inks may dissolve, break down or crosslink with fillers and photo-emulsions, causing problems with printing, cleaning and decoating.

Many industrial water-based inks are designed to be washed from the mesh using water and a high-pressure hose. However, in fine art studios, meshes need to be reclaimed with household cleaner as water may not remove dried ink. As an economic measure, commercial screenprinting companies often strip the mesh from the screen frame rather than reclaiming this.

Artists often add substantial quantities of retarder to slow down the drying time in order to prevent the ink drying in the mesh. However, these retarders are in some cases more hazardous to health than the inks, and an MSDS should be consulted before purchase. Commercial water-based screenprinting inks and retarders may contain chemicals which are classed as

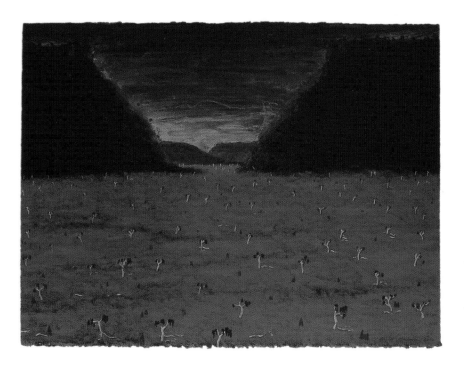

Robert Maclaurin, *Late Afternoon*, water-based screenprint, 56 x 76 cm (22 x 30 in.), edition of 50, 2001. This rich image was screenprinted using standard mixes, Lascaux paints and Kremer pigments, including a range of earth pigments. The Australian landscape was built up by painting a series of autographic positives with Lascaux Tusches.

primary irritants, mutagens or reproductive effectors. Some industrial water-based inks may release toxic fumes which are heavier than air and require low-level extraction systems. Another cause for concern is the inclusion of dimethylethanolamine in a popular water-based ink and retarder. The MSDS for this chemical states that it is harmful if inhaled, swallowed or absorbed through the skin. Inhalation causes severe damage to the upper respiratory tract. Contact with eyes may cause blindness. Dimethylethanolamine may stimulate the central nervous system, possibly resulting in restlessness, lack of coordination, tremors and convulsions. Prolonged or repeated skin exposure may cause dermatitis. Animal studies have shown target organ effects on the liver and kidney.

Another example is a recent study of the printing industry in the UK which showed aziridine to be a cause of dermatitis. An aziridine compound is an ingredient in a widely marketed water-based ink activator. The MSDS states that this chemical is not

a carcinogen at detectable levels, but because of the positive mutagenic test and carcinogenic effects of lower molecular weight aziridines, this product has to be handled with due care. Some inks contain chemicals which are oxidizers, and care must be taken regarding their safe storage. Others have components which are classed as fire hazards. All require the user to practise good studio hygiene and wear skin protection; the wearing of goggles is also often recommended by manufacturers. The type of protective glove may be important, and some MSDSs specify the use of butyl gloves when handling chemicals such as N-methyl-2-pyrrolidone (NMP), which is a modern solvent compatible with both water and organic solvents. Chemicals of this type are sometimes used in commercial water-based inks which, although fully miscible with water, can contain organic solvents in concentrations of up to 16.5%.

Many commercial water-based products contain types of glycol. Glycol ether solvents are powerful and are used in many processes, and as components in

stains, inks, lacquer coatings, reducers and dry-cleaning solvents. Glycol ether solvents such as 2-butoxyethanol (synonym: ethylene glycol monobutyl ether) are common ingredients in industrial water-based inks. In its pure form this substance can be absorbed into the body by inhalation, through the skin and by ingestion. If generated into a mist, this chemical could be rapidly absorbed by the body. Short-term exposure irritates the eyes, the skin and the respiratory tract, and could cause central nervous system depression as well as liver and kidney damage. Long-term exposure to the liquid de-fats the skin. The substance may have effects on the haematopoietic system, resulting in blood disorders. This glycol decomposes, producing toxic fumes. It can form explosive peroxides and reacts with strong oxidants, causing fire and explosion hazards.

Hexylene glycol is another constituent of some water-based inks. It is one of the lower molecular weight glycols which are miscible in water. In its pure form it can irritate eyes, skin and the respiratory system, and can cause headache, dizziness, nausea,

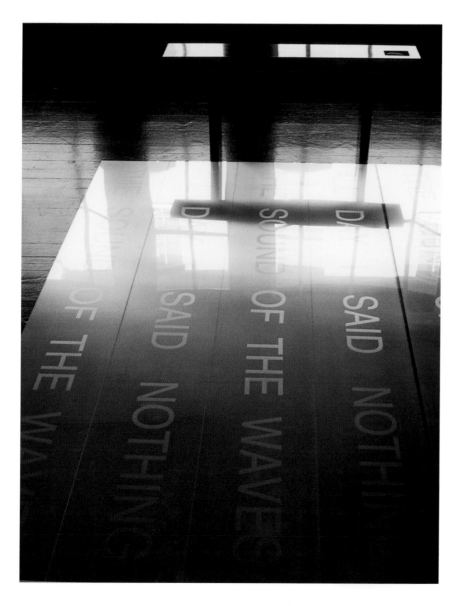

Elizabeth Ogilvie, *Waves*, water-based screenprint on Perspex, installation, 1996. In order to print these sheets of Perspex (which are thicker than a normal substrate), the screen frame was raised by adjusting the press. A fine mesh of around 120 T (305 T in the US) was used to print the text, as a coarse mesh would have printed stepped or zig-zag edges on the letters. The text was created and formatted, complete with a registration system (to align it with the Perspex panels), using a computer and a simple word-processing programme. The artwork was output onto acetate and used to create a series of photostencils. The text and registration marks were then printed onto a registration sheet, which was used to position the text accurately on the panels. The registration marks were closed using a simple gumstrip stencil before printing. To achieve an effect resembling etched glass, the text was screenprinted with a translucent green made from Lascaux products.

lack of coordination, central nervous system depression, dermatitis and skin sensitization.

UV-curable inks are at present the most common choice in the screenprinting industry. A curing unit ('reactor') is required to dry the prints. Health concerns relating to leakage from reactor units have been reported. The cost of reactor units and their size make this screenprinting method unsuitable for most small fine art workshops. Nitrile gloves should be used, as latex and other materials offer very little protection from UV inks, which have been linked to cases of dermatitis.

In general these products are not ideal for artists' use.

Commercial water-based screenprinting inks and the environment

Commercial water-based screenprinting inks are available which do not contain ozone-depleting chemicals as described in the Montreal Convention. They are formulated free from aromatic hydrocarbons which are known to have an adverse effect on the environment. However, they may contain chemicals such as 2-butoxyethanol (synonym: ethylene glycol monobutyl ether) which may be hazardous to the environment.

The mixed inks do not generally store well and harmful waste ink may need to be disposed of by specialist companies to comply with the law. It is therefore important to refer to the appropriate MSDS before purchasing an unfamiliar product.

Selecting products

In general, industrial screenprinting inks, mediums and additives have limited colour quality, range and surface control. Some brands have colours within their ranges which are incompatible and will not mix. These inks do not carry an AP Seal or have ASTM D 4236 ('no health labelling required') status, and some require fume

extraction. Their handling and printing characteristics are similar to solvent-based inks in that they require protective clothing and dry rapidly in the mesh. These inks can dissolve, break down or crosslink with fillers and photo-emulsions, causing problems with printing, cleaning and decoating. For these reasons they generally are not ideal for artists' use.

Selecting Frames, Meshes and Squeegees

Good quality screen frames, meshes and squeegees are available from a number of commercial screenprinting suppliers.

Screen frames

Choice: aluminium screen frame
- strong, lightweight, non-warping, non-rusting and non-water-absorbing

General purpose meshes

Choice: yellow or orange polyester monofilament mesh, non-abraded, 120 T (305 T in US), wide range of thread counts available, professionally stretched for accurate printing
- product has consistent quality from batch to batch
- non-absorbent to water
- static-free
- resistant to staining
- remains taut and evenly stretched
- strong and resistant to wear
- excellent for all stencil methods

49 T or 70 T (125 T and 180 T in the US) polyester mesh should be used for printing on canvas or printing heavy deposits of colour, metallics and powder pigments or paints with large particle size (49 T mesh is generally only available in white filament).

Squeegee handles

Choice for hand-printing: wooden handle
- waterproofed by varnishing or painting
- warm to touch and comfortable to hold

Choice for one-arm printing: heavy aluminium handle
- strong, inflexible, non-rusting, non-water-absorbing
- grips squeegee blade securely

Squeegee blades

Choice: soft, rectangular-profile, urethane blade
- long-lasting
- resistant to chipping
- suitable for water-based printing mixes
- able to print on soft or hard papers
- able to print on textured printing papers
- suitable for applying photo-emulsion and screen fillers

Medium and hard blades produce different printed results, and it may be useful to have a few squeegees with blades of varying durometer in a large professional studio.

Selecting Photo-Emulsions

Capillary stencils were the first type of light-sensitive stencil to be made. These indirect stencils consist of a photo-sensitive film which is exposed and then adhered to the mesh. Capillary stencils were superseded in the 1970s by liquid photo-emulsions, which are direct stencils. These encapsulate the mesh and lie between the threads, making a thinner and smoother stencil which prints more accurately.

There are many different types and brands of photo-emulsion available for purchase, but not all are suitable for artists' needs. For instance, some types of photo-emulsion can fail due to humid, dusty or greasy conditions, or incorrect drying, coating or exposure procedures. These problems are common in fine art studios, partly because artists generally do not have access to the automated screen-coating machines and high-technology UV exposure equipment for which these products are designed, and partly because artists tend to focus on their images rather than on the technicalities of the process.

For commercial printers and artists alike, stencil failure is frustrating, demotivating and costly in materials and time. Industrial screenprinters go to great lengths to avoid this problem by using a variety of specialized equipment such as hygrometers, thermometers, exposure calculators, microscopes, profilometers and thickness gauges in their printshops. They use this equipment to monitor screenroom humidity and temperature, to control UV exposure and to examine the stencil. The smoothness of the stencil (the Rz value) is gauged with a profilometer or Rz meter. The emulsion over mesh (EOM) is measured with a thickness gauge. The EOM is also referred to as emulsion build-up and consists of the total stencil thickness minus the mesh thickness. Some screenprinting companies have excellent websites which give detailed information about these topics.

The top-of-the-range dual-cure diazo-photopolymer emulsions are able to overcome many of these difficulties and perform consistently and reliably to a very high standard. These industrial products allow artists to make excellent photostencils with quite simple equipment in less than perfect conditions. Artists using these emulsions need not be greatly concerned with Rz values and EOM measurements. However, warm-air drying cabinets and domestic dehumidifiers, together with equipment such as a self-contained UV exposure unit with a built-in light integrator, are necessary for a professional studio. Dual-cure diazo-photopolymer

emulsions are excellent for stencil-making with artist-quality positives and for printing with water-based artist's materials. The photostencils themselves are safe for anybody to print with, but the processes of mixing and applying photo-emulsion and removing photostencils should not be undertaken by children, or high risk or special needs groups. Although the top-of-the-range products are a little more expensive, they are cost-effective as they have the following qualities:

- high reliability and low failure rate
- ease of application and ability to tolerate some dust and grease
- can be applied in yellow light, artificial light or low natural light without compromising performance
- good resistance to humidity, which means that crosslinking of the polymers is optimized (see 'The Chemistry of Photo-Emulsion', p. 129)
- high resolution, which is the ability of the emulsion to reproduce the very finest details from the positive onto the mesh with great accuracy
- excellent mesh bridging, which is the ability of the emulsion to span the spaces between the threads of even coarse meshes
- strong stencil resistance to squeegee action, printing mixes, filler techniques and the soapy water used for cleaning
- excellent edge definition, which is the sharpness of the edge and the smoothness of the vertical plane in the emulsion build-up
- excellent mesh-structure equalization, which is the ability of the emulsion to lie between the threads of the mesh and self-level, creating a smooth coating which equalizes the interlaced three-dimensional structure of the mesh
- wide exposure latitude, which allows broad flexibility for successful exposure to UV light.

Photo-emulsion and health and safety issues

Industrial manufacturers have developed safer and more environmentally friendly photo-emulsions in recent years, and research continues. However, these products are designed for professional use only and good studio practice should be followed when photo-emulsions are part of a studio system. Modern direct photo-emulsions encapsulate the mesh and therefore adhere to it perfectly without the need for roughening the fibres. If the smooth surface of the mesh filaments is abraded or a multifilament mesh is used, printing mixes and the diazo in the photo-emulsion will stain the mesh more readily and this will have to be cleaned using a powerful chemical haze remover. Most photo-emulsions are formulated free of any volatile solvents and do not have a flashpoint, which exempts them from the 'Highly Flammable Liquid' regulations. They do, however, contain corrosive substances which can damage skin, mucous membranes and eyes. Most brands contain acrylic acid or acrylates in varying dilutions and as a result are classified as irritants.

Acrylic acid and its esters are used primarily for the production of acrylates and polymers, and are versatile substances which have widespread uses. They are reactive monomers and are employed as intermediates in the manufacture of useful, and in many cases essential, polymers and plastics. There is massive demand for acrylic acid, which is used to make protective surface coatings, paints and adhesives, amongst many other products. In its pure form acrylic acid is classed as embryotoxic and teratogenic. A 1999 report called for more research, as no carcinogenicity or mutagenicity data on this chemical was available. It does not remain in the body due to its removal in expired air and in urine.

Diazo sensitizers are added separately to some photo-emulsions in order to activate them. Some of these sensitizers can contain up to 50% phosphoric acid (synonym: orthophosphoric acid). The substance is corrosive to the eyes, the skin and the respiratory tract. The MSDS for the sensitizer states that close-fitting eye protection, protective clothing and gloves must be worn when adding the diazo sensitizer to the photo-emulsion. A particulate respirator must be worn when the sensitizer is provided in powder form rather than as a fluid. Photo-emulsion is often kept in refrigerators to prolong its shelf-life but particular care should be taken to avoid storage with (and possible contamination of) foodstuffs. The MSDS for phosphoric acid states that it is a medium-strong acid which can attack metals to liberate flammable hydrogen gas. It also decomposes on contact with metals to produce toxic fumes (phosphorous oxides). A clean plastic spatula (never metal) should be kept specifically for mixing the emulsion with the diazo sensitizer. Squeegees should be used to apply emulsion rather than aluminium coating troughs.

Photo-emulsions and the environment

Photo-emulsions and photostencil removers vary in their toxicity to the environment. Quantities of waste photo-emulsion should be removed professionally, not simply disposed of in household refuse. For this reason, one-litre containers should be purchased and shared with other printmakers so that all the emulsion is used up before it ages. Folex and Sericol diazo-photopolymer emulsions are moderately biodegradable, are free of phthalate plasticizers and volatile solvents, and do not contain ozone-depleting chemicals as described by the Montreal Convention.

Photostencil removers (or decoaters)

Safer photostencil removers have been developed based on sodium periodate meta (synonym: periodic acid, orthoperiodic acid, sodium metaperiodate). Periodic acid is any of various oxyacids of iodine. This type of decoater is very effective and is less damaging to screen mesh than bleach-based products. Concentrations of this chemical in different brands vary from 10% to 100%. Sodium periodate meta may cause irritation to eyes, and to skin if there is prolonged contact. It is important to purchase this decoater as a liquid, rather than as a powder, to avoid any risk of inhalation. Sodium periodate meta is an oxidizer and if it is in contact with combustible material it may cause fire. The chemical should therefore be stored sensibly and protective clothing should be worn when it is handled. This type of decoater is generally purchased in concentrated form and is usually diluted with water before use. The liquid should not be sprayed or misted even when diluted.

Selecting a photo-emulsion and a remover

Choice: Folascreen DC 200 has all the attributes listed for dual-cure diazo-photopolymer emulsion

- applied by squeegee
- high resolution
- minimal hazard to user and environment
- consistent quality from batch to batch
- tolerant of imperfectly prepared mesh
- decoatable from mesh even after long periods on the screen
- economical

Choice: Folex Folascreen CL 14 Liquid Stencil Remover
- effective, even on old photostencils
- contains no bleach.

PVC Sheet as a Key Part of Water-Based Screenprinting

When PVC sheet is used as a key part of a water-based screenprinting system, it radically alters the type and quality of work produced in the studio. In a practical way it also simplifies many processes such as registration and printing. PVC sheet is widely produced, and inexpensive if purchased from a paper merchant. It can also be recycled for a number of useful studio functions.

Selecting PVC sheet

Choice: gloss clear PVC 240 micron sheets

Positive-making uses

- map for building positives
- tusches easily removed from substrate
- will accept painted washes and other autographic marks
- support for photo positives and photo collages
- transparent to allow excellent resolution at short exposure
- stages of the image can be kept in this form for future images

Registration

- map for registration of printed layers
- screens can be removed from press bed, and the screen and image re-registered accurately for a future printing session
- robust and resistant to creasing

The range of products which make up the fine art water-based screenprinting system

- transparent, allowing accurate registration and colour selection
- useful for awkward registration
- repeat proofs may be removed with a sponge
- water, brushes, sponges and rags may be used to edit a print made on the registration sheet; in some cases the printed sheet may be pinned up on a viewing board in register with the proof in order to make decisions
- the edited sheet may be used as a positive if the new image is preferred
- if a stencil becomes fragile, a print made on a PVC sheet can be used as a positive in case the stencil suffers further degradation

A water-based screenprinting studio showing a range of workstations, including areas for paint preparation and positive-building, as well as screen filler, screen painting fluid and photo-emulsion application. The photo-emulsion drying cabinet is visible, as is screen storage and the UV exposure room. Note the autographic and photographic collage positive on the central bench, and the white bench tops: PVC sheet can be used as a cheap alternative to glass.

Other studio uses and recyclable uses for gloss clear PVC sheets

- protective artwork envelopes and tubes
- shielding open areas of the mesh while printing (on printing side of mesh)
- bench covering
- narrow strips suspended down inside of rear of wire drying-rack shelves to prevent prints from sliding off when shelves are lifted
- applications in etching studio

SELECTING MATERIALS FOR AUTOGRAPHIC POSITIVES AND PHOTO POSITIVES

Commercial printers use photographer's photo opaque (paint and pens) to make positives. These are designed for stopping out scratches and other unwanted areas on negatives. To make sensitive marks, artists often use lithographic tusches and crayons, which are formulated from pigment held in grease. A mark made using one of these lithographic media may look opaque to the human eye but during exposure only the pigment will block UV light, whereas the grease will allow the light to pass through. Therefore only a proportion of the mark will shield the photo-emulsion from the UV light, and as a consequence an inaccurate photostencil will be produced. Other traditional media include oil paints and etching inks combined with solvents or baby oil. However, these take a long time to dry and also introduce grease to the degreased mesh. More recently artists have been mixing photocopy toner with acetone, methylated spirits or other solvents. These solutions are hazardous to make due to the toxic and volatile ingredients: the solvents evaporate as they are painted with, and the toner dust which remains after the solvents have evaporated is an inhalation hazard. Heat is sometimes used to melt the photocopy toner onto the substrate but this is inadvisable as it generates toxic fumes in the studio and is a potential fire hazard.

All of these characteristic marks and many more effects can be generated using non-toxic artist's materials and safe working methods. Lascaux manufacture a range of tusches designed especially for artists to paint positives for use with water-based screenprinting. In addition, some artist's acrylic paints and gouaches can be used effectively. A wide range of drawing materials are also suitable: a simple test strip should be made when experimenting with new media. All the selected products share the following characteristics:

A view of artists' paintings and drawings made on smooth PVC sheet. Lascaux Tusches, spray window cleaner, some tannin powder, a basin of soapy water, a translucent blue highlighter pen, an oil bar and a clean cloth can be seen on the lightbox. Note the three painted positives: one is made from tusche washes and oil bar, the second is a dry tusche which has been scratched through, and the third is a tusche wash with added tannin.

- excellent light-blocking ability
- ready adherence to substrates
- consistent quality from batch to batch
- economical

Selecting drawing media

Choice: conté crayons, compressed charcoal, soft pencils (these media should be used on grained film); typing correction pens, some types of marker and felt pen (may be used on smooth or grained film)
- suitable for drawing, mark-making and fine editing

Selecting painting media

Choice: Lascaux Tusches
- non-toxic to user and low toxicity to the environment
- provide a range of media that are excellent for painting, fine editing and unusual mark-making
- offer choice of waterproof or water-soluble materials
- can be used on gloss PVC sheet, grained substrates, lith film photo positives, digital positives and photocopy acetates
- wide range of reticulated wash effects, including lithographic-type (stone or zinc plate) and watercolour-type
- continuous tone effects can be created
- can be diluted with water
- free-flowing; no pooling or retraction
- dry brush marks
- images can be created by scratching away the tusche
- compatible with other painting and drawing materials such as gouache, acrylics, conté and pencil
- washed off when wet with soapy water
- easily removed from substrate when dry using household cleaner
- painted tusche marks are flexible and strong when dry, allowing positives to be rolled for transport or storage

- Tusche soft-ground effect can be rolled out on PVC and used in a method similar to traditional etching soft ground to make a positive
- Tusche soft-ground effect can be rolled out on PVC and used for monoprinting techniques (offsetting)
- Tusche soft-ground effect can be rolled out on PVC and the roller marks used as a positive
- Tusche wash/spray may be applied using airbrush techniques
- aquatint-type effects can be made
- sugarlift-type positives can be made using Lascaux Lift Solution in conjunction with airbrushed tusche
- easily cleaned from tools and brushes

Some brands of acrylic paint can also be used for creating images or to edit photographic, photocopy or digital positives.

Selecting a substrate

Films used to paint, draw and assemble positive collages on should be around 240 microns thick. If the film is thinner than this, it is likely to crease when handled. Paintings can be made on grained or smooth sheets. Drawings must be made on a grained film: the textured surface holds the drawing and breaks it up into a series of dots which print with subtle tonalities. Heavyweight tracing paper is suitable if only dry drawing media are used. If painted marks are to be included, a wide range of grained drafting films will produce good results. Smooth PVC sheet is sometimes sanded by printmakers to create this type of surface: PVC dust is hazardous if inhaled, however, so this practice is not recommended. True-Grain film, which has a surface quality similar to that of a textured paper or lithographic stone, is specially marketed for this type of autographic positive. However, grained sheets are slightly opaque which makes registration to a map or a proof more difficult

than with a clear film. The clarity of the exposure may also be affected by the cloudiness of some types of sheet.

Collages of positives, painted marks and reticulated washes can be made successfully on smooth Pentaclear (gloss clear) rigid PVC sheet, which is easy to see through, simplifying the processes of registration and colour-matching when proofing. This type of sheet is inexpensive, readily available from paper merchants, easily recycled for further images and useful for other purposes in the studio.

SELECTING PRODUCTS FOR CLEANING AND PREPARING MESHES

In water-based screenprinting, printing mixtures are cleaned with a sponge and soapy water (see p. 21) and stencils are easily removed with the most ecological and safe cleaning materials available. Unlike solvent-based screenprinting materials, which reduce the life of screens due to the harsh effect of the solvents, materials used in water-based screenprinting are mesh-friendly. Squeegee blades also benefit, remaining sharp and soft for much longer.

Both industrial and commercial products are used in the water-based system, and each chemical is applied using a designated CPS brush. These cleaning brushes have frayed bristles which hold the chemicals without dripping. The handles are also designed to minimize run-off onto the user's hand. Similar car-washing brushes are now available at auto-accessory stores.

Artists can print in a very safe way by using screen fillers, paper stencils and artist's material printing mixtures, as well as by degreasing meshes with safe products and cleaning meshes with soapy water and household cleaners. This is a suitable way to work with children and special needs groups, too. Professional artists can also make use of these methods, as the products are fully compatible with photostencils. The removal of photostencils requires the use of powerful chemicals and a pressure hose, but the process can be carried out safely.

The stages of mesh preparation and cleaning make use of different products. All the materials selected here share the following advantages:
- minimal hazard to user and environment
- consistent quality from batch to batch
- economical
- long shelf-life
- effective

Abrasive screen preparation products

In a water-based screenprinting system using direct photo-emulsions, it is not necessary to abrade the mesh at any point. Abrasive screen preparation products contain corrosive ingredients and other hazardous chemicals. These products should be avoided as abrading the fibres makes them more difficult to clean, weakens them and shortens the life of the mesh.

Degreasers

Non-abrasive degreasers are available with varying levels of toxicity. A specialist screen degreaser should be used rather than household cleaning products, which are less effective. Gibbon manufacture a pH-neutral degreaser, Safeguard, which has no hazardous ingredients. The Danish company CPS manufacture a useful acidic degreaser which was developed specifically for less toxic screenprinting. Other companies manufacture products which contain no caustic or other toxic chemicals, but MSDSs should be consulted as some

Rebecca Mayo, *Chewing the Facewasher*, water-based screenprint and acrylic-resist etching, paper size 76 x 56 cm (30 x 22 in.), 1994. Photographic positives with added autographic marks were used to create photostencils for the screenprint. These stencils were screenprinted using Lascaux products. The etching plate was created with a range of techniques, including photographic positives in combination with photopolymer film. The plate was also worked by hand, using acrylic-resist etching methods and burnishing. The artist describes her working method as follows: 'I printed the green text at the bottom before the etching was printed. I wanted a flat image that would not interfere with the embossing of the etching. I had to make up a printing mixture that would not dissolve when the paper was dampened for etching. After I had printed the etching, I screenprinted a small section of the pale green through the centre of the image to hold it all together.' The artist describes one aspect of the complex processes involved in combining different printmaking media to build an image. She also used her thorough technical understanding of essential processes such as screen cleaning and degreasing. The preparation and degreasing processes for etching have close parallels to those required for screenprinting.

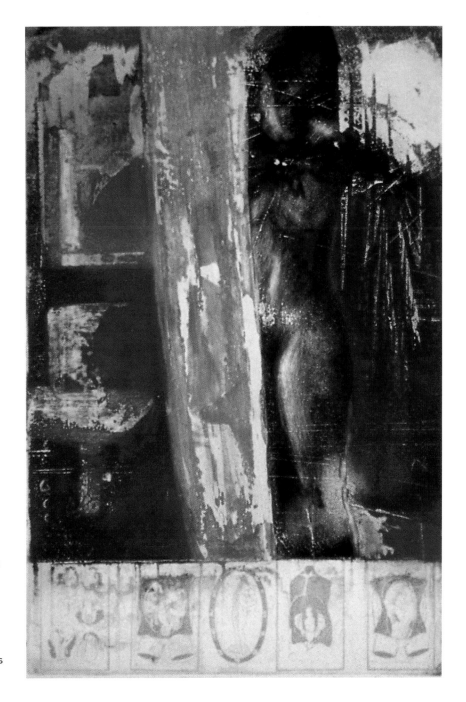

degreasers contain hazardous chemicals such as 2-hydroxy-1,2,3-propanetricarboxylic acid monohydrate.

Choice: CPS Mesh-Degreasing Concentrate or Gibbon Safeguard Degreasing Concentrate 200
- powerful grease and dirt removal
- non-foaming and easy to remove
- neutral to acidic pH
- excellent static reduction
- leaves no powdery residue

Photostencil removers (see p. 33)

Screen filler removers and anti-stain
Household cleaners can be used to remove screen fillers and printing stains from meshes. In common with water-based paints, many cleaners contain propylene glycol (see p. 21). Everyday household cleaners can contain hazardous ingredients such as surfactants, de-limonene, formaldehyde and 2-aminoethanol. Eye and skin protection should be worn, and these cleaners should be rinsed from meshes with a soft hose before a high-pressure hose is used (to prevent misting and inhalation).

Choice: Mystrol household cleaner
- effective filler remover
- useful for anti-stain, other printmaking functions and general studio cleaning

Other household cleaners such as Greased Lightning, Mr Muscle Bathroom and Flash may be useful.

Haze removers
The diazo stains and other ghosts which result from daily use will need to be removed if they affect printing quality. Haze removers tend to be corrosive sticky pastes which are difficult to apply evenly and may splash when brushed on. In addition many manufacturers advise the use of a high-pressure hose to remove the cleaning agent. This procedure causes misting and the risk of inhaling powerful alkaline chemicals such as sodium hydroxide and sodium hypochlorite (synonym: bleach). Sodium hydroxide can cause severe burns and sodium hypochlorite can cause serious damage to the eyes. It also irritates the skin and the respiratory tract, and repeated or prolonged contact may cause skin sensitization. This chemical can be absorbed into the body by inhalation (in its aerosol form) and by ingestion. People with impaired respiratory function or heart disorders or disease may be more susceptible to its effects.

Choice: CPS Haze Remover (alkaline part)
- effective acrylic paint and pigment stain remover
- effective diazo stain remover
- low percentage of caustic
- liquid is easy and economic to apply with a squeegee
- washes easily from mesh with a soft hose.

DESIGNING A WATER-BASED SCREENPRINTING SYSTEM

PLANNING A WATER-BASED SCREENPRINTING STUDIO

Unlike a solvent-based screenprinting studio, a water-based system needs no solvent storage units or extraction systems. It is possible to print with water-based materials working on a bench with a simple hinged bench-screen using paper stencils and screen filler techniques. The only equipment required for this is a squeegee, a sink with running water, household dishwashing liquid, CPS screen degreaser, paper, newsprint, PVC sheet, sponges, drying cloths and brushes.

To make prints to a professional level, and to explore the medium fully, specialist printing and stencil-making equipment and a properly designed studio are necessary. When identifying a potential studio, points to consider include access for large equipment and the possibility of future expansion. Consider the aesthetics of the space, noting sources of bright natural light, low levels of light, quiet areas, and nooks and crannies. Areas with good natural light should be used for drawing and printing workstations as these activities, which involve accurate colour work, will benefit from this. Small rooms and corners can be useful for storage, toilets and shower, or for creating areas of low-level light, or for containing washing areas such as screen cleaning. An office with computer, telephone and filing cabinets is essential for most print studios and educational establishments. A quiet, private space is also useful for interviews, assessments and staff meetings. A kitchen with a microwave oven, refrigerator, kettle, table and chairs provides a place for artists to eat, drink and socialize. Books, journals and a noticeboard help to make this an area where artists can relax and exchange information. Artists using the studio will require lockers for aprons, brushes and tools, and clean storage space for coats and portfolios.

The architectural quality of indoor plants can be used to create a sense of private space. Scientific research has shown that spider plants, ivy and other plants actively detoxify the surrounding atmosphere and improve air quality.

If large screenprints are planned, all the equipment will have to accommodate this size. This includes screens, screen storage, presses, UV unit, exposure drying cabinets, wash-out bay, plan chests, paper and print storage, and framing. Therefore a clear decision concerning studio policy on the size of prints will have to be made at an early stage.

Workstations

In a busy studio the movement of artists working through the stages of the screenprinting process can be managed successfully with the use of well-designed workstations. Each workstation should have close at hand the appropriate equipment for the process, kept in a clearly marked location. Colour systems can also guide artists to use – and replace – the tools allocated to particular chemicals, preventing contamination and related problems. No alternative hooks or shelves should be made available, so that the equipment is returned to the correct marked location ready for the

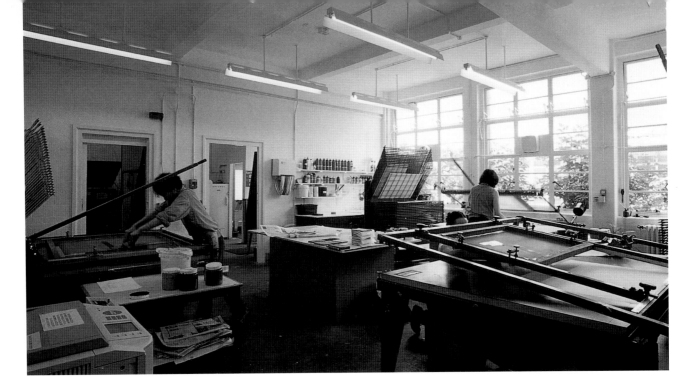

next user. Each workstation should display appropriate safety and educational information. These visual aids also act as an important support for teaching and learning. A shared studio structured in this way is user-friendly, and any staff intervention can be managed sensitively. Artists unfamiliar with the screenprinting process will rapidly gain confidence.

Students at work in a water-based screenprinting studio. Note the various workstations in the main studio: ink mixing, central working area, photocopier, print-drying racks, printing tables and vacuum presses. The artists are (from left to right) printing, fixing a paper stencil and cleaning up. The other rooms contain the screen wash-out area, screen storage area, photo-emulsion application bay, UV exposure unit and screen-drying cabinets. Note that the central table is being used for collating prints.

Planning the space

A practical way to plan the layout of a studio is to measure the room accurately and draw it to scale on graph paper, creating a floor plan.

● Mark on this plan existing or new plumbing for hot and cold running water and drainage, as this will be necessary for a hand-washing sink and the wash-out unit.

● Windows, doors (show direction of opening), ventilation and power points should also be indicated on the plan.

● Ensure that doorways and gangways are sufficiently wide to allow disabled access.

● Consult fire safety officers to locate fire exits and fire extinguishing equipment. The gangways should be planned to allow easy access to fire exits.

● Electricity will be required for presses, the lightbox, screen-drying cabinets, UV exposure unit and a hand liquidizer.

● Check with a plumber, electrician or architect that these plans are feasible and economic before starting work. When discussing the studio with building control and safety officials, make it clear that a water-based system is being planned, in case it is assumed that the stringent regulations applying to solvent-based screenprinting have to be enforced.

Positioning equipment

Moving screenprinting equipment is awkward, so the planning process is easier using the scale drawing. Large items of equipment should be measured, allowing for operating space – for instance, manoeuvring paper on and off a press, or opening the drawers of a plan chest. Squares should then be drawn on a separate sheet of graph paper to represent these items, together with any space that may be needed around them. Each square should be clearly labelled and arrows included to show the direction of any moveable parts. When these paper shapes are cut out, they can be moved around on the scale drawing of the studio. When the positioning of the equipment, plumbing and electrical wiring has been decided, the paper shapes can be glued to the scale drawing. Photocopies of the plan can be made for reference. The positioning of new plumbing and electrical wiring can be marked on these. The following points are important:

● The locations of vacuum presses, wash-out bay, UV exposure unit, lightproof cabinet, drying cabinet and benches need to be planned to allow ease of movement between the equipment.

● All the facilities required for creating photostencils should be grouped in the same area, with artificial or subdued natural light. The photo-emulsion application

An example of a studio layout plan drawn on graph paper. The cut-out paper shapes, which represent items of equipment (and their working spaces), have not been finally positioned.

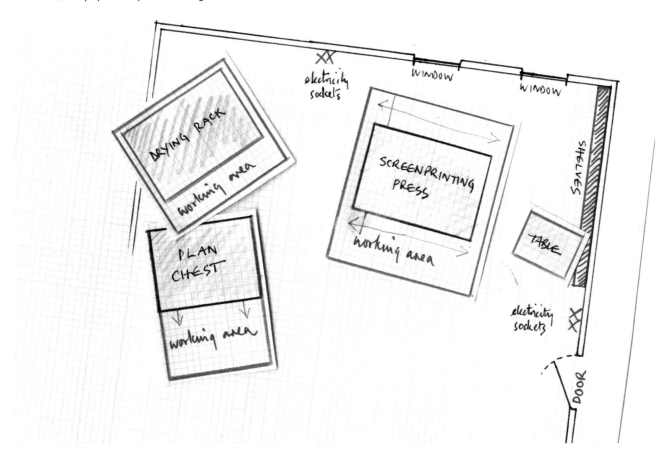

bay should be clean and dust-free, and close to a horizontal lightproof cabinet for drying and storing coated screens. The UV exposure unit should be next to this. The wash-out bay should also be as close as possible to this equipment so that screens can be developed immediately after exposure. A vertical drying cabinet for newly developed screens should be at hand.

● Screen storage should be out of range of moisture from the screen wash-out bay, as any droplets of photostencil remover which land and dry on meshes with photostencils will make these stencils impossible to decoat.

● The paper preparation area should be for clean work only.

● The printing mix workstation should incorporate a considerable amount of shelving and a large sink with hot and cold water for filling basins and hand-washing.

A labelled screen being returned to the screen storage rack. The horizontal lightproof cabinet and vertical screen-drying cabinet are visible, together with safety and location signage. Note the vents in the drying cabinet doors which allow the warm air to escape.

Safety

Safety considerations which should be considered include the following:

● Safety and user information should be displayed clearly, but not intrusively. All containers must be labelled with their contents and any relevant safety symbol. MSDSs and full safety information should be available for reference.

● Fire doors may have to be installed, and fire exits must be kept clear at all times.

● Doors should have see-through panels made of safety glass.

● The design should take into account hazards such as awkward doors and stairs.

● Floors should ideally be level throughout the working space. If there are changes in level these will have to be accommodated in the design. Hard-surfaced floors are cold and tiring to stand on: non-slip rubber mats are useful for work areas. Screen-cleaning areas should be equipped with non-slip plastic duck boarding. These materials are widely available from general industrial suppliers.

● Equipment should be sited so that no hazardous parts project into passageways; a band of fluorescent red acrylic painted on any protrusions or possible hazards will make them more visible.

● The layout should take into account the space needed to handle screens safely and easily.

● To prevent accidents, electrical flexes should never be laid across passageways. Power points may need to be installed to avoid this.

● Pressure hoses generate noise and moisture so this will need to be taken into consideration.

● Electrical power points in areas affected by moisture should be the appropriate waterproof safety type.

● Storage shelves should be within easy reach.

EQUIPPING A WATER-BASED SCREENPRINTING STUDIO

Screenprinting manufacturers sell a wide range of products and machinery, and there is an active second-hand market for many of the larger items, some of which can also be home-built. Useful studio equipment can be seen in the photographs on pp. 42 and 47. Screenprinting suppliers sell screen frames, meshes, squeegee handles, blades and screen-cleaning brushes. Safety equipment can be purchased from industrial suppliers and home improvement stores. Artist's materials, paints for printing, tusches, screen fillers, screen painting fluid, papers and PVC sheets are available by mail order from specialist art and paper suppliers. Smaller items, such as basins, spatulas, scales, jugs and sponges, can be purchased in household stores. Manufacturers' addresses are given in the section listing suppliers (pp. 201-4) and an Internet search may provide other information.

Drawing area

Although an artist can do a lot of preparatory work for a print in a painting or drawing studio, having a space for quiet thought, planning and making artwork in the print studio is very useful. A drawing area can have many purposes, from working directly on the screen – including making permanent margins, and working with screen painting fluid and screen filler – to drawing, designing maps, working on positives and making paper stencils. Screen filler, screen painting fluid and materials used for making positives can be stored in the drawing area.

In a large studio the drawing area should have a lightbox and some work surfaces. It is important to keep bench tops that screens may be laid on scrupulously clean, as tiny particles of grit will damage the mesh.

To create a practical working surface, sheets of paper are placed on the bench top, and this is then covered with PVC sheet or glass. The edges can be sealed with parcel tape. The space will look light and fresh, and is easy to maintain. To protect the bench and lightbox surfaces, a cutting mat should be supplied for cutting paper stencils on.

A lightbox makes working on maps and positives much easier. One can be purchased from specialist art suppliers or may be available second-hand. A lightbox is an enclosed unit with a glass top and a fluorescent light source underneath. A simple home-built lightbox can be constructed from a heavy, tempered, ground-glass table top, supported on trestle legs. Fluorescent light units with diffusers can be installed beneath. This type of table can be purchased in IKEA shops and fluorescent light units are available in home improvement stores.

Paper and print storage

A set of plan chests is needed for the safe storage of paper and prints. One drawer should be set aside to store scrap acid-free paper for recycling. Metal plan chests are long-lasting, intrinsically inert (i.e. not made from an acidic material) and maintenance-free. Wooden plan chests, although attractive, are more susceptible to damp, warping, wear and tear, and attack by insect pests and rodents.

Paper preparation and print-collating workstation

A clean bench area should be used for preparing editioning paper or collating finished prints. A bench top covered with PVC sheet or glass is easy to keep clean. Storage should be made for a T-square, a metal straight-edge, a metre stick, a graphics ruler, pencils, waterproof pens, erasers, scissors, scalpels, a cutting

mat, a printer's chop, a set of wooden registration jigs, PVC templates for commonly used paper sizes, masking tape and some glass cleaner with a cloth. Rag rolls can also be stored here. These are square cloths that are folded, then rolled and secured with three bands of masking tape. They are used to support the corners of a screen to raise it from the workbench when working on the printing side. A number of these items can be hung on a wall near the bench and their locations marked by drawing their silhouettes in waterproof pen.

Portfolio rack
A simple box unit provides a place to store visiting artists' portfolios.

The digital studio
An ideal digital studio will be equipped with a computer (for instance a Macintosh G4 or a PC, with at least 128 megabytes of RAM and scope for upgrading later) connected to the World Wide Web, with suitable software. Artwork can be created using a mouse, or a stylus and pressure-sensitive tablet. Images can be input using a digital still or video camera, or a scanner (preferably capable of scanning photographic transparencies). Files can be stored on the computer's hard drive or saved in portable form using a Zip/Jaz drive or a CD writer. Many different output devices are commercially available, but domestic laser or inkjet printers are suitable for creating small positives.

Before investing in this equipment it is worth finding out if a local facility exists, as commercial and community digital resource studios are often well equipped and provide open-access facilities and run educational courses. Any artist can learn to make digital images and positives, and can develop an understanding and skill with the user-friendly interactive tutorials offered by many software programmes.

A digital studio.

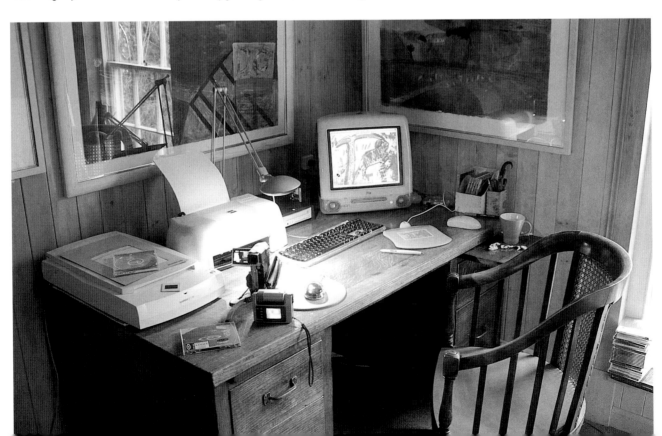

A home-built screen storage unit, with screen dividers made from slightly bent tubular plastic conduiting.

Screen storage units

A properly constructed storage unit will optimize studio space, help protect meshes from damage and reduce contamination by airborne chemicals (especially photo-emulsion remover mists from the high-pressure hose), dust and grease. It is advisable to purchase frames of uniform size as meshes are then less likely to be damaged in storage. These are more convenient to store than a collection of odd frame sizes, and selecting a suite of screens to fit a particular size of image is easier. The number of screens required is not great if the images are cleaned off the mesh after printing, thereby freeing the screen ready for the next image.

A screen storage unit is not difficult to construct. It consists of five sides of a box made from plywood or chipboard. The base should be divided into channels slightly wider than the thickness of a screen frame (around 50 mm/2 in.). These channels can be made by fixing parallel wooden battens (40 x 20 mm/1½ x ¾ in.) to the base. A series of lengths of tubular plastic

conduiting (diameter 20 mm/¾ in.) can be screwed to the outer ends of the floor battens, and then be bent slightly and inserted at the other end into holes drilled in a batten (50 x 50 mm/2 x 2 in.) attached horizontally to the back panel of the box, about one quarter of the box's height from the top. This series of parallel, bowed plastic tubes will act as a safe support to hold screens vertically in the unit without touching each other.

A roll of gumstrip and a waterproof marker pen should be hung on a loop of string from the unit for making temporary identification labels for screens.

Screen preparation and mesh-cleaning workstation

These processes are wet and noisy, and the workstation should be positioned with this in mind. Mists generated should be contained and extracted so a small ventilated room is ideal. This should be close to the UV unit and within easy reach of the printing presses.

● The first requirements are a non-slip, draining floor and a simple extraction fan to remove moisture. All electrical equipment should have waterproof safety switches. A floor-cleaning mop and bucket should be at hand to allow artists to clear up any spilled water on the floor.

● A cupboard should contain a spare waterproof apron, eye protection, ear protection and nitrile gloves.

● A high-backed wash-out unit which has been specially designed to accommodate large screens is used for washing out photostencils, degreasing and removing stencils. The water used for these processes should be contained within the unit and should drain into a gravity sump, then into the waste-water system. A back-lit plastic unit will enable the artist to monitor photostencil development accurately and to see if the mesh is truly clean. Plastic, welded polypropylene or fibreglass units are the preferred choice, as metal units create more

noise when the pressure hose is being used. A home-made unit can be constructed from marine plywood and then varnished.

● Portable, electrically-powered, high-pressure hoses are widely available from home improvement stores. They are reasonably inexpensive and are suitable for screen cleaning. Safety information and instructions for use of the high-pressure hose should be displayed. The pressure hose should be attached to the cold water supply. In addition, an ordinary hose with adjustable hot and cold water is necessary for rinsing screens.

● A system for keeping the chemicals apart, and for helping artists identify the correct container to be used for each stage of the process, is simply established. A shelf with different coloured sections can accommodate four one-litre, colour-coded containers for chemicals (recycled Lascaux acrylic paint containers are suitable). Information relating to the procedures should be clearly displayed in each coloured section. For instance, red for photostencil remover, blue for degreaser, green for dishwashing liquid to remove ink, and yellow for filler remover. Acrylic paint can be used for the colour code, labels can be photocopied, and clear adhesive vinyl can be used to cover and protect the labels and painted surfaces. A matching coloured CPS safety screen-cleaning brush should be suspended from the shelf in each section (see the photograph on p. 191).

● The waste-water system in a studio should incorporate a sump which will collect any solid residues, for example acrylics washed from meshes. The sump should be emptied each week and the silt disposed of with other studio waste.

Screen drying

After degreasing or removing stencils the wet screen is dried in a vertical drying cabinet with a warm-air fan.

This type of cabinet takes up very little studio space and offers the screens some protection from unwanted handling and from airborne dust and grease. If wet screens are dried in the horizontal photo-emulsion drying cabinet, there is a risk that they may drip water onto coated screens, dissolving the coating.

Photo-emulsion application workstation

A screen-coating area is needed for photo-emulsion application. This space should be as free of dust as possible, and should be sited close to the exposure and stencil development workstations. Photo-emulsion should be applied under yellow light, artificial light or low natural light to minimize exposure to UV light. This type of environment can be created by making simple blinds from wooden rods and yellow-dyed cotton sheets; alternatively yellow gouache (with a little acrylic paint added) can be painted on the windows of a screen-process room. This paint will come off easily with warm water should the room need to be returned to normal use. (Paint a small patch on glass, leave this for one day and then remove it with household cleaner to check that the mix is not too strong.)

● A set of squeegees suitable for applying photo-emulsion should be hung on the wall. The following should also be available: a one-litre container of dual-cure diazo-photopolymer emulsion and its storage bucket, a designated sponge, a basin, a bucket of clean dry rags, a hand-spray containing water to reduce dust, a flexible plastic spatula and a mat (made from a recycled PVC sheet) to place tools on. The mat can be hung from the wall and other items can be stored neatly on a shelf accompanied by safety and procedural instructions.

● A screen-holder is used to hold the screen securely in the correct position for applying photo-emulsion. It leans

slightly back from the vertical and has an adjustable bar to grip the top edge of the screen frame. Screen-holders cannot be purchased but are easily constructed. The adjustable assembly is similar to that found on a wooden painting easel. Two wooden boards are assembled on a slightly tilted frame about a finger's width apart, so that they form a plane with a central vertical slot running from top to bottom. A bolt connecting two short (10 cm/ 4 in.) sections of wood (secured with a wing nut) should be placed in the channel, with the two wooden sections 'sandwiching' the boards. This assembly will slide up and down the channel, and the wing nut can be tightened to grip the screen frame in the right position. The outer wooden piece should be deep enough and shaped to hold the screen frame securely. A photograph of a screen-holder is shown on p. 132.

Photo-emulsion drying workstation

After the application of photo-emulsion, the screens are light-sensitive and must be dried and stored in the dark until they are exposed. A vertical lightproof drying cabinet can be used but may not produce good results as the photo-emulsion will tend to flow down the mesh, affecting the uniformity of the stencil. A horizontal warm-air lightproof drying cabinet is ideal, as the screens can be dried flat-side facing upwards. This allows the emulsion to settle in the spaces between the threads and to self-level into a coating which has consistent thickness. The cabinet offers the screen some protection and cuts down on dust which causes fisheyes in stencils. Powder-type degreasers should be avoided for this reason, and a vacuum cleaner can be used periodically to remove any dust from the cabinet.

Commercially available cabinets are generally low and made of metal, and the space between the shelves is narrow. Home-built cabinets are inexpensive and easily designed to fit the workstation, and can be placed at chest height (for easy manoeuvring of screens). The space below is useful for storage. A busy studio should need no more than five shelves. When the screens are dry they can be stored in an upright lightproof cabinet. The horizontal cabinet can be constructed on a wooden frame, with light plywood or chipboard cladding. The front should consist of a flap which is hinged (use a length of piano hinge) along the bottom so that the flap opens downwards.

The water in the photo-emulsion coating needs to be drawn out and evaporated, and so heat-drying is necessary. In a humid environment a dehumidifier may be useful. Manufacturers recommend a drying temperature of around 38° C (100° F). Hot circulating air can be provided by an electric fan heater. This should be maintained regularly. As it is designed to operate at room temperature, placing one inside a cabinet will reduce its effectiveness and is dangerous. A lightproof duct should be attached to the outside of the cabinet – low down – so that it will support the fan heater. The duct should be located in a visible position, so that the heater can be seen and maintained easily. A vent should be made – at the opposite side to the fan – to allow the warm air inside the cabinet to escape. This can consist of several 1 cm ($^3/_8$ in.) holes drilled within an area a few centimetres or inches square. Light can be excluded by making a flap of weighted PVC (painted black) which will completely cover the drilled holes. This should be hinged with tape along its top edge, allowing it to lift slightly when the fan is blowing. On the cabinet door a child's erasable 'magic slate' is useful as a temporary dust-free noticeboard to identify the owners of screens being dried. The 'magic slate' information also reduces the need to open the lightproof cabinet.

Ultra-violet exposure unit

A self-contained UV exposure unit with a powerful single UV light source with special safety glass, reflective panels, safe lights, light integrator, powerful vacuum lid and external controls is well worth the expense. These machines make detailed, accurate stencils very quickly, are safe to operate and save space in the studio. The UV light source used in these units is quartz halide and exposures are rapid (usually less than thirty seconds). The integrator measures the precise amount of light emitted in light units, allowing fine control and accommodating any variation in the strength of the bulb. As a result exposures can be repeated with complete consistency.

The least powerful quartz halide bulb is the most suitable for fine art screenprinters as it offers the widest latitude of exposure times. This is because the photostencils used by artists are generally more thinly applied to the mesh than commercial stencils, and as a result require less exposure to UV. More powerful bulbs sometimes require a three-phase electric power supply, which is costly to install. These machines can be purchased through screenprinting materials suppliers, directly from specialist companies or second-hand.

Before self-contained UV exposure units were available, a room had to be made light-safe. The UV light source was mounted on the wall and operated from outside the room. A vacuum clamp-down unit held the positive and the screen together, and when the air was extracted these were held firmly in place between the glass and the flexible rubber of the lid. The unit was then swivelled round so that the screen was vertical and could be moved towards the light source. The floor was marked out with lines to indicate different exposure possibilities. The UV lights were turned on and an integrator or minute timer was used to measure the length of the exposure. This type of system takes up a lot of space, and is less safe than an enclosed unit as there is a possibility of the user or another artist becoming exposed to hazardous UV rays. However, these swivel units can be adapted to create the basis of a home-made, enclosed, self-contained unit. Simple UV bulbs or tubes can be used as a light source. A light integrator can be installed as part of the system, or exposure times can be measured in minutes and seconds. This kind of exposure unit is generally considered to be less effective but many of the prints illustrated in this book were made with such a system. The 'Autographic Positives' section (pp. 98-115) demonstrates how sensitive these stencils can be.

The use of a cloth screen landing pad will prevent screen frames scratching the glass. Some glass cleaner (spray-type) and a cloth should be used to keep the glass clean. The bulb may need replacing occasionally.

Developing and drying photostencils

The exposed screen is developed in the screen preparation and mesh-cleaning workstation. Some studios have a separate back-lit wash-out unit for stencil development, but it is possible to develop stencils in the same unit that is used for removing stencils if the sink is thoroughly rinsed after the previous activity. Apron and gloves should be worn during this process, and an 'S' sponge, Ramer sponge or chamois leather should be used for developing the stencil.

After developing, the screen is dried in a vertical drying cabinet. Wet screens should not be dried in the horizontal photo-emulsion drying cabinet, as this will increase the humidity and there is a risk that they may drip water onto coated screens, dissolving the coating.

Paint preparation workstation

Even a small studio will benefit from having a special space for mixing printing colours. This should be a relaxing part of the studio, with good natural light. In professional studios provision should be made for high-quality 'daylight' bulbs or tubes to aid colour matching when the natural light is poor.

Unlike commercial or solvent-based ink systems, where colours are usually supplied in large, opaque containers, artist's colours for water-based screenprinting are sold in attractive 500 gm bottles or smaller containers. Each colour is clearly visible and, as these are inexpensive and last well, even a small studio will soon assemble a substantial collection.

Shelves are the best means of storing and displaying these containers. As they vary in height, the spaces between the shelves should be carefully measured to accommodate them. The shelves themselves should be just wide enough for the containers to sit on comfortably. A colour-spectrum backboard behind the bottles of colour will help establish and maintain an orderly system, as artists will automatically put the materials back in the correct place. A coloured backboard can be made by dividing a card strip into sections which measure the width of each bottle of paint, and which are then painted with each colour. When dry, the strip can be covered in clear adhesive plastic film for protection.

A bank of shelves should also be provided for storing jars of surplus printing mixtures. Recycled glass jars are suitable, but clear plastic containers may have to be used in educational establishments due to safety regulations.

Keiko Sato, *Natural Elements*, installation incorporating water-based screenprint, bamboo and Japanese paper, 2000. Ambitious print projects like this are much more easily achieved in a well laid out and equipped studio.

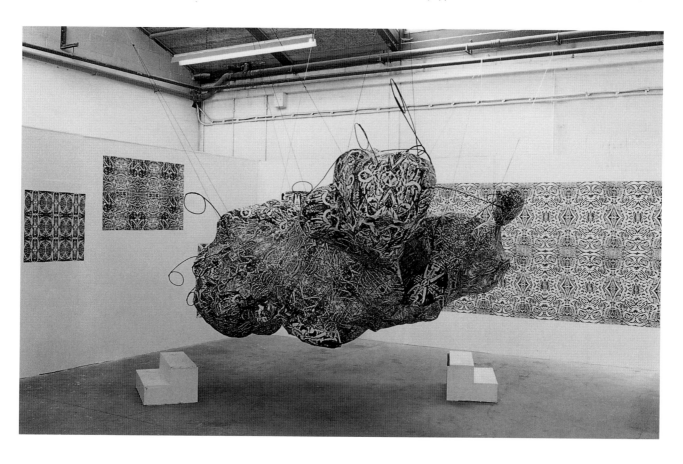

A white-surfaced bench covered with PVC or hardened glass will make it easy for studio users to keep the area clean. The bench should not be too wide or high, and it is useful to have shelves below for storing basins, household detergent, Mystrol or similar household cleaner, non-abrasive cleaning pads and sponges ('S' type or Ramer sponges are suitable). Ideally a sink, with running hot water, should be set in the bench or nearby.

The main components and equipment for making printing mixes should be kept on the most accessible shelves behind the workbench, which should be sturdy and within easy reach. To help screenprinters become confident and familiar with the system, a waterproof marker pen can be used to identify equipment storage locations (e.g. drawing round the base of containers and making an aide-mémoire by writing in the circle) and to add extra, easy-to-read labelling to containers.

The first shelf should hold the equipment and materials most often used to make printing mixes. This includes a five-litre container of Lascaux Screenprinting Paste, labelled 'Screenpaste (slow drying, 30% maximum)', five-litre containers of Lascaux Acrylic Transparent Varnishes, labelled 'Gloss Varnish (fast drying)' and 'Matt Varnish (fast drying)', a set of easy-to-read scales (electronic digital scales are best), some Pyrex (sturdy glass) mixing bowls, a bottle of household dishwashing liquid, a box containing scraps of editioning paper on which to make and test colour, a jar of up to six firm acrylic paintbrushes (1 cm/3/8 in. wide), and a labelled container of standard transparent printing mix. Some hooks can be attached to the edge of the shelves from which flexible plastic spatulas (kitchen-type) can be hung.

The second shelf should store a range of colours and a space should be allocated for a particulate respirator and – in a professional studio – an electric hand-held liquidizer.

Printing workstation

The press should have within easy reach a sink with warm water, a paint preparation area, a printing table, squeegee storage, a waste paper bin, a drying rack and the wash-out unit.

● At its simplest, two people can hold a screen in position on a substrate while a third pulls a print. In Thailand teams of people print long lengths of cloth with complex patterns using this method. However, a vacuum press is designed to simplify printing and registration, and it is worth investing in a good model. Presses can be purchased new or reconditioned from specialist manufacturers, or they can be bought second-hand. The vacuum printing press should be a sturdy, basic, hand-operated machine with a well-designed one-arm mechanism. The vacuum pump should be powerful and quiet: it draws air down through the perforated screenbed to hold the paper in position during printing. Second-hand machines may need the perforations re-drilled.

Kippax hand-operated presses (manufactured in the UK) are excellent. Other presses, such as carousels and fabric presses, are quite different in design and not appropriate. Some presses are highly mechanized, with electrically powered one-arms and press frames. These are designed for commercial screenprinters to edition in thousands, and are difficult for novices and artists to work on. Other types of machine have press frames which lift up from the bed horizontally, but these are not needed with water-based printing mixes which are thixotropic. Moveable press beds are adjusted by screenprinters as they register their images by looking through the mesh to the print underneath. This type of mechanism is not required with the PVC registration system. In addition the operating handles tend to get caught in clothing when printing.

Some enterprising screenprinters make their own presses from vacuum cleaners and home-made frames. Simple wooden bench-hinged screen presses can be made quite easily and work well with water-based printing mixes.

● A print-drying rack consists of a stack of around fifty hinged wire shelves, usually on casters, and is an essential piece of equipment. When buying a new rack, it is advisable to purchase the strongest available. Each shelf is designed to support a single sheet of paper (up to the size of the shelf) and weighting shelves with more than this will damage the springs. Shelves with damaged springs cannot remain in the raised position and will fall down, with the result that prints are often overlooked and missed during editioning.

Washing machine with tumble drier
Rags are used for drying up wet registration sheets, press beds and benches, and for other studio cleaning tasks. They can last for years if they are washed and dried by machine.

Safety equipment
It is important that fire extinguishers are clearly visible and of the correct type for each hazard. This equipment has a limited lifespan and will need to be tested and replaced regularly. Fire officers will specify the number and type of extinguishers and other equipment required for a particular workspace. Premises may be inspected on a regular basis by fire safety officers who will monitor the systems which are in place.

● In large studios a member of staff should hold a first aid certificate. An incident book should be kept to record any accidents or near misses: this information should be acted on as appropriate. Health and safety officials may make regular inspection visits to monitor studio safety systems. All studios should display safety information in visible, accessible locations, and should provide the following safety equipment:

● first aid kit and eyewash station
● MSDSs for the chemicals in the studio, in case of an accident: accurate chemical information may need to be supplied to medical or firefighting personnel
● gloves, eye protection, ear defenders, spare aprons
● particulate respirator for artists working with powders (stored in an airtight container such as a recycled Lascaux Screenprinting Paste bucket)
● fire-extinguishing equipment and sand to absorb any chemical spills
● any container of photostencil remover in use should be stored in a clean plastic bucket
● in case of a chemical spill facilities should be in place to douse any affected people with quantities of water
● plastic storage jars for storing printing mixes: many institutions prohibit the use of recycled glass jars in case of breakage.

Teaching equipment
Visual aid folders can be made, and built up, so that they form a visual reference library of exposure times, printing mix recipes and effects. Once a visual aid folder is set up, artists working in the studio can add to this realia to create an evolving compendium of marks which is invaluable for anyone using the studio.

● Ringbound folders with plastic envelope sleeves can be used to collect and display annotated examples of types of positive and printed material which have been created in the studio. Sections of proofs and prints (often a damaged print may display an interesting element) can easily be trimmed to fit the envelopes.
● Paper, cut to fit the page size of the visual aid folder, can be kept for artists to print any unusual marks on.

● Magazine articles, recipes, Internet documents and other relevant information can be added to the folder, and artists and students using the studio should be encouraged to do this.

Store room

A well-maintained store room will improve the efficiency of day-to-day running of the studio. Most materials used can only be purchased by mail order and may take some time to arrive. To avoid running out of any essential products, a back-up supply of materials should be held in the store room. At the point the back-up supply is required in the studio, replacements should be ordered.

● The store room should be secure, dry, cool and ventilated. Safety information concerning storage of any hazardous chemicals should be clearly displayed.

● The store room should be well organized and kept tidy. Sturdy shelves should not be too wide and should be attached to the walls. Hazardous materials should be stored on low shelves to reduce the risk of spills over the upper body.

● Areas for specific chemicals should be designated and clearly labelled. This is to separate incompatible chemicals which could react dangerously with one another.

● Photostencil remover concentrate is an oxidizer and should not be allowed to come into contact with combustible materials. The exterior of this chemical's container should be rinsed with water to remove any residue after use, and it should be stored in its own clean dry plastic bucket to isolate it.

● Do not store materials in food containers as this practice can result in accidental ingestion.

● Use clearly labelled unbreakable containers with lids.

● The store room should contain spare safety equipment, spill control equipment and safety equipment for handling chemicals. Good housekeeping regarding chemical storage, decanting and general usage should be followed.

● Screenprinting chemicals usually require dilution and these concentrates should be kept in the store room rather than the studio to avoid confusion. Funnels, calibrated containers and hand siphons for mixing and decanting chemicals make this task simpler and safer.

● Haze remover is used rarely, and only by professional printmakers or studio staff. It is not needed for daily use and is best kept in the store room.

● An easy-to-manage stock control system should be established to keep track of paints, screen chemicals, educational equipment, sponges, rags, squeegee blades, fillers and sundries.

● Mixed photo-emulsion has a longer shelf-life if kept in a refrigerator or cool-box. Foodstuffs should be stored elsewhere as they can be contaminated by this chemical.

Personal equipment

Suggested tools, materials and consumables for full-time screenprinters are listed below:

● eye protection, ear defenders, aprons or overalls, and gloves

● range of good quality paintbrushes

● pencils, erasers, waterproof marker pen and translucent blue highlighter pen

● scissors, scalpels or knives

● graphics ruler, T-square and metal straight-edge

● range of adhesive tapes, including masking tape, gumstrip and parcel tape

● PVC sheet, tracing paper and positive-making materials

● proofing and editioning paper

● polythene envelopes for storing paper and prints

● portfolio

- sketchbook
- curating notebook or computer
- personal embossing stamp (printing chop)
- camera for documentation
- particulate respirator for working with pigments or powders.

GOOD STUDIO PRACTICE FOR WATER-BASED SCREENPRINTING

It is essential to make safety information available to students, employees and studio users, as the processes and equipment in print studios are potentially hazardous. Simple studio systems will reduce the risk of accidents or injury, increase efficiency and help to avoid problems in the general running of the studio and in individual processes. The following is a suggested model for studio information relating to the fine art screenprinting system described in this book:

- All studio users must act professionally and show consideration and respect for their colleagues.
- Familiarize yourself with the location of fire exits, fire-extinguishing equipment, eyewash stations and first aid equipment in the studio.
- Immediately report to a member of staff any accident, near miss, faulty equipment, hazard or hazardous practice. These incidents should be recorded and dated in an 'incident book' maintained in the studio. One of the reasons for this is to allow speedy action to be taken to prevent further incidents.
- Never touch an electrical socket or unprotected switch when the floor or your hands are wet.
- No smoking in the studio.

Working with equipment and machinery

- Do not operate any equipment until you have been thoroughly instructed in its safe use.
- Take full responsibility for being in control of any machinery; moving parts can also injure a bystander.
- Do not miss out procedures which could compromise safety.
- Be constantly aware of other studio users in the vicinity.
- Do not distract other studio users, or allow yourself to be distracted when operating machinery or equipment.
- Workstations should be used only for their intended purposes, and displayed information should be heeded.
- Only use equipment in its designated space.
- Clearways should not be obstructed.
- No equipment should be altered or modified.
- When cleaning screens, rinse chemicals and paints from the mesh with the soft hose before using the high-pressure hose.
- UV light is dangerous at concentrated levels. No UV light should be visible from any part of the exposure unit.
- Take care not to drop screens on the exposure unit glass, and use the screen landing pad.
- Follow with care the correct routines when lifting the screen on and off the bed, and all other printing procedures.
- Make sure the sliding bar on the press is fixed before installing or removing the screen.
- Handle the one-arm mechanism with care at all times in accordance with the instructions you receive. This includes procedures for assembling and dismantling the mechanism.
- Obtain assistance from a staff member if you need to adjust the counter weights.
- When printing large editions, take regular breaks to help avoid repetitive strain injury.

Caring for the studio

● It is good practice to allow time to tidy up at the end of each work session.

● The floor should be vacuum-cleaned rather than swept to reduce dust which causes many problems.

● Remove dust periodically from inside drying cabinets with a vacuum cleaner.

● Masking and adhesive tapes should be removed from press beds, the lightbox, work surfaces and registration sheets.

● Benches and workstations should be left clear and clean, with all tools returned to their storage locations.

● Debris should be removed from the wash-out bay, and this should be rinsed free of chemicals.

● Waste containers should be emptied daily into an external waste receptacle.

● Presses need to be checked and greased regularly.

● Containers in the wash-out bay may need to be refilled.

● Paper can be torn for colour-testing palettes.

● Empty paint containers can be soaked in water overnight prior to cleaning and recycling.

● The glass on the lightbox and the UV exposure unit should be cleaned regularly.

● Pot plants should be watered regularly.

Protective clothing

● Protective clothing should be part of an individual's personal equipment. This includes an apron, eye protection, ear defenders and gloves.

● A particulate respirator is necessary when working with powders or pigments.

Clothing, hair, jewelry, etc.

● Wear strong, non-slip shoes and close-fitting clothing.

● Tie back long or loose hair to eliminate any risk of entanglement in machinery or tools.

● Remove rings, necklaces, earrings and bangles, as chemicals can react with metals and can be trapped next to the skin. Jewelry can be caught in machinery or tools.

● Do not wear personal stereo headsets or audio equipment, as flexes can be caught in machinery and tools.

How chemicals used in water-based screenprinting enter the body

● In this fume-free system, the only way chemicals can be inhaled is if they are suspended in a mist as a result of being blasted with a high-pressure hose. Chemicals in this form can have a direct effect on the nose, upper respiratory tract and lungs, or they can enter the bloodstream and affect the blood, bones, heart, brain, liver, kidneys and bladder. To avoid hazardous mists, chemicals should be rinsed from the mesh using a soft hose.

● Inhalation of finely divided powders is a risk in systems which use chemical powders or pigments. A particulate respirator should be worn when working with these.

● Ingestion is when chemicals enter the body by swallowing. Food should not be stored or eaten in the studio as it absorbs toxins from the air. The same applies to beverages. Hand-washing before eating or smoking is important, as chemicals can be transferred to the lips via food or cigarettes. Substances can also enter the stomach through indirect means. Coughing pushes material out of the lungs, allowing this to be swallowed and to come into contact with the stomach and other internal organs.

● Some materials are absorbed through the skin and enter the bloodstream, which carries them throughout

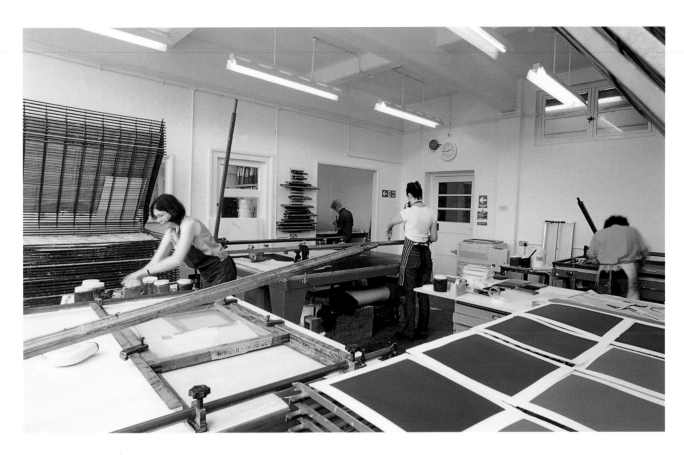

Students editioning in a busy water-based screenprinting studio. Note the fire exit signage, the squeegee rack, the prints drying flat on racks, and the photocopier.

the body. Skin contact can also result in allergic reaction, the removal of protective skin oil, or dermatitis. Even when handling non-toxic artist's materials and using soapy water, artists should wear gloves.

High risk groups

● Children are more susceptible to the effects of hazardous chemicals than adults but they can make prints safely using a hinged bench-screen with gouache, paper stencils and screen filler. They can clean up using a soft hose and dishwashing liquid. If adult helpers set up and remove photostencils, children can print safely with these, too. Children should not be allowed to use a high-pressure hose, or have access to hazardous chemicals or equipment.

● Smokers and heavy drinkers are at a higher risk than others of damage to their lungs and liver respectively. Nicotine and alcohol mixed with toxic chemicals in art materials can cause synergistic reactions.

● Individuals on medications are also at a greater risk. Medical advice should be sought to ensure that any medication will not interact with materials used in the screenprinting process to cause illness.

● The physically disabled, the elderly and those with allergies, sensitized conditions and illnesses are also within the high risk group.

● Pregnant and breastfeeding women are at particular risk as chemicals and other factors are able to cross

Kaori Shibayama, *Chopped Celery*, installation incorporating etched copper plates, paper, water-based screenprints, 2000. The artist etched copper plates, using acrylic-resist etching techniques. The blue panels are water-based screenprints based on the etched plates. The artist was able to make this installation safely in a well-designed printmaking studio which was equipped with water-based screenprinting and acrylic-resist etching facilities.

the placental barrier and possibly cause damage and birth defects. The most sensitive time for chemical interference with normal development is from the eighteenth to the sixtieth day after conception. Hazardous chemicals include powdered cadmium and copper.

● Noise, vibration, strenuous activity and other stresses can be hazardous. The amount necessary to damage a foetus or embryo is much smaller than that which can injure an adult.

● Chemicals can affect the respiratory and circulatory systems and some of these, especially heavy metals, can be found in a woman's milk several hours after exposure and can affect the infant.

● Contact lens wearers should take particular care concerning eye protection.

Ian MacIntyre, *Rubbish*, water-based screenprint, 1993 (detail). The artist cut the image separations from flooring linoleum. These were inked up in black and printed as relief prints on smooth clear PVC sheet for use as positives. The resulting photostencils were printed in opaque layers of Lascaux Studio Acrylic and Screenprinting Paste on BKF Rives paper. The first layer to be printed was black and the final layer was opaque yellow. Some of the stages involved, such as cutting the linoleum with a sharp blade, would not be suitable activities for high risk groups. The actual printing, however, could be undertaken safely.

PLANNING A SCREENPRINT

BUILDING AN IMAGE

Although screenprints tend to be associated with simplified photographic images and large fields of flat colour on smooth paper, nowadays any type of mark can be held accurately on a screen in the form of a stencil and can be printed faithfully on a wide range of substrates. These flexible characteristics make screenprinting a useful print tool for artists working in many different ways and media.

There are so many approaches to building an image that it is difficult to describe all the possible working methods in detail. The prints illustrated in this book, which have been constructed using interesting approaches, include a brief explanation of the working method in the captions.

Screenprints need not always be made in the format of an edition on paper but may become a set of prints which all differ from one another. They may take the form of a book; they may be a means of documenting, disseminating and advertising an artwork; a way of generating material to be reworked; or an element in a mixed media or installation piece.

The screenprinted part of a piece may consist of a single printed shape or a shape which is printed in multiples; alternatively many different screenprinted layers may be combined to construct an entire image. This last way of working is close to painting but has the advantage that the painted and drawn marks (or marks generated using other techniques) can be placed with great accuracy, and considered choices may be made about colour, opacity and surface quality. Screenprinting

can be used as a collage tool, bringing together and homogenizing disparate parts, for example photographic and painted elements. This characteristic can be used by artists to incorporate text, photographs, photocopies, torn materials, soft-ground marks, monoprint marks, offset marks, lithographic-type washes, frottage, reversals and digitally generated images into paintings, sculpture and installation pieces.

Before embarking on a screenprint it is necessary to plan the construction of the image carefully. This will probably involve starting with a strong concept, and making a map and a written plan. The written plan can be thought of as a 'virtual' rehearsal of the printing process, allowing possible mistakes to be identified in advance. In this way each printing layer can be made as efficient as possible. Traditionally a 'key' drawing was used to aid registration during printing. This was a method in which the main drawing would be printed initially in pale grey, assisting in the location of subsequent layers, and then reprinted at a later stage of the process in its true colour. This way of working tends to lead to a sense of 'colouring in' an already constructed image, whereas images made using a map registration device are more conceptual, and seeing the image gradually develop in printed form is stimulating for the artist. The map helps the planning and creative process to remain flexible. The time spent on this need not take more than half an hour but can lead to significant savings of time and effort (see 'Making a Map', p. 64).

Planning concerns related to making installation works can include dealing with substrates which may be

Barbara Rae, *Hill Fort*, water-based screenprint, 1998 (detail).
An opaque white mark was coloured by translucent drifts of colour.

and the layers output as positives. When these are screenprinted the surface qualities of the colour can be manipulated.

This way of working is unlike painting, where the image can be reacted to after each brushstroke and kept continually in balance, tonally and in terms of colour. With screenprinting, as each successive layer is printed, the image rapidly becomes more complex. Marks and colour laid down on the first layer may not start to function as planned until much later in the development of the image, so it is not always possible to react instinctively to each layer as it is printed. For example, by printing three textured stencils, using translucent carmine, vermilion and magenta, onto a piece of red paper, the resulting print will show many different reds with a richness of texture, tone and colour. The same three stencils could be printed on white paper in yellow, blue and red to produce an image showing white, yellow, green, blue, red, orange, purple and brown.

Opaque layers cover previous printings and their effect is very different from translucent colours. As the colours printed will not combine with each other, a layer will need to be printed for each colour. Opaque layers can be used very effectively in conjunction with translucent colours. For example, when a glowing 'backlit' translucent colour is required against a rich or dark ground, an opaque white mark can be printed where the glowing colour is required. With clever designing, this can be overprinted with a larger area in the translucent colour required. The white mark becomes vibrantly coloured, the dark ground becomes deeper where the translucent colour overlaps it, and the rich ground is tinted or dappled.

The sections on stencils (pp. 76-95) and positives (pp. 96-128) describe and illustrate the type of image suited to each process, and the procedures typical of

unusual, unwieldy or large. This may require a lot of studio space, printing mixtures with particular qualities and special registration methods. Images involving repeat printings of a stencil will require a fast-drying printing mix (to minimize unwanted offsetting) and may need careful registration. Prints which are built up in layers will need a map firstly to register (position) the different positives or stencils as they are made, and secondly to register each new printed layer exactly on top of all the previous layers, so that these interact as desired.

This layering approach to image-building is employed by Adobe Photoshop computer software, and experimenting with this programme can be interesting for artists who plan to make screenprints. A good exercise is to scan a colour photograph or a painting into Adobe Photoshop, and to manipulate the image by selecting Image → Adjust → Curves. By using the more advanced techniques offered by Adobe Photoshop, images may be altered, separated or built,

This sequence illustrates some of the stages that were required to build *Flow – Day* by Margaret Hunter.
1. The artist made this first map on tracing paper (as etching was involved). Later a PVC map was used for the screenprinting stages.

2. A paper stencil of the figure was registered in an open area (using the map) and a screenprint was made using a standard mixture with magenta and red Lascaux Studio Acrylic. This printed with a characteristic flat field of colour.

3. A photostencil was made from an autographic positive, which had been painted using Lascaux Tusches on smooth PVC sheet. It was screenprinted using Lascaux Screenprinting Paste mixed with Acrylic Transparent Varnish and Decora paints.

4. A stencil was made using Lascaux Screen Painting Fluid (standard method). After proofing, it was decided that some alterations were needed and that it should be printed after the red layer (see no. 6).

5. A photostencil was made from an autographic positive created using Lascaux Tusches. It was printed in red using Lascaux Gouaches and Lascaux Thickener. The top right corner shows the result of poor printing technique.

6. Lascaux Screen Filler was painted on the mesh to alter the stencil. The colour was lightened and made more opaque. A second similar stencil was printed directly afterwards with a derivative and tonally adjusted version of this colour.

7. The map was used as a guide to make a positive using Lascaux Tusches. The resulting photostencil was printed in semi-translucent cream (the previous beige with white and standard printing mix added).

8. An acrylic-resist etching which was made by the artist on copper. The plate was printed on Arches cover white paper, and when this was dry a photocopy was made onto tracing paper, which in turn was used to create a photostencil so that this image could be printed onto the screenprint. The intaglio plate could not in this case be printed directly onto the screenprint as the layers of screenprinted colour were too dense.

9. This stage proof shows all the colours printed so far. (This proof was rejected because the etching-based positive was too crude and the stencil needed to be re-exposed.) It is interesting because at this stage the image is out of balance: for instance the bold beige brushmarks in the river look harsh at present, but will later create a sense of movement. Also the bright patches of magenta by the figure's knee are too 'sweet' and will later be quietened down.

10. (left) The map was now superseded by the stage proof. A sheet of smooth PVC was masking-taped over the stage proof and the artist used a dry decorator's brush to paint a positive for the river (using Lascaux Tusche waterproof).

11. (right) The artist painted with Lascaux Tusche wash to create a positive which was printed in translucent pale cream. A second similar positive was printed in white on top of this.

12. These small red spots and scratches enlivened the central figure. Conté crayon on tracing paper was used for the positive.

13. An autographic positive was made by drawing with a typing correction pen on PVC. This was printed with a shiny black made from Lascaux products.

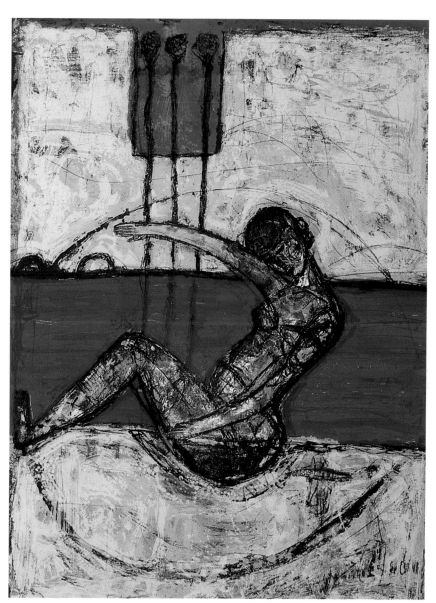

14. Margaret Hunter, *Flow – Day*, water-based screenprint on Arches paper, 76 x 56 cm (30 x 22 in.), edition of 30, 2002. The finished print shows how all the layers work together to form a rich image.

each way of working. This includes flat-field images built with paper stencils, reduction prints made with screen filler, and digital images and painted marks printed with photostencils.

Moving from the concept to the finished print requires the artist to become a competent screenprinter. To achieve this it is necessary to understand the behaviour of the mesh and the characteristics of different stencils and positives, together with the qualities of different printing mixes, and how to register the printed image on the substrate. It is also necessary to acquire control of the physical aspects of printing and the correct management of screens and tools – activities which are complementary to the artistic process. This development of technique may seem complex but soon becomes automatic, and is similar to learning to play a musical instrument.

Making a Map

A concept of the planned screenprint should be established and possibly notated. An idea should be formed of what types of positives (autographic, photographic, photocopy, digital) will be needed. A plan can be made to identify the simplest route to realizing the image. Listing the colours, their opacity or translucency, and the order in which they will be printed (and the other colours which might be formed as a result) can help avoid printing sequence errors. If the image is complex, a 'map' (which is never printed) is a practical and creative tool. A map is simple to make and is useful when building a series of positives and as a registration aid when printing.

● Initial sketches and rough layouts can be made.

● Taking into account the size of equipment (and suitable paper) in the studio, a size for the screenprint can be decided. The outer edge of the image size should

Barbara Rae, *Trancas Pink*, water-based screenprint, 56 x 76 cm (22 x 30 in.), edition of 40, 2002. The print is lying beside two of the positives painted by the artist with Lascaux Tusches on smooth PVC sheet. The larger positive with the beach-hut structure has been printed in black on the screenprint and is easily identified. The smaller positive was printed in orange on the sun. The image was screenprinted using Lascaux Screenprinting Paste, Acrylic Transparent Varnish, Thickener, Gouache and Studio Acrylics, Perlacryl paints and Golden Acrylics.

be drawn accurately with a waterproof marker pen on a smooth clear PVC sheet.

● The outlines of important printing elements of the image are drawn accurately (with a waterproof marker pen) within this space. The resulting line drawing is not meant to be aesthetic, but simply a clear guide to the location of colour changes, tonal changes, textured areas, text and the major components of the image. Some artists find it helpful to label colour sections on the map. The top right corner of the map should be clearly identified with a note – e.g. 'top right' – as the PVC sheet can easily become inverted, and the image may not be instantly read in this form. A simple map is illustrated in 'Digital Positives' (p. 122).

FRAMES, MESHES AND SQUEEGEES

SCREEN FRAMES

Screen frames have to be strongly constructed to hold the mesh flat and evenly tensioned for perfect printing. Commercial screenprinting suppliers sell a wide range of sizes and types of frame, and offer a specialist service of stretching and gluing the mesh. Screen frames are made from wood, steel and aluminium.

Wood

Wood is the traditional material for screen frames. The main disadvantages of wooden frames are that they are comparatively bulky and heavy, and that they can absorb the water used to clean ink and stencils from screens, causing the frame to swell or warp. Any changes within the structure of the frame due to absorption of water can lead to fluctuations in the mesh tension, causing registration and other printing difficulties. Wooden frames should be strongly constructed with mortised or dovetailed corner joints if they are to be stable and have a long life. Cedar is the best wood for screen frames as it is light, strong and naturally water-resistant. The wood surfaces should be smooth and free of splinters or cracks which could damage the mesh or make handling unsafe. All wooden frames should be painted or varnished before stretching to create a waterproof seal.

Small frames can be built from wood, and stretched and stapled at home. They can be hinged to a printing board to make a simple bench-top screen press suitable for less detailed work. Special hinges allowing removal of the frame are available from screenprinting suppliers.

Home-made wooden frames can be used for printing images direct onto canvas.

Steel

Frames made of steel are less bulky than wood, but heavy compared to aluminium. They are strong and very stable, and are generally factory-painted. However, scratches caused by studio wear and tear can lead to rusting.

Aluminium

Aluminium is generally the preferred choice for screen frames as it combines lightness and ease of handling with strength and stability, and is unaffected by water. Aluminium frames which are designed for high-tension polyester and stainless steel meshes have strengthened corners, bevelled edges and sand-blasted surfaces to aid adhesion of the mesh. Special frames are available which allow the mesh tension to be adjusted, but a standard aluminium frame with stretched polyester mesh should be adequate for most professional printmakers.

Screen size

For a large studio with a range of experienced and novice printmakers, three different sizes of screen are useful. To calculate the optimum maximum screen size for a studio, measure the bed-size of the vacuum press and the surface area of the UV exposure unit, and take into account the available space for screen storage. It is also worth considering the range of paper sizes used and

A clamp attached to the press frame is holding the aluminium screen frame in place. Note the screen does not have a permanent margin and has not yet been taped.

MESHES

The fabric which is stretched tightly over and glued to the screen frame is called the mesh. This supports the stencil, which in turn defines the printed image. It is made from specialist material which is designed to be a perfect grid of regular, fine threads. The spaces between the threads are so tiny that at first glance the fabric looks impermeable, but during printing the ink passes between the threads onto the substrate below. The thickness of the thread and the number of threads per centimetre or inch determine the fineness of image detail and the deposit of ink printed on the substrate.

New high-technology textiles used for meshes, together with improved photo-emulsions and the use of water-based inks which pass easily through the finest mesh, have radically extended the range of marks it is possible to print. Fine photographic halftones and digital pixelations, expressive painterly marks and delicate washes are readily achieved, changing the role of screenprinting, which now rivals lithography as a sensitive fine art print medium.

It is important to invest in a mesh of the correct size and type, as many printing difficulties arise from the use of slack or inappropriate material.

Traditional mesh materials

Silk meshes were rapidly weakened and destroyed by the bleach used to remove traditional photo-emulsion stencils. These natural fibres have been superseded by strong, reliable, synthetic fabrics, such as nylon and polyester.

Modern mesh materials

Stainless steel and nylon meshes are available from specialist screen suppliers, but the former can be ruined by denting, and nylon mesh absorbs water which

stored in the studio. The maximum size of screen should just fit the vacuum presses and the UV exposure unit. A useful smaller size is approximately half the size of the large screens: this is a practical size for novice printmakers as the screen is easier to handle. The smallest screens are hinged bench-screens, and these offer a flexible alternative for artists who prefer not to work on a large vacuum press.

Large screens are used for most images, as a minimum margin of 10 cm (4 in.) from the frame is required to enable the mesh to flex down easily to reach the substrate to be printed on. This margin allows the squeegee to reach beyond each side of the open printing area and also provides space for the ink reservoir (see 'Permanent margins', pp. 71-3).

Preparation for application of mesh

A good frame should last a lifetime, so when a mesh is damaged and cannot be repaired it should be stripped off the screen frame. The remaining glue and any hardened ink need to be sanded and cleaned from the frame before it is sent to a commercial supplier to be stretched with a new mesh.

destabilizes stencils and causes difficulties with registration. Polyester meshes are strong, stable and elastic, and their lack of absorbency makes them the best choice for reliability and accuracy of registration. Polyester has the additional advantage that it is less likely to pick up a static charge than nylon, and this reduces the amount of dust attracted to the mesh. Particles of dust block out light when positives are exposed, causing fisheyes, which will print. The smooth fibres of modern polyester monofilament meshes allow perfect printing and are easier to clean than multifilament meshes. New photo-emulsions and fillers have excellent clinging properties and so there is no longer any need for multifilament meshes or the practice of 'toothing' the mesh with an abrasive powder to help stencils adhere.

Specialist companies sell a wide variety of meshes including calendered meshes or special twill weave (TW) in different grades. Calendered meshes are fragile as they have been flattened between rollers to a very fine tolerance: they print a very thin deposit. Multifilament and twill-weave threads are composed of many fibres woven together and the meshes formed from them are harder to decoat and more difficult to clean than monofilament meshes.

Mesh types are displayed by retailers in chart form. It is important to note that thread counts denote threads per centimetre where metric measurement is the norm, and threads per inch in North America. The headings of these charts generally indicate count/cm (in the US, count/in.), count diameter, opening area, thickness and ink volume. This information may at first seem bewildering but, with greater experience of printing with different meshes, artists will find the charts make informative reading. The count/cm (or count/in.) column, which indicates the number of threads per centimetre (or inch), is the only part of the chart that a novice printmaker needs to understand. The letter beside these numbers is a code describing the type of fibre: S – light, M – light to medium, T – medium, HD – heavy duty.

The naked eye is unable to detect the differences between very fine meshes, but a fine mesh will feel smoother than a coarse mesh. Most screen-stretching companies will note the mesh size in waterproof marker pen under the glued mesh in a corner of the frame.

Selecting a mesh

The best general purpose mesh for water-based screenprinting is 120 T (305 T in the US) standard plain weave (PW) monofilament polyester, professionally stretched and glued onto a sturdy aluminium frame. This grade is equally suitable for novices and professionals, and can be used for almost any type of image. It can be used for printing the ink mixes suggested in this book onto most materials, including Japanese papers, printmaking papers, canvas, plastics, metals, wood and leather.

The higher the thread count, i.e. the greater number of threads per centimetre or inch, the less detail will be lost from stencil to print. A very fine and delicate mesh of 165 threads per centimetre (420 threads per inch) is able to hold tiny particles of photo-emulsion or painted filler, and would be suitable for an artist working with delicate imagery or digital positives with a high image resolution. The deposit of ink from such a mesh will be very thin, almost looking like a stain on the paper, making it suitable for translucent layers or for printing water-based inks onto cartridge paper. If this mesh is used to print on canvas or a textured printmaking paper such as Moulin du Gué, only the top surface of the substrate will print. The ink in the areas of the mesh that are not printing will soon dry in the mesh permanently.

Fine meshes of this type are expensive, very delicate and easy to damage.

A 70 T (180 T in the US) mesh is more open and will allow metallic paints and mixes made of large pigment particles to print more easily through it. A mesh with 49 T (125 T in the US) is much coarser and a heavy ink deposit will be printed. This grade is good for printing on rough canvas and heavyweight printing papers, or for printing opaque marks with pigment mixes or gouache. Large particle metallic pigments will often require this type of mesh. If a 49 T (125 T in the US) is used to print on cartridge paper, the large deposit of ink printed will cause the paper to buckle. Screen filler or photo-emulsion will have to be applied sufficiently thickly to bridge the spaces between the threads or fine detail and tonal effects may be lost. Lines and text printed with this type of mesh may reveal the structure of the grid. However, it is surprising how much detail can be achieved with a coarse mesh, and the rich deposit of ink will sit up on the paper. These coarse meshes are cheaper to buy than finer equivalents, but it is worth noting that they use up more photo-emulsion, screen filler and printing mixes. Fine meshes may be more cost-effective in the long run.

Meshes and photostencils

When a photo-emulsion-coated screen is exposed to UV light as part of the stencil-making process, it performs more efficiently if it is made from yellow or orange mesh. White mesh reflects and scatters UV light, and can never produce the same resolution as dyed fabric which absorbs light, thus increasing stencil resolution.

Experimental mesh material

Net curtain materials and other fabrics can be used as screen mesh for experimental purposes. These open-weave materials leave a heavy deposit of ink and can be used for printing on canvas. Fabric shops sell silk taffeta, which has a plain weave, or silk bolting cloth, which has a different type of weave and is dragged less by the squeegee. These fabrics are quite rough in texture compared with specialist meshes, and this will affect stencil quality. They will also be substantially altered by changing humidity, and some fabrics will absorb water.

Stretching meshes

Screen-stretching equipment, glues and rolls of mesh can be purchased from specialist screenprinting suppliers, but for most printmakers it is more economic to have the meshes stretched by a professional screenprinting company. Machine-stretched meshes will be reliably tight and evenly applied to the frame, allowing them to 'snap' away from the printed substrate without leaving a mark. A mesh stretched in this way will not distort the image and will permit perfect registration.

Manufacturers recommend that nylon and polyester should be professionally stretched, as the tension affects resolution, registration and snap behaviour. Artists who wish to have direct control of this can purchase specialist frames with adjustable mesh-tensioning systems and meters which measure the tension in newtons.

Home-made screens can be stretched by stapling and gluing material to a sturdy wooden frame. These meshes are not suitable for close registration and the resulting heavy ink deposit will warp thin paper, but they can be effective for printing on canvas and other coarse surfaces. Staples can scratch the glass of exposure units and puncture the rubber lid, so they should be covered with sealed gumstrip as a preventive measure.

It is useful to differentiate between the two sides of a screen and these are therefore generally referred to as the flat side and the printing side.

PREPARING AND DEGREASING THE MESH

The thorough removal of dust and grease from the mesh is an important part of the screenprinting process. Degreasing is required to prepare a mesh before a permanent margin can be applied and is necessary in preparation for stencil application, as only a mesh which has been correctly and thoroughly degreased will support stencils that are both strong and stable. A layer of grease may prevent the easy removal of stencils which have been held on a mesh over a long period. Thorough degreasing before applying stencil-removing solutions will remove this greasy barrier and let the solutions break the stencils down. At whatever stage degreasing is used the procedure remains the same.

Equipment and materials required
● waterproof apron, eye protection, ear defenders, gloves and non-slip footwear
● screen wash-out unit, high-pressure hose (see 'Screen Preparation and Mesh-Cleaning Workstation', pp. 190-91)
● soft hose with warm water, which is more effective than cold for breaking up grease and rinsing away chemicals
● degreaser in a one-litre, colour-coded, clearly labelled, flexible container with a nozzle
● colour-coded specialist screen-cleaning brush for applying degreaser

Principle: to remove dust and grease from the mesh.

Method
Work in the screen wash-out bay.
● Wear safety equipment.

● The screen frame and mesh must be free of any ink, chemicals and adhesive tapes.
● Squirt degreaser onto the mesh (when working on coarse meshes, pour some degreaser into a clean bowl and apply this to the screen by brush).
● Work the degreaser into the mesh with the big specialist soft brush, making circular movements in a steady and methodical progression across the screen. It may be possible to detect greasy areas on the mesh as the degreaser will initially be repelled by these. These parts of the screen will require extra degreasing.
● Degrease both sides of the entire screen and the frame, not just the centre of the mesh.
● When the mesh is properly degreased, water poured onto it will not run into rivulets but instead the mesh will look damp all over.
● Rinse all the degreaser from the screen with the soft hose.
● Rinse any degreaser from the sink as it may react with other chemicals.
● Only when the degreasing chemical has been rinsed from the mesh should the high-pressure hose be used to remove any residue.
● Manufacturers of some degreasers recommend that their degreasing products should not be allowed to dry on the mesh, as this can cause stencil and decoating problems.

Problem solving
As grease and dust are often not easily visible on the mesh before stencil application, it is tempting to think that the degreasing process is unnecessary. However, photo-emulsions and screen fillers are water-based, and any greasiness on the mesh will repel these materials and interrupt their carefully balanced flow characteristics. For this reason manufacturers

A specialist screen-cleaning brush is used to apply degreaser to this white mesh. Note the ghosts and the permanent margin which is of the minimum size.

specify that degreasing must take place before their products are applied to the mesh. Omitting to degrease a screen can lead to problems which will appear at apparently unconnected stages of the process.

Grease and dust are airborne in studios and can easily contaminate meshes. Touching the mesh can transfer natural oils from fingers, and for this reason meshes that have been newly stretched are often very greasy. Many household detergents contain lanolin oils, so using these products will also make meshes greasy. Static charges on meshes will attract dust particles to the fibres. Dust will be introduced to drying cabinets and the mesh if a degreaser is used which dries leaving a powdery deposit. For these reasons it is important to use a specialist screen degreaser of the correct type. Neutral or acidic non-toxic degreasers are necessary for use with screen fillers which are weakened by alkaline solutions. It is also important to use a non-abrasive product to avoid damaging the delicate fibres of the mesh.

- New meshes may need to be degreased several times to remove all contamination.
- Pinholing is caused when the photo-emulsion is repelled by oily residues on the mesh. This results in a thin spot in the coating which may break up and allow ink to leak through or print.
- During stencil development areas of photo-emulsion may fail to adhere and will fall away from the mesh.
- During printing a stencil may begin to break up, altering the printed image.
- Fisheyes occur when photo-emulsion or filler is affected by a particle of dirt in the mesh. This draws the fluid towards it, creating a thin surrounding area which will break up and print.
- Pinholes and fisheyes can also result when a fleck of dirt caught in the emulsion breaks off during printing, allowing ink to leak through the stencil.
- The printing performance of inks is affected and colours are spoiled by dirt picked up from screens. Sometimes a screen may have become dusty and greasy in storage and will need to be degreased and dried before printing.
- It is important to degrease the frame as well as the mesh, otherwise water can run down from the frame, carrying grease and dust onto the mesh.
- Occasionally photo-emulsion or a screen filler may be difficult to remove from a mesh. This can be caused by a build-up of dust and grease on top of the stencil. The solutions used to dissolve stencils are not designed to remove grease so quite simply cannot break through any grease to reach the stencil. This may result in blotches or streaks of undissolved stencil remaining in the mesh. By degreasing the screen before applying the stencil remover, this difficulty can be avoided and all the stencil will dissolve away with an economical quantity of decoating chemical.

MARGINS

Permanent margins

When a screen is new it is good practice to make a permanent seal between the screen frame and the mesh before printing for the first time. Traditionally these margins were made with gumstrip and shellac varnish. Now they are made from gumstrip sealed with acrylic paint. These margins will make the screen easier to use and to clean, and are not only essential to lengthen the life of screens but also provide a non-porous area for ink reservoirs and for the squeegee to rest. On a large screen they should measure at least 10 cm (4 in.) from the frame.

If the band of mesh immediately around the edge of the frame is roughly flexed, or if the squeegee pushes it down, the overall tension of the mesh may be adversely affected. As this damage is not reversible this area should never be used for printing. Margins prevent the risk of this happening and they also make applying emulsion and fillers easier. Excess amounts of these solutions which are deposited on the permanent margin during application will be uncontaminated and can be used again.

Repairs (patches made of glue and thin dishwashing cloth) can be seen on the unprotected margin area of this mesh. Dried residues of printing mix may have caused the rip. A permanent margin might have prevented the tear from running across the full length of the mesh.

The seal between the frame and the mesh prevents printing mixes becoming trapped and building up in the space between the stretched, glued-on mesh and the frame. If the printing mixture is trapped in this space, it may dry as a hard crust with sharp edges which can cut the mesh. Even when the screen is in storage, a change in humidity can cause the mesh to flex against these sharp edges. This type of damage is usually impossible to repair as the tear runs quickly down the length of the frame.

Equipment and materials required

- clean workbench
- clean and newly degreased screen
- four rag rolls
- Caran d'Ache water-soluble colour crayon
- ruler
- plastic parcel tape
- scissors
- sponge and basin of soapy water
- small squeegee or piece of neatly cut squeegee blade or stiff card
- scraps of reasonably thick paper
- masking tape
- paper gumstrip tape
- Cerulean blue Lascaux Studio Acrylic
- decorator's brush (5 cm/2 in.)

Principle: to form a permanent seal between mesh and frame which will both save time and protect the mesh.

Method

- Position the screen printing-side up on the workbench, with a rag roll under each corner to support the frame and to prevent the mesh sticking to the surface of the bench.

- With dry hands roll out four lengths of gumstrip and measure them against the length of the frame. Cut the strips neatly to fit from one inside corner to another. Put three strips aside and lay the other flat on the bench with the sticky side facing up. Hold one end of the gumstrip down with a finger, and run the dampened sponge along its full length. Take care not to overwet the sponge, and beware of wiping away too much of the glue. The gumstrip should lie flat after being sponged. If it curls up it is too dry to do this task well.

- Pick up the wet gumstrip, holding one end in each hand. Then centre your thumbs between the edges of the gumstrip with the sticky side facing away from you. Aim to place your thumbs in the corners of the screen and then release the gumstrip. Throughout its length, half the tape should be on the mesh and the other half stuck to the frame. After doing this examine how the gumstrip is lying. If it looks very squint put your thumbs back into the corners. Lift the gumstrip off and try again. Once it is lying fairly straight, start at the middle point and use a finger to press it firmly into the inside edge of the frame. Repeat this at the quarter point and at the three-quarter point. Now run a finger along the lower edge, smoothing the tape on the mesh side first, then on the frame side. Repeat this process with the other three sides of the screen.

- While the gumstrip is drying, work can start on the margin.

- Turn the screen over on the bench so the flat side is facing upwards.

- Measure out from the frame on the flat side of the screen and mark the planned margin with the Caran d'Ache water-soluble colour crayon. Make at least four marks and join them up using the ruler. Remember that this border will be permanent. A screen measuring 147 by 114 cm (58 by 45 in.) should have a permanent margin of 10 to 15 cm (4 to 6 in.).

- Lay the parcel tape along the inside of the line. This will act as a simple stencil and should protect what will be the printing area, leaving the margin space to be filled with acrylic paint.

- Cut the parcel tape 4 cm (1½ in.) longer than required and lay it gently in place, securing the middle section but avoiding pressing down the ends. Mark the parcel tape with the Caran d'Ache water-soluble colour crayon where the cut is to be made. To prevent accidents to the mesh with the scissors lift the parcel tape up and peel it back until the line on the tape is approximately 10 cm (4 in.) clear of the mesh before you cut it. Then smooth the cut tapes down to create a parcel tape rectangle which is the inner perimeter of the permanent margin.

- Protect the centre of the mesh by shielding it with a piece of PVC sheet or sheets of newsprint slightly smaller than the outside measurement of the parcel-tape rectangle. It is best to masking-tape the PVC or newsprint to the parcel tape, leaving at least 3 cm (1⅛ in.) of the parcel tape clear for the squeegee to pass over.

- Squeeze some Cerulean blue Lascaux Studio Acrylic paint onto the metal frame, where it will not be able to leak through the mesh (for some reason this particular colour and brand works best). Apply the acrylic paint to the mesh using a piece of neatly cut card or a small squeegee.

- Allow the acrylic to dry.

- Turn the screen over so that the printing side is facing upwards, and use rag rolls to support the frame and to prevent the mesh sticking to the surface of the bench.

- Carefully paint the gumstrip with acrylic paint using the decorator's brush. Paint over both edges of the tape to seal it and to prevent water seeping in.

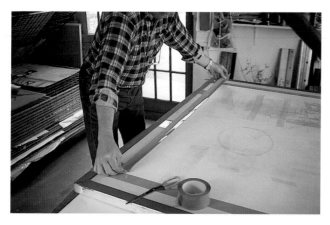

1. Parcel tape is laid along the inside of the line to act as a simple stencil to protect the mesh which will become the printing area.

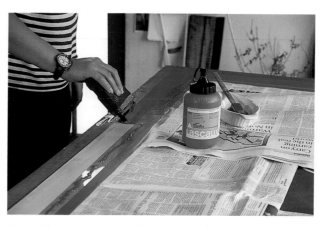

2. Acrylic paint is squeegeed onto the mesh to create the permanent margin. Note that the centre of the mesh is shielded by newspaper taped to the parcel tape stencil.

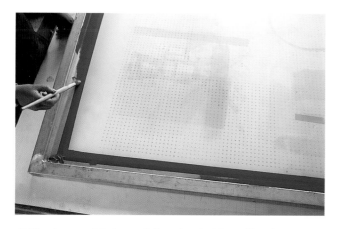

3. The dry gumstrip is carefully painted with acrylic paint.

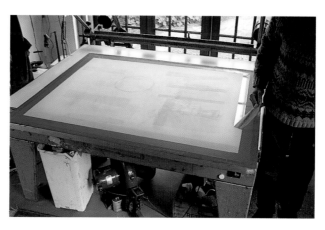

4. The margin has dried and so the parcel tape can be removed. The vacuum pump for this screen press can be clearly seen under the press bed.

- Allow to dry and repeat procedure.
- Place the screen in the horizontal drying cabinet and leave to dry thoroughly.
- When the margin is dry, remove the parcel tape, the masking tape and the PVC or newsprint.
- The screen is now ready for use.
- Degrease the mesh before applying any stencils.
- Wear and tear to the margin can be repaired with more gumstrip and acrylic paint.

Temporary margins

Parcel tape can be used to create temporary margins to prevent ink flowing into the space between the frame and the mesh. Each time the screen is cleaned this margin will need to be removed and then renewed before the next printing. The disadvantages of this method are that it uses up a lot of parcel tape, making it time-consuming, expensive and wasteful. Squeegee blades are also damaged by running over the tape.

SQUEEGEES

Squeegees are used to squeeze the printing mix through the mesh onto the substrate below, and to apply photo-emulsion and screen filler to the mesh. The tool is made of two parts – a handle and a flexible blade – and should be of good quality and well maintained. Handles and blades are available from screenprinting suppliers.

Wooden handles are warm to the touch and pleasant to hold when hand-printing. They must be painted or varnished to prevent water swelling the wood. Aluminium handles are strong and are ideal for printing with the one-arm attachment.

The blade must be clamped straight and securely in the squeegee handle so that good contact with the mesh surface is made throughout the blade's length. The blade is attached by a number of screws which are set into the handle. These screws should be countersunk or have rounded heads, as otherwise the mesh may be ripped by them if a squeegee is laid on it.

Blades are generally made of different grades of urethane, the softness or pliability of which is measured in 'shore' or 'durometer'. The different grades are coloured according to their pliability. The colours may vary from country to country, but the range of shore

Varying types of squeegees and components, including a wooden handle, specialist brass fixing screws and some soft squeegee blade.

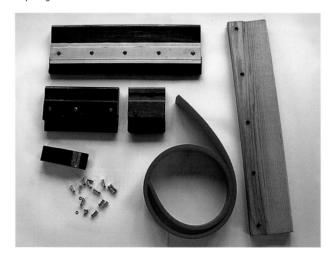

includes extra-soft, soft, medium, medium-hard, hard, very hard and extra-hard. For fine art water-based screenprinting, a soft blade is best. This type of blade can be used to print on smooth paper, plastic and metal, or on textured mouldmade papers, handmade papers and canvas. Harder blades will print a smaller ink deposit and will print only the top layer of a textured paper.

There are several different profiles of blades available, of which rectangular is the most suitable for this type of printing on paper. Both of the square sharp ends of the squeegee blade should be rounded off (use a sharp Stanley knife, and then sandpaper). This reduces any risk of damage to the mesh when refilling during printing.

Problem solving

● Old handles which cannot hold the blade straight will cause numerous technical problems both when applying stencils and when printing.

● Small chips and dents will appear in blades if they are roughly treated or run over bumpy tapes and filler on the printing side of the mesh. For this reason squeegees should always have a clear area of mesh to glide on. Damaged blades will not make an even contact with the mesh, and this will show up as lines and streaks on photostencils or prints, and can cause bridging when using filler in conjunction with screen painting fluid.

● Dried ink or photo-emulsion on a blade can rip the mesh.

● Solvents and chemicals used in solvent-based screenprinting damage squeegee blades and make the blade hard and inflexible. With the water-based system, blades are cleaned with mild household detergent so they are not damaged and will seldom require sharpening or replacing.

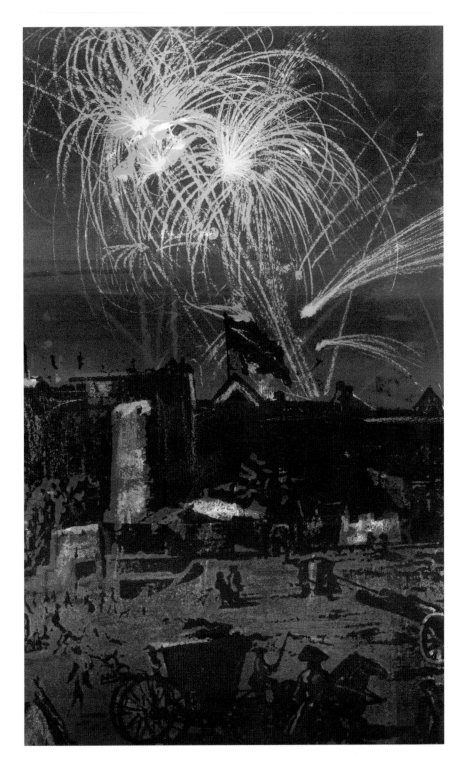

Carol Robertson, *5th of November*, water-based screenprint, 1992 (detail). This print was made using a 120 T (305 T in the US) polyester monofilament mesh and printed by hand using a wooden squeegee with a soft urethane blade. An open area was made using screen filler and the paper was printed with four rainbow blends to create a pattern resembling tartan. The fireworks were drawn and painted on a red sheet of paper using white chalks and paint. A photocopier was used to reduce the size of these marks and then to photocopy them onto tracing paper to create a positive. The resulting photostencil was printed over the bright pattern in a rich dark blue. The photocopier was then used to enlarge and to alter the contrast of an eighteenth-century engraving by Paul Sandby. A tracing paper photocopy was cut up and rearranged to make a positive. After experimenting with these elements, the cut-out photocopy pieces were attached in register to the back of a gloss PVC sheet. Lascaux Studio Acrylic was painted on the front of the PVC sheet to edit the image and create a composite positive. This image of the castle and figures was printed in a dark colour. Finally a positive consisting of conté crayon marks drawn on tracing paper was printed, using a blend ranging from opaque orange through pink to white. These marks created highlights across the image.

TYPES OF STENCIL

Screenprints are made by squeezing printing mix through mesh onto paper or some other flat substrate. The threads of the mesh form a matrix which supports the stencil. The stencil closes areas of the mesh, preventing the passage of printing mix.

The remaining open areas of the mesh allow printing mix to pass through freely. The combination of open and closed areas of mesh defines the form of the printed image. Stencils vary in their complexity, offering a wide range of choice in terms of mark-making. Different types of stencil may be used,

Photostencil: this bleed print on white Somerset paper was printed with a red printing mix (Golden acrylic colours, Golden Screenprinting Medium, Golden Gloss Medium and Lascaux Retarder). The positive was created by placing actual daisy flowerheads on a photocopier and covering them with a dark cloth. A photocopy was made onto tracing paper. The opaque toner of this positive created the photostencil's open areas, which were then printed in red.

Photostencil (see left) edited with paper stencils: the stencils in the shape of the ring and the figures holding hands were made from greaseproof paper (see opposite). Other stencil shapes were made from newsprint. The stencil was printed using Golden acrylic colours and Golden Screenprinting Medium.

Photostencil edited with screen filler: another part of the 'daisies' positive was made into a photostencil. Lascaux Screen Filler was used to edit this by painting the word 'sweet' and other image elements, including flower stalks and buildings. The stencil was printed with Lascaux Gouache and Thickener.

either individually or in combination, to build up an image.

Stencils are classed as indirect or direct. Indirect stencils are made separately and are then attached to the mesh. This category includes paper stencils, some early types of photostencil (such as Novastar) and lacquer films (which are now out-moded). In industry indirect stencils are rarely used, as they are relatively crude and are less precise than direct stencils.

Direct stencils are applied to the mesh as a liquid which settles between the mesh fibres to form a smooth, thin membrane. These liquids include photo-emulsion, screen fillers and painting fluids. The modern direct stencils described in this book are precise, reliable, and easy to apply and remove.

The following sections describe each type of stencil. The same photostencil was altered using each method to illustrate their different characteristics.

Photostencils

Photo-emulsions are used in combination with positives (transparent or translucent substrates which support marks made from opaque materials). Positives are classed as autographic, photographic or digital. By using an ultra-violet light process, the opaque marks become the open areas of the photostencil. These areas of the mesh will print to form the image.

Photostencils are the most versatile and precise form of stencil and enable artists to print virtually any mark. The application, exposure, development and removal of photo-emulsion from the mesh require specialist equipment, professional skills and appropriate safety precautions. Children and special needs groups can safely make positives and print photostencil screens.

Paper stencils

Paper stencils can be made from thin papers or other materials, and are the only indirect stencils used in the water-based system. The stencils may have cut or torn edges, and the prints generally have a distinctive halo around the edge of the closed area. They can be used on their own to build images or in conjunction with screen filler stencils and photostencils. A unique feature is that paper stencils are added after the initial proofing stage, which makes them useful for rapid editing and image-building. This method of working is suitable for any printer.

Screen filler stencils

Screen filler is used to create or edit images by closing areas of mesh, preventing them from printing. It may be painted, squeegeed or offset onto the mesh to make a variety of marks or a border. This simple and immediate

Paper stencils: some of the greaseproof paper stencils (see centre illustration opposite) were removed from the mesh and laid on a dark background after editioning was finished. Note the pattern printed on the stencils which resulted from them being in contact with the underside of the photostencil.

technique is used for reduction printing. Screen filler can be used in conjunction with a photostencil or screen painting fluid to create an image reversal. Screen filler techniques are non-toxic and are suitable for use by children and special needs groups.

Screen painting fluid stencils

Screen painting fluid can also be used to create or edit images. After a simple process (using screen filler and water) these painted marks will print. This technique is non-toxic and is suitable for any user.

Photostencil edited with screen painting fluid: the photostencil of the 'daisies' image (see p. 76) has been altered using Lascaux Screen Painting Fluid in conjunction with Lascaux Screen Filler. The image now has a white ground, and a vermilion sun and leaf shapes.

CREATING OPEN AREAS

Paper sizes used in a studio are often the same, and artists frequently work in series or suites of prints. This practice means that a mesh with a pre-prepared open printing area is very useful for a multitude of tasks. A screen made in this way may be used when a flat-ground, all-over flat tint, paper stencils, screen fillers or painting fluid images are required. A variety of stencil materials can be used to make an open area.

The method which is used to create a permanent margin can also be used to create a permanent printable open area. This type of border economizes on photo-emulsion and screen fillers but cannot be removed, therefore the application of the acrylic has to be undertaken carefully.

A removable border can be made in a similar way by squeegeeing Lascaux Screen Filler onto the printing side of a mesh. This type of margin is suitable for use with paper stencils.

If a border is made from photo-emulsion, many printings can be made from paper stencils, screen fillers and Lascaux Painting Fluid without much damage to the border. The other advantage of a photo-emulsion border is that it is simple to make. A piece of editioning paper is painted red or black along its edges (a 2 cm or $\frac{3}{4}$ in. wide strip) and allowed to dry. This is then laid painted-side down on the exposure unit and exposed to the photo-emulsion-coated mesh. When the stencil is washed out, the exposed edges become the border of an open area, which is exactly the same size as the editioning paper.

When a larger size of open area or other shapes are wanted, red cartridge paper can be cut into shapes and exposed. The images created by these cut-paper shapes can resemble traditional cut-film stencils or paper stencils. Complex designs may be supported on

smooth PVC sheet. This method has the advantage that the stencil is direct (held in the mesh) as opposed to indirect (adhered to the mesh), and therefore the image will print sharply and without any halo effect.

PAPER STENCILS

Paper stencils are a simple but effective means of closing areas of the mesh so that no printing mix can pass through onto the printing paper. The remaining open areas of the mesh will form the printed image. The cut-out paper shapes are held in place on the underside of the screen by the surface tension of the printing mix in the mesh. Papers used to make stencils have therefore to be lightweight. Thin papers gather less printing mix around their edges, reducing the characteristic halo effect common to this process.

Images can be built up entirely using paper stencils, or they can be used effectively in combination with screen filler or photostencils. Basic changes to other types of stencil can be made using these stencils during proofing. Paper stencils offer a safe, non-toxic way to work and are suitable for all screenprinters.

Materials for paper stencils

When screenprinting with water-based materials, a variety of different papers for stencil-making can be used, such as newsprint, very thin PVC or acetate. The printing performance will vary according to the characteristics of the stencil material. Large flat sheets of glassine paper (a glazed translucent paper) or a roll of kitchen greaseproof paper for smaller stencils will provide reliable stencil performance during long editioning runs.

Glassine paper and kitchen greaseproof paper

- easy to draw on and cut out
- a circle can be torn with attractive and controllable edges which print consistently
- thin and lightweight
- water-resistant, but slightly absorbent
- can be used in conjunction with photostencils and screen filler stencils
- forgiving of poor printing technique
- suitable for long editioning runs
- greaseproof paper is easily available
- glassine is manufactured in large sheets and is available from paper merchants

Newsprint

- these inexpensive papers vary in absorbency and water resistance, affecting their performance
- if a line is painted with water, the paper will soften and can be torn along the wet line, creating a soft edge
- suitable for short editioning runs
- easy to draw on and cut out
- a circle can be torn with attractive and controllable edges, but torn edges become saturated with printing mix and will become indistinct
- can be used in conjunction with photostencils and screen filler stencils
- stencils will become sticky if they are saturated with printing mix due to poor technique

Gumstrip tape and gummed paper squares

- easy to draw on and cut out
- suitable for short editioning runs
- can be used in conjunction with photostencils and screen filler stencils
- the water-soluble gum will run into open areas of the mesh if stencils have become saturated with printing mix

- the water-soluble gum may dilute the printing colour, causing unwanted pale streaks to print
- the water-soluble gum may dry in streaks and block the mesh
- during longer editioning runs, the water-soluble gum will transfer to the surface of the prints: this usually goes unnoticed until the prints are dry
- dry gum will show on the finished print as a permanent shiny line or mark

Adhesive tapes such as parcel tape, masking tape and scotch tape
- not suitable for use as stencils, as the moisture in the mesh repels the adhesive

Thin PVC sheet (the thickness of photocopy acetate)
- suitable for short editioning runs
- reusable and therefore stencils can be repositioned or used for other prints (useful for one-offs and monoprints)
- suitable for use with open mesh only, not overlapping other stencils
- suitable for use with coarse meshes
- easy to draw on and cut out
- no lightbox needed
- likely to fall from the mesh due to a build-up of printing mix between the mesh and the waterproof stencil, resulting from repeated overfilling or poor printing technique

Tinfoil
- opaque and therefore not suitable for use with map when first drawing shapes
- creases may change stencil shape
- easy to tear unintentionally
- tends to curl up, making registration and application to mesh difficult

- can fall from the mesh due to a build-up of printing mix between the mesh and the waterproof stencil, resulting from repeated overfilling or poor printing technique
- suitable for short editioning runs
- suitable for use with open mesh only, not overlapping other stencils
- suitable for use with coarse meshes

Japanese and Chinese papers
- easy to draw on and cut out
- semi-opaque so lightbox needed when first drawing shapes from map
- torn edges are irregular and characterful
- have varied and often inconsistent open weave which allows printing mix to pass through parts of the stencils, creating tonal effects
- thin and lightweight
- suitable for short editioning runs
- stencils will become saturated with printing mix if the mesh is repeatedly overfilled due to poor printing technique
- wet stencils can become sticky and adhere to the printing paper
- wet stencils may disintegrate, or lose surface tension and fall from the mesh

Other thin materials may be experimented with to create particular effects, for instance gummed stars and catering doilies (decorative paper mats).

Making Paper Stencils

Having selected a material for the stencil, this will need to be torn or cut to the appropriate shapes. The simplest approach is to tear or cut stencils randomly, or to draw shapes on the paper with a waterproof marker

pen before cutting them out. When stencils are to be placed accurately, it is useful to use some form of registration system. Stencils may be a cut-out section in a larger sheet of paper or a floating element.

Equipment required

Paper stencils are normally made in the drawing area.

- map (see p. 64)
- stencil material of choice
- waterproof marker pen with broad or narrow tip
- cutting board
- scissors or scalpel
- two sheets of PVC for safe storage of paper stencils
- tools for particular procedures such as newsprint wet-tearing technique

Principle: the paper stencils will close parts of the mesh, leaving the open areas to print.

Method for drawing paper stencils

Work on a lightbox or bench.

- If the map is drawn with a broad marker pen, the lines will be clearly visible through the stencil paper even without a lightbox.
- Stick the map down to the worktop surface with masking tape on all four corners.
- Lay the stencil paper over the map and secure this at the corners with little pieces of masking tape.
- Examine the map through the stencil paper and decide which areas will have to be cut away to make stencils.
- Using the waterproof marker pen, trace the cutting lines from the map onto the stencil paper.
- Check the lines and mark (with a symbol) the shapes which are to become the stencils and which have to be kept in a single piece.

- In order to register stencils, an arrow drawn in the top right hand corner of the stencil at this stage will help with orientation.

Method for cutting or tearing paper stencils

- Carefully remove the masking tape (or cut the stencil free close to the tape) and transfer the stencil paper to a cutting board.
- Tear the shapes out, or cut with a sharp scalpel or craft knife on the cutting board.
- If scissors are used, take special care that stencils do not become crumpled as this will make them less effective.
- Take care to keep all the stencils flat and in one piece if possible.

Two 'floating element'-type stencils which have been cut from an acetate sheet: note the marker pen outlines.

An acetate stencil printed with magenta Lascaux Aquacryl and Lascaux Thickener.

An acetate stencil printed with yellow Lascaux Aquacryl and Lascaux Thickener.

An acetate stencil printed with blue Lascaux Aquacryl and Lascaux Thickener.

- Lay the cut-out stencils on a sheet of PVC to keep them flat. Double check that the correct shapes of paper are being preserved. Cover them with another sheet of PVC to protect them.

- Moving a screen can create a sudden draught which will easily blow stencils onto a damp or dusty surface. Dampness will make a stencil stick to the substrate, pulling it from the mesh. Dust picked up by a stencil from the floor can also prevent it from remaining on the underside of the mesh.

- Store any offcuts between the PVC sheets as these may be used as stencils at another stage of printing.

Good studio practice

- Do not cut on the vacuum press bed (scratches on the surface will show up on prints), on the lightbox or on the UV unit as glass is easily scratched. Always use a cutting board or mat when cutting tape or paper for stencils.

- Make sure knife blades are sharp.

- Use a safety straight-edge where appropriate.

Printing Paper Stencils

Considerable preparation is necessary before paper stencils can be applied to the mesh. Firstly, a defined open area is required: this can be made using screen filler or photo-emulsion (see 'Creating Open Areas', pp. 78-9). The size of the open area will generally determine the size of the image.

The open area is proofed, the printing colour checked, and the printing paper and map are registered before the stencils are applied. If these steps are missed out, a variety of technical problems may arise. Registration will often be faulty, the stencils may not be firmly held, the colour may be incorrect or the mesh may have a blockage. Any or all of these problems could result in the stencils needing to be repositioned. This is possible with acetate stencils but, as paper stencils become wet and fragile, moving them is difficult.

After the open area is successfully proofed and registered to the paper and the map, the following method can be used to position stencils accurately and to begin editioning.

Equipment and materials required

Paper stencils are applied at the printing workstation. Lay out the following on separate shelves of the print-drying rack in readiness for use, starting with the lowest shelf:

The translucent yellow and magenta printed layers interacting to create an orange.

The blue printing (see opposite) has now been added.

A layer of strong magenta has been added (and one stencil has been repositioned).

- paper stencils in PVC envelope
- map
- newsprint for proofing
- paper for edition or proofs, or for edition in progress

Laid out on printing table:
- gloves and apron
- bowl of slow-drying printing mix
- plastic spatula
- basin of warm soapy water
- sponge
- three clean drying cloths

Hanging up next to press:
- gumstrip, masking tape and parcel tape

On press:
- screen with a margin and a defined open area
- squeegee and squeegee support
- registration sheet

Principle: the paper stencils are held in place on the underside of the mesh by the surface tension of the printing mix and close these areas so that they do not print.

Applying the paper stencil to the underside of the mesh
- The open area is printed on the clean PVC registration sheet which is held flat by the press vacuum in order to check that the mesh is printing correctly. Standard proofing procedures should be followed (see 'Proofing and Editioning', p. 185).
- When the mesh is printing correctly, a sheet of editioning paper with the map in register should be positioned below the registration sheet. The standard registration procedures should then be followed in order to align the open area with the printing paper (see 'Registration Techniques', pp. 181-2).
- Use a damp sponge to clean the registration sheet, and dry it thoroughly, as the paper stencils will stick to any dampness on the sheet and will not transfer to the underside of the mesh.
- Place a sheet of newsprint on top of the clean, dry registration sheet.
- Print onto this newsprint and refill the mesh with

fresh printing mix, which will create more surface tension and stickiness to help the stencils adhere.

● Lift this newsprint proof away and check that the registration sheet is still clean.

● Carry the PVC envelope containing the paper stencils over to the press and move the stencils into register, using the marker pen lines on the map as a guide. The map lines should be easy to see through the registration sheet.

● Lower the screen gently, and print slowly and steadily onto the stencils and the registration sheet. The action of the squeegee will push the printing mix through the mesh to make contact with the stencils. These will adhere to the underside of the screen where they will be held in place by the surface tension of the printing mix.

● The image will have been printed on the registration sheet as the stencils were lifted.

● Before filling the mesh with printing mix, lift the screen gently and look at the underside of the mesh to check that the stencils are secure. Stencils that overlap closed areas of the mesh, such as the edge of the open area or areas of photo-emulsion or screen filler, may hang or fall down. These stencils may need a little smoothing out with fingers or securing to closed areas of the mesh with dampened gumstrip.

● The printed image on the registration sheet can now be examined. It is often useful to proof the image onto the editioning paper and to clip this up for assessment.

● The image is now ready for proofing and editioning.

A detail of the complete image (right) made with the horse-shaped acetate stencils (see pp. 82-3). This detail shows the characteristic halo effect associated with paper stencils.

The complete image from which the detail (left) was taken. The wavy patterns and tonal variations are the result of printing with a slackly stretched mesh.

Problem solving

- If there are any areas out of register or otherwise unsatisfactory, do a registration check (see 'Registration Techniques', pp. 181-4). If the image is completely unsuccessful, stencils should be washed from the mesh and the whole process repeated.
- Wet prints should not be printed on because the stencils will adhere to the sticky printing mix on the paper and will be pulled from the mesh.
- Stencils will fall off the mesh if printing technique is poor. Overfilling the mesh leads to a build-up of printing mix between the mesh and the stencil. This saturates the stencil and affects the surface tension holding it in place.
- Loss of detail and the appearance of unwanted marks in areas which should be closed are usually caused by overfilling the mesh. If this happens look at the stencil from below; if the stencils have printing mix on them take at least five proofs onto newsprint to offset these marks. Aim to do this with good printing technique to prevent this happening again.

Removal of paper stencils

- Follow the standard cleaning-up procedure for printing (see 'Removal of Printing Mixtures and Paper Stencils from the Mesh', pp. 192-4).
- Flip the registration sheet into place on the press bed. Lower the screen and wet the printing side of the screen with a sponge and soapy water. Allow this to soak for a few minutes. The soapy water will loosen the stencils, which will have become quite dried on. Use the sponge on the printing side of the screen to press the stencils off the mesh and onto the registration sheet. Lift the wet paper stencils from the registration sheet and discard them. The screen should then be cleaned in the usual way.
- PVC stencils can be washed thoroughly, dried and stored.

SCREEN FILLER STENCILS

Screen fillers can be painted or squeegeed onto the mesh. The filler dries quickly, closing the mesh to form a stencil which is waterproof and impermeable to the water-based printing mix. The stencil lies between the threads of the mesh and is known as a direct stencil. There are four main methods for using screen fillers. These are:

- painting a stencil on the mesh
- painting with screen painting fluid on the mesh and using screen filler to create a stencil from this
- stopping out and editing photostencils
- creating a reversal of a photostencil.

These methods are described in detail in the following pages.

Speedball and Lascaux manufacture non-toxic fillers which are suitable for different purposes. Lascaux Screen Filler is ideal for professional and general use and is designed to have sensitive handling qualities. It works well for all methods of application and can be used for editing photostencils. As well as being reliable and able to withstand long editions, it is effective at bridging meshes of all grades, from fine to coarse, and can be applied to either side of the mesh. Mystrol is required to soften the filler before final removal using a high-pressure hose. Detailed instructions for the removal of this filler are on pp. 196-7.

Speedball Screen Filler is not suitable for editing photostencils but can be used to make successful reversals. The filler should be applied to the printing side of an open mesh for good results, and large flat areas are less likely to break up if they are applied by squeegee. Speedball Screen Filler can be used when working with children and special needs groups. This filler should be applied to meshes which have been degreased with an acidic or neutral degreaser and then

thoroughly rinsed. The stencil can be removed easily after printing by brushing a household cleaner such as Flash, Mr Muscle Bathroom or Mystrol onto it and leaving it for ten minutes before rinsing away with a soft hose and warm water.

Using Screen Filler to Create or Stop Out Images, or to Edit Photostencils

Images can be made or altered by applying screen filler directly on open mesh using a paintbrush or a squeegee. Marks can also be created by painting the filler onto materials such as embossed wallpapers, leaves, feathers and sponges, and then offsetting the filler onto the mesh to make textures and patterns. Lascaux Screen Filler can be diluted with water (in a ratio of 50:50) to create wash effects and soft marks on fine meshes. Splashes and other raised marks should be made on the flat side of the screen.

One method of making an image is to paint with screen filler within a predefined open area (see pp. 78-9). The closed areas will not print but a positive image can be made by printing a pale tone on a darker ground. The examples below illustrate how the choice of colour, its translucency, and the colours already printed affect the result.

Another method known as reduction printing involves using a single mesh. An image is built up in a sequence of painted filler stencils, each of which gradually reduces the printing area (see pp. 89-90). This method generally requires careful planning and very accurate registration.

More usually, an image is built up by printing a series of separate stencils in register. An image may be constructed in this way solely using screen filler stencils, but more commonly a variety of stencil types are used. The illustrations of individual printing layers of an image shown on pp. 61-3 demonstrate some of these methods.

below Lascaux Screen Filler was diluted 50:50 with water and painted on a fine mesh. More water was added and splashed onto the painted filler to create washes. This stencil printed reliably over fifty times.

below and below right Lascaux Screen Filler was applied to a screen with a photostencil open area. The artist used a watercolour brush, fingerprints and offset marks made with crumpled newsprint and embossed wallpaper to create this seascape. Hard edges were softened by brushing water around the edges of the wet filler. When the filler was dry, a translucent blue was mixed

from Lascaux Thickener and Perlacryl white and blue. This was printed on white Somerset 180 gsm paper and then the same printing mix was printed on the dark ground, where the pearlescent quality of the paint can be seen. The different characters of the two prints demonstrate that a stencil need not be categorized as negative or positive.

above A positive was created by rubbing conté onto textured watercolour paper and by photocopying this onto tracing paper. This positive was used to make a photostencil which was then altered using Lascaux Screen Filler. This was printed with Lascaux Artist's acrylic paints, Retarder and Thickener.

above Sally Rice, *Seven Days*, water-based screenprint on bark-flecked Japanese paper, 1992 (detail). The artist used a computer to format her poetry.

Two text layers were output onto acetate to create positives. The resulting photostencils were edited using filler and printed using Lascaux products.

Stopping out is the process of applying screen filler to photostencils or filler stencils to edit or repair them. Most photostencils will require some stopping out to close unwanted open areas such as fisheyes and pinholes. The filler should be applied to the flat side of the screen.

Stopping out can be used creatively as a means of radically altering a photostencil, as the illustration above left shows.

Equipment and materials required

Work in the drawing area with the screen appropriate-side up on the lightbox, or alternatively on the press. A horizontal screen-drying cabinet can be used to dry the stencils.

- degreased dry screen
- screen filler
- map or soft water-soluble crayons
- squeegee or cut card
- brushes or texture-making materials, which can include sponges, stencils, rubber tools for household decorating, plant leaves, feathers, embossed wallpaper, and some clean water for painting with
- basin of warm soapy water, flexible plastic spatula, sponge and three drying cloths
- four rag rolls

Principle: screen filler stencils close the mesh and these areas will not print.

Method of making a screen filler stencil or stopping out a photostencil

- Shake the filler container well, then squeeze a small amount onto a closed area of the mesh as a palette.
- For images painted on the mesh, place the map on the lightbox and then position the screen, printing-side upwards, above this. By looking through the mesh, the broad lines of the marker pen on the map

should be clearly visible. If the work is being carried out on a press, the screen will be held above the map by the press frame. However, on a lightbox, four rag rolls will need to be positioned to support the screen and prevent the wet filled mesh from adhering to the map. If very close registration is required, the map may be masking-taped in register to the flat side (underside) of the dry screen. The stencil areas can be identified by drawing on the mesh with a clean Caran d'Ache water-soluble crayon. The map should be removed before painting the screen with filler.

● Editing a photostencil does not usually require the use of a map, as the image exists on the mesh. Working on the lightbox will illuminate any areas of mesh which are open. The filler should be applied to the flat side of the screen.

● When screen filler is used to edit a photostencil or to close flaws such as fisheyes and pinholes, a squeegee or a sable paintbrush (or synthetic equivalent) is required. The reason for this is that a thin, even layer of screen filler is needed to close the mesh. Some brushes may deposit the filler in uneven streaks, leaving parts of the mesh insufficiently closed. Impasto layers make less

effective stencils, and the raised edges of the filler cause printing difficulties and damage to squeegees. Very coarse meshes may need several applications of filler to close the mesh effectively. In this case the filler should be allowed to dry between applications. The space between the threads is measured in microns so a thin coating will form an effective stencil. A thick layer has no advantages and will be more difficult to remove.

● If an error is made when applying the filler, it can be washed off with water before it dries.

● Once work on the mesh is complete, the filler can be dried. Once it is thoroughly dry, the stencil will withstand the water used in the printing process and proofing can begin.

● Paper stencils can be added at this stage.

● After proofing, alterations to the stencil may be needed. Filler cannot be removed in a controlled or sensitive way, but changes to the image can be made by closing more areas of the mesh with filler. In this case, the mesh will have to be cleaned of printing mix, degreased and dried before painting the filler on.

● When proofing is satisfactory, the edition can be printed (see 'Proofing and Editioning', pp. 184-6).

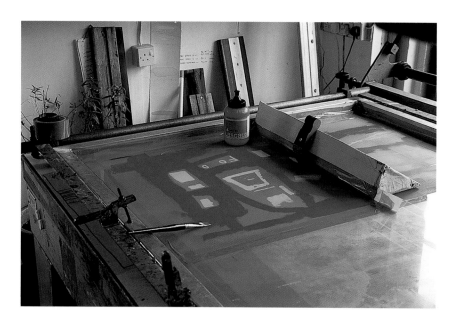

This photostencil has been stopped out with Lascaux Screen Filler: the photostencil is brown and the filler red. The screen is clamped in place on the press and is set up so that one half is closed off with a sheet of recycled PVC taped to the mesh with parcel tape. A small squeegee is resting against a squeegee support. Note the open areas of mesh, which are bright yellow: these will be divided off later and printed with separate colours.

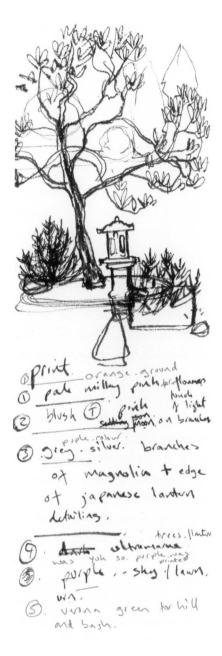

① print. orange ground
① pale milky pink for flowers
② blush ⑦ pink touch of light
 setting from moon on branches
③ grey. silver. branches
 of magnolia + edge
 of japanese lantern
 detailing.
 trees. lantern
④ ultramarine
 was yok so. purple was printed
⑤ purple. - sky / lawn.
 wn.
⑤ viridian green for hill
 and bush.

This page and overleaf A sketch with a
printing plan for a simple reduction print
was scanned into a computer, edited
and enlarged. The resulting image was
printed out on paper and a map was
made. This was laid under the mesh
and, using it for guidance, an open area
was painted with Lascaux Screen Filler.

When this was dry, a printing mix was
made from Lascaux Screenprinting Paste
and other products. This was printed
through the open area to create a flat
orange ground. All the sheets of paper
making up the edition were printed, and
then the mesh was cleaned and dried on
the press. The map was placed in register
once more and the areas which were to
remain orange were clearly identified by
the artist. These areas were closed by
painting on the mesh with filler. Once
the filler was dry, the next colour
(opaque pink) was printed in careful
register on all the orange grounds.
This process was repeated for each
stencil and the artist made changes
to the printing plan in response to the
way the print was evolving. With each
subsequent printing (lilac, purple and
green). The green layer was unsuccessful
and was not editioned. At the point when
there was hardly any remaining open
mesh, the artist felt that the image was

not yet fully resolved and decided to
explore it further by creating a new
filler stencil on another screen. The
map was used as a guide and the filler
was diluted with water and painted on
the mesh. A semi-opaque white was
printed on the edition, changing the
image radically. A proof from before
this stage was scanned into a computer.
A detail (below) of the moon and tree area
was manipulated using Adobe Photoshop.
The artist was then able to print out
positives so that this new image could be
explored in screenprinting.

Problem solving

● If the filler appears to be repelled by the mesh when being applied, there may be grease on the mesh. This can be solved by correct degreasing.

● If the filler washes off during printing or when the printing mix is cleaned off, it may have been applied to damp, greasy or contaminated mesh, or to the incorrect side, or the stencil may not have been completely dry before printing. Speedball Screen Filler should not be used to stop out photostencils and should not be applied too thickly by brush. Large open areas should be filled using a squeegee.

● If the image begins to change during printing, this could be faulty printing or the result of the filler breaking up. This latter may be caused by the presence on the mesh of substances which destabilize the filler, and is generally the result of incorrect degreasing.

Using Screen Filler for Photostencil Reversals

The image on a photostencil can be reversed using screen filler. Reversal is a term used in printmaking to describe how all the areas which are open (and which print) become closed (non-printing), and all the closed areas are opened so that they can now be printed.

Equipment and materials required for the reversal process

Work on the press, using the press frame to hold the screen firmly.

● degreased dry photostencil image on screen
● Speedball or Lascaux Screen Filler
● squeegee and flexible plastic spatula
● basin of warm soapy water, sponge and three drying cloths

Principle: the photostencil image will be completely reversed.

Method of using screen filler to reverse a photostencil image

● The degreased screen with a dry photostencil should be placed in the printing position on the press.

● Squeegee the filler thinly over the photostencil, filling the open areas but leaving the photostencil itself clean-looking. Coarse meshes may need several applications of filler to close the mesh effectively, but beware of over-filling and bridging the photostencil.

● Once the filler has dried thoroughly, the photostencil may be removed in the normal way (see 'Removal of Photostencils from the Mesh', pp. 194-6).

● The filler will remain in the mesh in the form of the previously printed image. As there is now no border, a new one will have to be created using filler. The map may be required to register this accurately. The reversal should be edited at the same time, using filler. Once the filler is completely dry, the screen is ready for proofing.

● After proofing, alterations to the stencil may be needed. Filler cannot be removed in a controlled or sensitive way, but changes can be made by using paper stencils. Alternatively the mesh can be cleaned of printing mix, degreased and dried before more filler is applied.

● When proofing is satisfactory, follow the standard printing procedure (see 'Proofing and Editioning', pp. 184-6).

Problem solving

● If the filler appears to be repelled by the mesh when being applied, there may be grease on the mesh. This can be solved by correct degreasing.

left Jenny Hendra, *Untitled*, 2002. The artist drew on a collage made from found, photocopied and painted elements. A digital positive was made and the resulting photostencil screenprinted on cartridge paper. Lascaux Screenprinting Paste, Acrylic Transparent Varnish and Studio acrylic paints were used.

below left The previously illustrated photostencil has been reversed using Lascaux Screen Filler and printed with Lascaux Screenprinting Paste, Acrylic Transparent Varnish gloss and a range of black Lascaux paints on cartridge paper.

opposite left Sandra Casey, *Rosslyn*, water-based screenprint, 24 x 16 cm (9³⁄₈ x 6⁵⁄₁₆ in.), 2002. Lascaux Screen Painting Fluid was processed using Lascaux Screen Filler, and this stencil was printed with Lascaux Gouaches, Screenprinting Paste and Acrylic Transparent Varnish. Note the characteristic brush marks.

opposite centre A seascape was made by painting Lascaux Screen Painting Fluid on the mesh and processing this using Lascaux Screen Filler. This was printed with a blue printing mix onto white paper.

opposite right The same seascape was screenprinted with white gouache on a blue ground.

● If the filler washes off the mesh during the removal of the photostencil, this suggests that it was not completely dry, or that the mesh was contaminated with filler remover from the cleaning brush or the wash-out unit.

● If the photostencil is difficult to remove from the mesh, the filler may have been applied in too thick a layer, which may have bridged the photostencil. Alternatively, the filler may have been applied on the wrong side of the mesh (it is important that the photo-emulsion was previously applied to the flat side of the screen for this process to work).

SCREEN PAINTING FLUID STENCILS

Screen painting and drawing fluids are used in conjunction with screen filler. The painting fluids are water-soluble and are used as short-term stencils in a similar way to the sugarlift method in etching. By using this simple process the painting fluid marks on the mesh will ultimately become the printed image.

Using Screen Painting Fluid to Create Images or to Edit Stencils

Lascaux Screen Painting Fluid is non-toxic and suitable for all screenprinters. It can be painted or squeegeed onto the mesh to create an image or to edit a stencil. The fluid is easy and pleasant to work with and, in conjunction with Lascaux Screen Filler, results in accurate and reliable stencils. The fluid dries quickly and the entire process does not take long.

Equipment and materials required

Work in the drawing area.

● degreased dry screen with a margin and defined open area or stencil to be altered

● Lascaux Screen Painting Fluid

● four rag rolls, map or water-soluble crayon

- squeegee or cut card, and flexible soft plastic spatula
- brushes or texture-making materials, which can include sponges, stencils, rubber tools for household decorating, plant leaves, feathers, embossed wallpaper
- basin of warm soapy water, sponge and three drying cloths

Principle: areas painted with screen painting fluid will print.

Method of using Lascaux Screen Painting Fluid to create an image on open mesh, or to alter a filler stencil or a photostencil

- Place the map on the lightbox and then position the screen, printing-side upwards, above this. Four rag rolls should be positioned to support the screen and prevent the filled mesh adhering to the map. By looking through the mesh, the broad lines of the marker pen should be visible. If very close registration is required, the map may be masking-taped in register to the underside of the dry screen. Identify the stencil areas by drawing with a Caran d'Ache water-soluble crayon and then remove the map before painting the mesh with screen painting fluid.

- Squeeze a small amount of screen painting fluid onto a closed area of the mesh, using this as a palette.
- A thin layer of screen painting fluid is sufficient to block the mesh. If an error is made when applying the screen painting fluid, it can be washed off with water.
- Apply screen painting fluid to the printing side of the dry, degreased mesh with brushes, squeegees, pieces of card, sponges or other materials to create painterly and textural effects.
- The screen painting fluid can now be dried. Once it is completely dry, a thin layer of Lascaux Screen Filler can be squeegeed over the entire painting to fill the open mesh. The press can be used to hold the screen securely.
- When this layer of filler is fully dry, a sponge and soapy water can be used to wet the screen. The screen painting fluid, which is water-soluble, will dissolve, leaving open areas which will print. The filler remains in the mesh, closing it and acting as a waterproof printing stencil.
- The screen is now ready for proofing. After proofing, alterations to the stencil may be needed. Filler cannot be removed in a controlled or sensitive way but changes to the image can be made by closing further areas of the mesh. Paper stencils can be used, or the mesh can be cleaned of ink, degreased and dried before more filler is applied or the screen painting fluid process is repeated.

Problem solving

- Screen painting fluid may be repelled from the mesh if degreasing has not been carried out correctly.
- If the screen painting fluid is difficult to wash away, this suggests that the filler was applied too thickly, or to the wrong side of the screen, or before the screen painting fluid was properly dry.
- When the image washes out with more printing areas than expected, the filler may not have been dry before processing.

opposite A Lascaux Screen Painting Fluid painted image has been covered in a layer of screen filler which is dry. The painting fluid is now being washed out of the mesh with soapy water to form an open printing area. This screen painting fluid is now available in an easily cleaned turquoise hue.

right Carol Robertson, *Spinning Plates*, water-based screenprint, image size 20 x 14 cm (7⅞ x 5½ in.), 1992. The stencils for the sea and sky areas were painted with Speedball Drawing Fluid in conjunction with Speedball Screen Filler. Autographic positives were exposed to create the dark lines, the moon and other white areas. The twenty separate stencils were all supported on a single large mesh, allowing the entire edition to be printed in two days. Printing mixes were made using standard mix and Lascaux Artist's Acrylic paints. The printed image was positioned in the centre of a much larger sheet of paper.

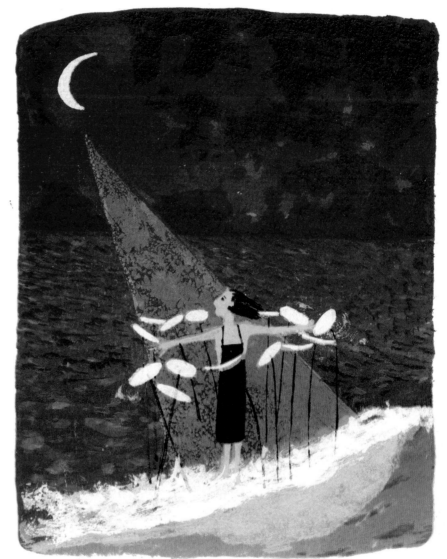

- Textures resembling halftones may appear in areas which should have been closed. This happens when the filler is applied too thinly and has been unable to bridge the mesh.
- Irregular, unexpected, textured, open areas can result if a mesh with wet filler has come into contact with the surface of the press or map, causing the filler to offset and leaving the mesh partly open.
- Soapy warm water will remove any thickly applied painting fluid which has remained in the mesh.
- If there are problems with the filler behaviour, see 'Using Screen Filler for Photostencil Reversals', pp. 91-3.

PHOTOSTENCILS
Photo-Emulsion and Positives

Photo-emulsion (from the Greek *phos* meaning 'light') is a light-sensitive solution which has been specially designed to create accurate, smooth and long-lasting stencils. The use of photo-emulsion allows artists to create line, tonal and gradated marks, which may be made up of complex and delicate elements. Methods of creating tone include the use of special substrate surfaces, painting materials which break up into light-blocking particles, a variety of drawing techniques (such as cross-hatching), photographic halftone separations and digitally created halftones. These and other ways of working are explained in the sections on different positive-making techniques.

Unlike the use of paper stencils and screen fillers, where the artist is working on the screen itself, this stencil method involves using a screen coated with photo-emulsion in conjunction with a transparent substrate which supports opaque marks (the positive). After processing, the opaque lines or tones on the positive will be replicated as open areas on the mesh and these can then be screenprinted in any colour. This way of working is reasonably fast, flexible, practical, simple, reliable and very creative. The chemistry of photo-emulsions and the processes of applying the emulsion, drying the coated mesh, exposing the positive and the coated screen to UV light, and developing the exposed emulsion to create a photostencil are fully explained on pp. 129–41.

The use of dual-cure diazo-photopolymer emulsions makes the process straightforward and suitable for artists. The positive needs to be reasonably thin and flat (creased substrates and impasto marks will prevent close contact between the positive and the photo-emulsion). The substrate should allow UV light to pass through easily, and the marks should be sufficiently opaque to shield the photo-emulsion from the light source. Colours from the red end of the spectrum (and black) are used to make effective positives as they absorb the UV light. Other colours may be experimented with but are generally less reliable, although there are exceptions. Written notes on positives (aides-mémoires), which are visible but will not print, can be made with translucent blue highlighter pens which the UV light passes through.

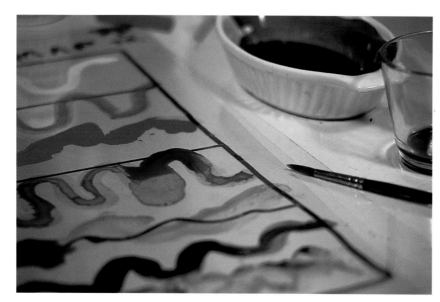

A smooth PVC positive showing some autographic marks made with different Lascaux Tusches. Note the map's marker pen lines which are visible beneath the PVC positive.

far left A detail of a water-based screenprint by Isla Hackney, built out of a number of printed layers. A photostencil was made by photocopying a piece of lace onto acetate. This was edited with screen filler and paper stencils, and printed using Lascaux products on BFK Rives paper.

left A detail of a water-based screenprint by Ruth Pelzer-Montada, made using four positives of black conté crayon on tracing paper, exposed to create photostencils. The stencils were printed in different colours, using Lascaux products on BFK Rives paper.

The artist can create positives in the painting studio or outdoors, rather than having to be based in a print workshop. The positives are undamaged by the exposure process, and they can be stored, re-exposed, reworked or used for another image at a future point. Compared with paper or filler stencils, which are worked with directly on the screen, positives are easily registered, as they can be laid on top of each other or used in conjunction with a registration device. This method has another advantage: it completely avoids any risk of damage to the mesh, which can easily occur when working directly on the screen, and this freedom allows artists to work vigorously on the image – splattering, drawing, scraping and scratching back without constraint. Artists can experiment with a wide variety of substrate and image-making materials, from digital printouts and photocopies to specially designed artist's painting materials for making positives.

As a screenprint may be composed of any number of different positives (often as many as sixty), the artist has to imagine that the opaque marks on each positive can be printed in any colour, and that this colour (depending on its opacity) will interact with previously printed colours. For example, a black positive is processed and the resulting stencil is printed in translucent lemon yellow onto a red and blue (and purple) print. When the yellow printing is dry, orange, green and brown will be seen in addition to the colours printed before. Yellow will only appear where there are areas of unprinted white paper. Imagining the layers of colour interacting and looking at the printed results is stimulating and sometimes surprising.

Moiré Patterns

Moiré is derived from the seventeenth-century French word for mohair. The word describes a watered or wave-like pattern, such as can be seen on watered silk. To understand or demonstrate a moiré effect, two hairdressing combs can be held a finger's width apart, against the light. When one comb is slowly rotated, the angle between the teeth of the two combs gradually changes and visual patterns (a moiré effect) will appear. Slight movements will create radical changes in the moiré pattern. This is a common form of visual

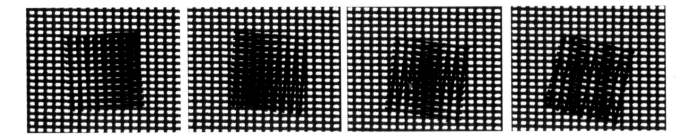

Two grids interfering and creating typical moiré patterns.

interference which occurs when materials with repetitive lines or grids are superimposed on each other.

As screenprinting is a layering process, moiré patterns can easily occur. Printing elements of the same image repeatedly in different colours may cause this to happen.

Another consideration is that many screen positives are made up of digital dots, halftone dots, granular washes or repetitive marks or lines. Combinations of these patterns and the screen mesh, which is a grid, can cause prints to show moiré patterns. If an unwanted moiré effect is encountered, it can generally be avoided by one of the following procedures:

● Rotate the orientation of the artwork to the screen by a few degrees to reduce or eliminate any visual interference.

● Re-expose the positive onto a mesh with a different thread count.

● Re-originate digital artwork at a different resolution.

● Output the image with a digital halftone screen of a different frequency (number of lines per inch). Adobe Photoshop, the design and printing industry standard software, provides useful information about halftone-screen frequency and image resolution.

Having access to a range of mesh sizes is helpful if digital positives and halftone printing are popular in a studio. Useful mesh sizes for this type of work are 120 T and 75 T (305 T and 190 T in the US).

Autographic Positives

The word 'autographic' is used to describe marks made by hand. Autographic positives can be drawn and painted using any opaque materials on a transparent substrate. Positives can be built up entirely from autographic marks, or can also incorporate photographic or digitally produced marks.

The illustrations opposite show a series of different types of positive which have been screenprinted in colour on cartridge paper. The finished print – with all the colours printed in register – is also illustrated, together with a detail (p. 100) which clearly shows the marks interacting.

Substrates for autographic positives

Suitable substrates include flat sheets of tracing paper, clear smooth PVC sheet, clear grained PVC sheet, drafting films and specialist film such as True-Grain. These materials are available from suppliers of screenprinting products, graphic arts materials and papers. The prices of some comparable materials vary considerably so it is worth researching the cheapest source. Rolls of film and tracing paper may seem less expensive, but are unsuitable as they tend to curl.

● Tracing paper is inexpensive and useful for drawn marks and frottage. Heavyweight tracing paper is more robust and tends to have a better drawing surface than the smoother lightweight equivalents. Tracing papers are unsuitable for painting on as any contact with moisture will cause buckling and creasing. The resulting poor

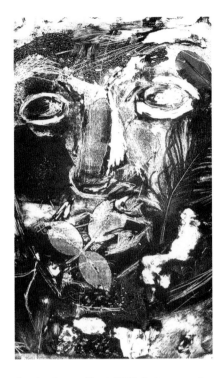

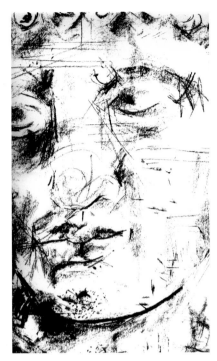

Sandra Casey, *Head*, 2002. A stage proof printed from a positive created using Lascaux Tusche soft-ground effect on smooth PVC (see p. 107 for a description of the method).

A positive created using conté crayons on tracing paper was proofed on cartridge paper. Lascaux Perlacryl green and red were used in a standard translucent printing mixture.

A positive created using Lascaux Lift Solution and Lascaux Tusche wash/spray on smooth PVC was proofed using Lascaux Studio turquoise in a standard translucent printing mixture.

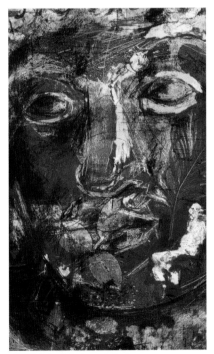

far left A positive created using Lascaux Tusche water-soluble on smooth PVC was proofed on cartridge with Lascaux Gouache lemon yellow and Perlacryl gold in a standard translucent printing mixture.

left The four stages were printed together in register on cartridge. The translucent printing mixes which were used allow the colours in each layer to interact, creating new tones and shades.

contact during exposure between the tracing paper positive and the photo-emulsion-coated screen will cause any creases to appear on the photostencil as open lines, and parts of the image may be blurred and distorted. If the image consists of several layers, accurate registration will be difficult.

Smooth clear PVC sheet is suitable for most applications, apart from drawing techniques using pencils or conté crayons. This substrate accommodates the broadest range of exposure times, and is ideal for photo collages and for painting on with a wide range of materials, including some types of acrylic paints and Lascaux Tusches. All of these materials bond well with the surface, but images can be removed if necessary without damaging the sheet. Clear PVC sheet should be used when scratching or drawing into Lascaux Tusches as the smooth surface will provide a clean line. The clarity of this type of sheet makes the registration of positives – to the map and to each other – simple and accurate. It has a number of other uses in the screenprinting studio, and artwork is easily cleaned from the sheet after editioning, allowing recycling. Paper merchants often stock this material and its price should be comparable with good quality printing paper. A 240 micron sheet is sufficiently thin to minimize light refraction during exposure and sufficiently robust for artwork to tolerate handling and recycling.

Drafting films, grained plastics and True-Grain sheets have a 'toothed' surface similar to the texture of watercolour paper or a lithographic stone. These materials are useful when drawn and painted marks are to be combined. The grained surface is less easy to see through than clear PVC sheet and a lightbox is generally necessary to aid registration to the map. The rough surface breaks up the drawn marks into a dot-like structure, allowing tonal marks to be screenprinted. Drawing on the sheet with pencils and crayons flattens the texture of the substrate and painted marks are often difficult to remove from the toothed surface without damaging the sheet, so these films are not easily re-used.

Some substrates may be greasy and the tusche or paints will be repelled. These sheets are easily degreased using a sponge and a household cleaner. Dry the sheet with a clean rag before starting work.

Painting and drawing materials for autographic positives

When making autographic positives, artists can employ the full range of techniques normally used when painting or drawing with pencils and crayons. Marks must be opaque to shield the photo-emulsion from the UV light. Painting and drawing materials should be chosen with this in mind. Good quality pigment-rich materials such as soft pencils, conté crayons, compressed charcoals, some acrylic paints and Lascaux Tusches are suitable choices.

After the positive is made and is dry, it can be examined on a lightbox or held up to a window to check that the marks are sufficiently opaque to block the light.

Sandra Casey, *Head*, 2002. An enlarged detail of the print (see p. 99).

Soft pencils (4B and softer) can deposit a dense layer of graphite, which will block the UV light effectively. A textured transparent substrate should be used. The opacity of small positives which have not exposed well can be improved by making a photocopy positive on acetate. Graphite powder can be used in a printing mix to produce a drawn effect in the final screenprint.

Charcoal pencils and conté crayons drawn on toothed transparent substrates create lively grainy lines. The crayons can also be used for frottage. Another technique involves dampening the substrate with spray-type window cleaner before the drawing is made: this procedure changes the character of the crayon, making it glide effortlessly over the surface.

Overhead-projector pens, waterproof pens, metallic gel pens and dip pens with traditional ink can be used to make opaque marks. Some types are more successful than others, and test strips should be made. Correction pens for typing errors can be used on smooth PVC sheet to produce a characterful opaque white line which exposes well (see p. 102).

(see p. 102)

Oily paint sticks can be used to create broad animated lines but they are slow-drying and may offset onto the mesh, so screens may need to be cleaned with household detergent after exposure. These positives are difficult to store.

Tusches

Lascaux manufacture specially designed tusches for creating autographic marks on positives of all types, including photographic and digital. These unique materials are unusually versatile, safe to use, water-soluble, opaque and easy to apply. The tusches are coloured differently so that marks can be identified on the sheet.

A frottage positive made by rubbing conté crayon on tracing paper held in contact with a concrete paving slab.

A frottage positive made by rubbing conté crayon on tracing paper held in contact with a slate paving slab.

A frottage positive made by rubbing conté crayon on tracing paper held in contact with a piece of wood.

They can be used to explore a range of painting techniques, including dry brush marks, wet washes, splattering, spilling, pouring, sponging, offsetting, dribbling, stippling, stencilling and scumbling. Brushes, rags, paper, rollers, airbrushes, stencils and paint shapers may be used to create marks.

They can be painted on in a smooth and even coat and then drawn into with paint shapers and other tools. Some types of tusche can be drawn into when the positives are dry to create non-printing lines.

Several of the Lascaux Tusches enable artists to make positives which contain marks usually found in traditional printmaking media. Printmaking-type marks include aquatint-like tonal effects, soft-ground impressions and drawings, and sugarlift, hard-ground and monoprinting effects.

Lascaux Tusche waterproof can be used to make a range of characteristic marks (see opposite). Lascaux Tusche waterproof is used when durable image areas are required on a positive. The waterproof nature of the tusche can be used as part of a painting method. For example, an element of the image is painted with Lascaux Tusche waterproof and allowed to dry before

other tusches are painted over it. The Lascaux Tusche waterproof will remain unaffected by this overpainting without re-wetting.

Lascaux Tusche water-soluble can be used to make a range of painted marks and washes. The tusche is easily manipulated and it can be re-wet to remove selected areas or to make soft edges. The tusche may be used to create delicate, non-printing lines. For example, a smoothly painted layer of tusche may be allowed to dry before the surface is drawn into with etching tools. The thin, delicate lines on the positive will not print, but the surrounding areas of tusche will. To protect the fragile image, any editing to the lines should be made on the reverse of the sheet.

Removing autographic materials

The tusches are water-soluble, and painted areas and brushes can be cleaned with warm soapy water. China or glass dishes should be used as palettes, as dry tusche can be removed from these by soaking them in hot water. Dry tusches can be removed from smooth PVC sheet with a plastic non-scratch household cleaning pad and Mystrol or Cif cleaner. Gloves should be worn.

left Artist's masking fluid was painted (using a disposable brush) on smooth PVC. When this was dry, Lascaux Tusche waterproof was painted over the entire image. After the tusche layer had dried, the masking fluid was rubbed away, leaving clear areas.

right Lascaux Tusche waterproof was painted onto smooth PVC sheet. When this was dry, an ordinary household knife was used to scratch away the paint, producing a jagged mark. The resulting photostencil was printed in red onto a piece of cartridge which had previously been printed with a blend. The printing mixes were made using Lascaux Studio Acrylics in a standard translucent printing mix.

opposite left Two different waterproof pens were used to make this positive on smooth PVC. The black lines will print.

opposite right A drawing was made on smooth PVC with a typing correction pen. The white lines on the positive are the areas that will print. Note how the line is solid in the circle shape, which was drawn slowly and steadily, and is broken in the marks behind the circle. These broken marks were made by drawing vigorously and quickly.

below A range of tusches painted on smooth PVC sheet were splashed with a tannin solution.

below Tusches painted on smooth PVC sheet, showing how the pigment can gather at the edges.

opposite top left Tusches were diluted with dishwashing liquid and water, and painted on smooth PVC sheet. The addition of the detergent created a bubble effect. Areas were wiped away with a cloth while the tusches were still wet.

left and below Lascaux Tusche wash/spray and Lascaux Tusche wash painted on smooth PVC sheets.

below Lascaux Tusche wash/spray was airbrushed over paper stencils laid on smooth PVC. Different densities of spray were achieved by spraying closer to the PVC sheet. The stencils were lifted away between layers and water was added to create washes. A paint shaper was drawn through the wet tusche to create dark lines.

below Sprayed tusche dabbed with tissue paper.

below Lascaux Tusche wash was painted on smooth PVC sheet and a pinch of fine carborundum powder was sprinkled over the wet mark, combining with it.

Tusche washes

Lascaux Tusche wash and Lascaux Tusche wash/ spray can be used to create washes which resemble lithographic, aquatint and watercolour tonal gradients. The tusche particles are opaque, so even dispersed or delicate tonal washes may be exposed and printed accurately. All of the Lascaux Tusches may be diluted to create different types of reticulation by adding water, tannin, Lascaux Diluting Liquid or clear window cleaner. Drying time is affected by dilution (water will take the longest time to dry).

Small amounts of fine carborundum powder may be sprinkled onto wash images on the PVC sheet to create further reticulations. Lascaux Tusche wash/ spray may also be used in an airbrush to create tonal effects similar to an aquatint in etching or a random dot screen.

right A detail of the top left image on p. 99. This single-colour water-based screenprint on cartridge was made from a positive created using Lascaux Tusche soft-ground effect. The method described opposite was used to take an impression from a collage of feathers, textured cloth, leaves, petals and threads. Paint shapers were used to draw into the image while it was still wet, defining shapes and creating non-printing lines. The artist then worked into the positive further by wetting areas with water and using cotton wool to lift tusche away, making soft marks.

below Another detail from the same image. Fine netting from fruit packaging was used to make this area of the positive.

below A detail from the same positive illustrating how it is possible to rework Lascaux Tusche soft-ground effect on smooth PVC sheet by shaping, lifting, wiping and dabbing. The artist used a range of tools.

Lascaux Tusche soft-ground effect

This tusche can be used to create marks which resemble the soft-ground method in traditional etching. The tusche is slow-drying, viscous and capable of a broad range of marks. One technique involves using an etching press to take impressions of fabric, leaves, feathers and other collage material. The collage will lift off some areas of tusche and the resulting screenprint will replicate the tonality of the positive. The sharpness of the impressions is affected by how dry the layer of tusche is on the PVC sheet.

In a simple version of this method, the tusche can be applied by brush and an impression taken using hand pressure, but the following method makes use of a roller and an etching press.

● The transparent PVC sheet is masking-taped to a lightbox, glass bench or clean drawing board. A piece of white paper should be placed below the PVC sheet.

● The tusche is laid out (using a plastic spatula) on a clean glass inking slab and is rolled out using a hand-roller. The tusche is applied thinly and evenly to the PVC sheet.

● The tusche-covered PVC sheet is detached from the bench and positioned on the etching press bed. A collage of low-profile textured materials, such as feathers, leaves, threads and paper shapes, can be laid on the top of the tusche. Avoid using wire, chain links or other hard objects that may cause damage to the blankets or press. Once the collage is complete, a second PVC sheet is laid on top, then a sheet of blotting paper and finally the press blankets.

● The collage is rolled through the etching press at low pressure. After it has passed through the press, the blankets and blotter are lifted, and the top PVC sheet is carefully peeled away. An image will have offset onto this sheet and may be used as a positive if desired.

The collage will be flattened and embedded in the tusche layer on the lower PVC sheet. An etching needle may be used to peel each item carefully away. Once the collage has been removed from the tusche, the positive can be examined on a piece of white paper or on a lightbox. The aim is to produce a positive with defined contrast; enough tusche should remain on the sheet to block the light. Positives often appear unpromising but expose to produce effective photostencils.

● The results will vary depending on how dry the tusche was when the collage was run through the press. If the impressed marks do not allow the light to pass through, either the tusche was applied too thickly or the etching press pressure was insufficient. If the background allows light to pass through, either the tusche was applied too thinly, the pressure was too great or the covering material was not sufficiently glossy to repel the tusche, and so too much was removed from the lower PVC sheet.

● Alterations can easily be made to the positive before exposure. When the image is still moist, brushes and paint shapers can be used to wipe away areas and make marks. The tusche will dry slowly and can be drawn into with etching tools at any stage. The tusche may be re-wet to create washes or to remove areas of the image. Marks can be added at any stage using any of the other tusches.

● When the tusche is dry, alterations to the image can be made on the reverse of the sheet. This method protects the fragile image and allows accurate editing. When the collage image is screenprinted, the tusche areas will print.

Lascaux Tusche soft-ground effect used to create drawing marks

This tusche can be used to make drawn marks similar to the traditional etching soft-ground method. The

drawings have a soft atmospheric character with the appearance of 'foul bite' across other parts of the image. The lines will be non-printing.

- The PVC sheet is masking-taped to a glass bench. The tusche is laid out (using a plastic spatula) on a clean glass inking slab and is rolled out using a hand-roller. The tusche is applied thinly to the PVC sheet.
- A piece of tissue paper larger than the tusche area is laid over the tusche, overlapping all the edges. The tissue is taped down at each corner. A piece of drawing paper is laid over the tissue and is taped down. The approximate boundaries of the tusche-coated PVC should be marked on the paper.
- A pencil or crayon can be used to draw vigorously on the drawing paper (this strong paper is used as it will not rip and its texture will animate the drawn line). Drawing papers with different textures will give different results. The tissue below will not be damaged and is sufficiently absorbent to lift the tusche where pressure has been applied, leaving the PVC clear.
- When the image is complete, remove the drawing paper and carefully peel away the tissue. The tusche drawing will be clearly seen on the tissue, and if the positive is held up to the light, these areas should now be clear of tusche. The drawings generally look faint but should allow light to pass through the drawn marks. The tusche will offset randomly in some areas, causing atmospheric 'foul bite' marks.
- When the tusche is dry, other tusches may be painted on the back of the sheet to avoid re-wetting.

Monoprinting technique

Lascaux Tusche soft-ground effect can be used to make positives with monoprinting-type marks.

- The tusche is rolled out on a glass surface or on a separate PVC sheet, and a sheet of clear smooth PVC is laid over the wet tusche. A map may be taped over the PVC sheet for registering the drawn marks.
- The drawing is made by pressing on the PVC sheet using fingers or the handle of a brush. This will cause the wet tusche to offset, creating an image on the sheet.
- When the drawing is finished, the PVC positive is peeled away. The image should be clearly visible on the PVC sheet. If the tusche was rolled up on a PVC sheet, this also may be used as a positive.
- Alterations can easily be made to the positive before exposure. When the image is still moist, tissues, cotton buds, brushes and colour shapers can be used to wipe away areas and make marks. The water-soluble dry image can be drawn into with etching tools or re-wet to create washes or to remove areas of the image. Marks can be added at any stage, using any of the other tusches. When the tusche is dry, alterations to the image can be made on the reverse of the sheet. This method protects the fragile image and allows accurate editing.
- The offset Lascaux Tusche soft-ground image on the positive will print.

Lascaux Tusche soft-ground effect can also be rolled up on linocuts, woodcuts and etching plates, allowing these to be printed onto clear smooth PVC sheet to make positives. The tusche can be used as a painting tusche and may be diluted with water, Lascaux Diluting Liquid or spray-type window cleaner to create wash effects.

Lascaux Lift Solution

Lascaux Lift Solution is used in combination with Lascaux Tusche wash/spray. The method is comparable to using the sugarlift technique in traditional etching and is good for bold line imagery. The painted line tends to have a particular character.

1. (above) Lascaux Lift Solution was painted on smooth PVC, producing characteristic marks similar to traditional sugarlift.

2. (above) The painting has now been airbrushed with Lascaux Tusche wash/spray and is entirely covered. The coating was allowed to dry between the two applications that were made.

3. (above far right) The positive has been gently washed with water and the Lascaux Lift Solution has washed away, leaving the PVC clear. The dark sprayed areas will print.

4. (right) A detail of the finished positive, showing the complex range of marks achieved.

- An image is painted on the substrate using Lascaux Lift Solution and is allowed to dry and become chalky. A substantial deposit of solution is necessary.
- Lascaux Tusche wash/spray is airbrushed over the lift solution image and the area of the PVC sheet which is to print. This should be allowed to dry thoroughly. A single, even layer will create a light tonal effect; many layers will create denser tones. If many layers are to be used, each must be allowed to dry before the next is applied. Should the sprayed layers become too wet, the lift solution image will be damaged.
- When the tusche layers are dry, the positive is immersed in a tray of warm water for ten minutes.

The Lascaux Lift Solution will start to dissolve, lifting the layers of sprayed tusche. The painted Lascaux Lift Solution should eventually lift away, leaving the substrate clear in the form of the image. The remaining airbrushed tusche on the positive will print.

Making a series of painted autographic positives for a single image

This approach to assembling a screenprint has been used as a starting point for many of the images in this book. The following pages show a finished screenprint, a detail from a stage proof, and details of some of the autographic positives that made up the image.

Equipment and materials

Work in the drawing area or painting studio.

- lightbox (useful for checking positives)
- white-surfaced bench covered with PVC or hardened glass
- suitable substrate
- selected positive-making materials
- ceramic bowls or palettes
- selection of artist's tools
- map
- print-drying rack or drying cabinet for positives
- basin of soapy water, sponges and dry cloths
- storage for dry positives

Principle: to create a series of positives which are in register with the map and with one another.

Method

- The map is taped onto the lightbox with a small piece of masking tape on each corner. The first transparent sheet is laid on top and taped down firmly. After referring to the sketch or printing plan, the first positive is painted. The artist has to hold in mind all the colour possibilities which may result from the effect of this printed layer. (The artist should also remember that the colours of the tusches bear no relation to the colours which will be printed.)
- The use of the map enables the artist either to work with great accuracy, or to work freely and adapt spontaneously to marks which occur.
- The positive is laid aside to dry flat. Any alterations may be made at a later stage if necessary.
- Further positives can be made in the same way.
- When all the positives are dry, they may be checked for opacity. They may also be stacked on top of each other in register on the lightbox. This gives an idea of any areas which may not print, leaving parts of the paper exposed.

Combining other types of positive

Autographic positives may be exposed in conjunction with random dot screens, halftone screens or other patterned screens. This process is used to create a tonal structure on flat, open areas of mesh, and requires a double exposure to be made. A photographic random dot screen may be used, or a basic random dot screen can be made by using an airbrush to spray layer upon layer of tiny dots of tusche all over a smooth clear PVC sheet.

Photographic, digital or photocopy positives can also be added to autographic positives.

Method of adding a photographic, digital or photocopied element

- The map should illustrate the element to be added. Rather than drawing this information on the map, it is quicker to incorporate an identical positive of the element.
- The element should be laid in register on the map and the positive substrate laid over it. The element can then be carefully attached with clear adhesive tape to the back of the substrate. The registration should then be checked by laying the positive, with its element in place, over the map.
- Marks made to alter or blend the added element with the autographic positive should be painted on the front of the sheet. Abrupt changes in the tonal structure and changes in opacity will show clearly on the print, so merging has to be done with care and subtlety (see p. 114).

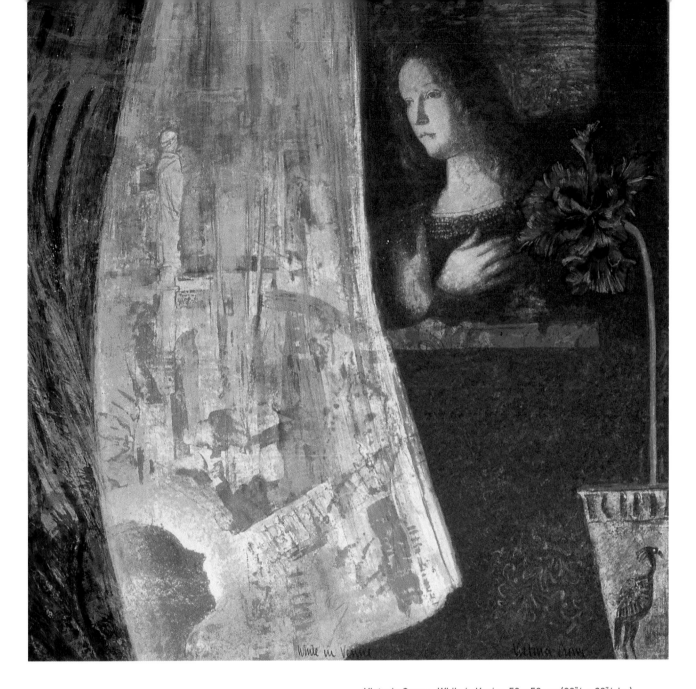

Victoria Crowe, *While in Venice*, 58 x 58 cm (22$\frac{7}{8}$ x 22$\frac{7}{8}$ in.), edition of 50, 1998. A water-based screenprint, printed using Lascaux products on Moulin du Gué paper. The artist painted and drew seventeen positives. She was able to imagine how these complex tonal positives would combine when printed in layers of different colours. The illustrations on the following pages show details from some of these.

left A magnified detail of conté crayon and wash marks from the curtain area.

left A detail of a positive (the statue seen through the curtain), showing the use of a soft pencil, a tusche and an acrylic paint wash on True-Grain.

below left A detail (of the textured area below the main figure) showing marks made by painting the raised surface of textured wallpaper with Lascaux Tusche water-soluble and offsetting these onto True-Grain.

above A charcoal pencil drawing on True-Grain (which became the dark red marks on the lily flower).

above A magnified detail of the lily charcoal pencil drawing.

above The artist painted this positive (the curtain area) using a tusche wash, which created a grainy texture and an interesting edge quality. Some of the light areas have had water added by brush, and in others the wet tusche has been lifted with absorbent tissue.

below This positive (from the lower left panel) was painted with a tusche, and a natural sponge was used to lift away the wet tusche. After this was dry, the sponge was dipped in Lascaux Tusche water-soluble and used to make patterns on top of this.

above Feathers were painted with Lascaux Tusche waterproof and offset on True-Grain (in the left panel).

above The True-Grain was painted with a range of tusches and acrylic inks (the curtain area). The substrate surface was slightly greasy and repelled the painting mixtures to some extent.

right A photocopy on acetate (the main figure) was attached with clear adhesive tape to the back of a True-Grain sheet. The grainy front surface of the True-Grain was painted with a mixture of tusches. Note the change in tonality between the photocopy and the autographic areas. Care has to be taken to merge areas of different density so that the resulting print looks homogenous.

below Tusche was used to paint the dark areas of the bird and vase detail (actual size).

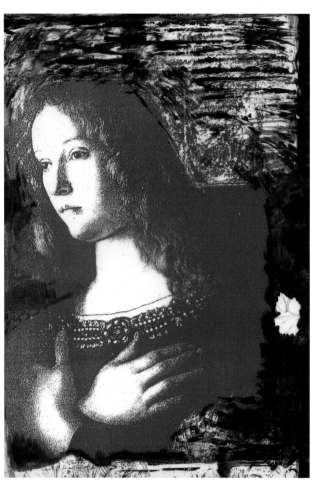

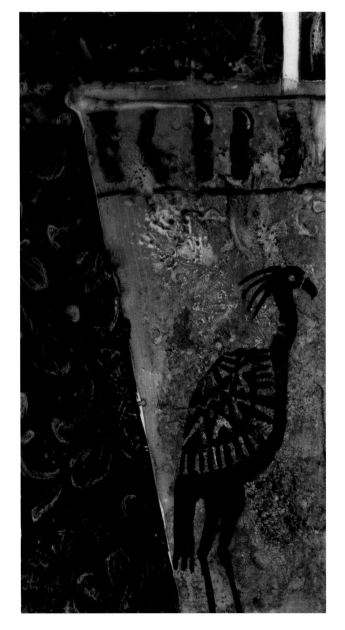

below A detail of tusche washes (the curtain area).

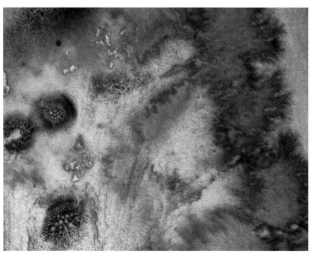

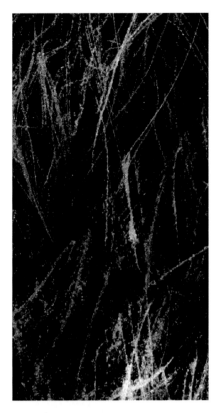

left Acrylic paint was used to create this dense flat area (the lily head).

below A varnish brush was used to paint these dry, dragged marks over the top of some dried tusche washes (the curtain area). Some wiping and scratching back, using etching tools, can be seen on the right side of the image.

left Lascaux Tusche water-soluble was painted onto True-Grain, allowed to dry, and scratched into with etching tools (the hair of the main figure).

right A detail of a newsprint proof which has been printed in two colours, showing how the marks on the positive print as they can be seen on the True-Grain. In the finished print this area of curtain is overlaid with pale blue washes, which soften and break up these earlier printings.

below A detail of washes and conté on True-Grain (the curtain area).

Using Halftone and Other Tonal Techniques

By its nature, the screenprinting mesh will print flat fields of colour. In order to create tone, stencils are used to create a structure of lines or dots to break up open areas into tonal gradients. Positives with tonal effects can be made autographically, photographically and digitally.

Autographic methods of creating tone

Tone can be introduced to a line image positive by drawing a series of close parallel lines, crossed by another series of parallel lines. The closer the lines are to each other, the darker the resulting tone. This is known as cross-hatching.

Pencils and conté crayons can create tonal marks directly if they are used on a textured material such as grained tracing paper, drafting film or True-Grain. The graphite or pigment sits on the raised areas of the textured surface and the grooves (which remain clear) break the line into fragments. The tonality of the mark will vary according to the pressure with which the drawing tool is applied to the substrate, as this affects the proximity of the drawn fragments to each other.

Painted marks on textured substrates also break up into tonal gradients as the pigment settles into the cavities of the grainy surface. Smooth PVC sheet can be painted onto with Lascaux Tusches (which contain suspended opaque particles) as the particles will reticulate into tonal wash patterns as they dry.

Another method of creating tone is to use an airbrush to spray patterns of opaque dots onto a positive. The areas where the sprayed dots are closest will print darkest. A similar but cruder effect can be achieved by splattering the positive using a toothbrush or stiff paintbrush.

All these dotted structures have similarities to the use of halftone and are comparable to the process of aquatint in etching. Using the double-exposure technique, an autographic positive may be exposed in conjunction with a patterned positive or a halftone contact screen in order to explore tonal effects.

Halftone

A common use of halftone can be seen in black and white photographs which are printed in newspapers or books. If these are examined using a magnifying glass, it is evident that the image has been broken up mechanically into a pattern of dots, which print from dark to light in an approximation of the original photograph. The darkest areas are where the black dots merge, and the lightest areas are where the dots are scarce and the light tone of the paper predominates. This halftone system means that black ink can print a scale of tones from black, through grey, to white. Similarly, any colour that is printed will show a range of tones.

Images can be translated into halftones photographically using a halftone positive (halftone contact screen). Halftone contact screens consist of very fine geometric grids or dot structures. The different configurations include grey screen (cross-line image), straight line, wavy line, mezzotint and random dot. This last type is the most commonly used by artists for aesthetic reasons: as its name implies, the arrangement of dots is not geometric or mechanical. These screens are available in fine or coarse grades and are marketed for printmakers as Dove screens and Imagon screens. Contact screens generally have to be purchased as they are difficult to make. They are available, mainly in smaller sizes, from a few specialist manufacturers, and tend to be expensive. They require careful handling to avoid scratches which will damage their delicate tonal structure. Moiré patterns can occur when the geometric arrangement of dots on the halftone screen interacts

with the woven structure of the screenprinting mesh (see pp. 97-8).

Photographic positives which are made from a grainy photographic negative, using a normal darkroom enlarger, may not require the use of a halftone contact screen to establish a printable tonal gradient. This is because the intrinsic graininess of the image on the negative may be sufficient to fragment the tone into random dots, if the enlargement is great enough. Photographs can be taken deliberately on high-speed film to enhance this effect.

Digital software such as Adobe Photoshop enables artists to apply a wide range of halftone effects and frequencies (the number of dots to a given measurement) to an image. The frequency of dots affects the appearance of an image, and this is an interesting area to explore. These programmes offer a choice of dot shape, such as round, elliptical, square, cross, line and diamond. Artists can also write programmes to define halftone patterns of their own invention.

However, when most inkjet printers output images, a form of random dot is automatically imposed on the image to simulate tonal changes. This is referred to as dithering, and the dithered dot structure often transfers successfully to a photostencil, eliminating the need for a halftone. Using Adobe Photoshop, it is also possible to impose a specified dither on the image itself, using different values to achieve a variety of effects.

Photographic Positives

Photographic positives can be made using a process camera or an ordinary darkroom enlarger.

With a process camera, original photographs, digital output, found material, collages, drawings or painted marks can be enlarged and reproduced as line or halftone images. Normal darkroom procedures are followed to expose, develop and fix the film, but a transparent positive film (lith film) is used rather than an ordinary photographic paper. Polyester lith films are usually handled in red safelight conditions.

below left A detail of a water-based screenprinted poster. The positive was made using a Repromaster process camera. The halftone is magnified and parts of the text can be seen as opaque orange and translucent white shapes.

below right A considerably magnified detail of the same area of the poster. The varying sizes of the halftone dots can be clearly seen. Note the surface appearance of the opaque orange and the translucency of the white.

Test strips should be made to ascertain the optimum exposure time. The dark opaque areas on the film will become the part of the image that can be screenprinted.

When a process camera is used, light is reflected off the original, through the lens, and onto the sensitive lith film. Process cameras can be purchased second-hand or from specialist suppliers. This way of working offers high contrast and superb detail, but is becoming less common due to the possibilities offered by (and the availability of) digital processes and photocopiers.

An ordinary enlarger can be used to make positives on lith film from photographic negatives. Normal darkroom procedures are followed, and test strips should be made to work out the optimum exposure time.

Photographic processes use toxic chemicals to develop and fix films, so safety clothing should be worn and the darkroom should be equipped with good extraction and ventilation equipment. Suppliers of lith films and related chemicals offer up-to-date health and safety advice. If making photographic positives is an important part of an artist's practice, it is advisable to attend a photographic course in order to get the best results from this process.

Photocopy Positives

Photocopiers can be used in a range of ways as a creative and practical artist's tool, and are invaluable in fine art screenprinting studios.

Photocopy toner is very opaque and is an excellent material for making positives. Some machines will print on good quality tracing paper and clear photocopy acetates are available which make excellent substrates. Most photocopiers have a maximum size of A3 (29.7 x 42 cm/11⅝ x 16½ in.), but many reprographic agencies are able to make large copies on tracing paper using plan-copying equipment. These are generally dye-line machines but large-format photocopiers are now widely used. Some of these copiers can output a paper copy up to 25 m (82 ft) long on a single sheet with no loss of print quality.

below left A detail of a poster for a Robert Maclaurin exhibition. A positive was created by enlarging a small etching made by the artist, using a process camera. The circular shape was made using a paper stencil. Lascaux Screenprinting Paste, Acrylic Transparent Varnish and Studio Acrylic paints in a standard mix were used to print these layers on cartridge paper.

below The original photograph of these doves was taken with a fast black and white film, which produced a grainy image. A lith film positive was made from this using a photographic enlarger. This avoided the need for a halftone screen (see p. 180).

above Part of a single-colour water-based screenprint poster on cartridge paper. The positive was made by laying and shaping lengths of white framing cord (see detail below) on a photocopier. The cords were then covered with a black cloth before a copy was taken onto tracing paper.

above A painting with an interesting surface and range of close-toned marks was photocopied in black and white onto acetate. This positive will be used to create tonal activity in a screenprint.

below A photocopier was used to increase the contrast of a child's line drawing on paper and to translate this into a positive on acetate. The resulting photostencil was printed in blue Lascaux Studio Acrylic in a standard mix on Fabriano paper. The other colours were printed from positives created using Lascaux Tusches.

above A detail of a photocopied image from a stage proof of Victoria Crowe's screenprint *While in Venice* (see p. 114)

Photocopiers can be used to photocopy text, painted marks, found objects (string, leaves and other materials) and drawings (for instance, a pale drawing on a positive can often be rescued by photocopying it and then exposing it successfully). They can be used to magnify, reduce, reverse or alter the contrast or tone of an image. Reprographic companies often offer other special effects, too.

Photocopy positives can be drawn and painted on. Positives that have been altered with tusches and paints often show extreme changes of tone and fail to look homogenous. A good technique to avoid this is to make any changes to a paper copy using typing correction pens, fine-liner pens, and black and white acrylic paints. A final photocopy of the modified artwork can then be made for use as the positive.

Colour photocopiers are able to make basic colour separations. If the colour control on the machine is set to one colour (for example, magenta), a photocopy of the magenta areas can be made (on transparent

A rather pale image created using Lascaux Tusche soft-ground effect was manipulated in terms of size and contrast on a photocopier before being output onto acetate.

paper) using the black toner cartridge. When this is processed to become a photostencil, a magenta printing mix can be screenprinted and the original image re-built in a different way. This process can be repeated to screenprint yellow, cyan and black layers. Experimental work using alternative colours can be explored.

In a number of the prints illustrated in this book, the artists have made use of photocopied material. George Donald (pp. 141 and 143) made drawings on scraps of paper which were then enlarged on a photocopier. The acetate photocopies were later exposed to make photostencils.

Digital Positives

Commercial screenprinting positives are almost all digitally created and output. Artists can make use of digital processes to originate, reproduce or separate images.

Creating positives

Artwork can be originated, manipulated and separated using applications such as Microsoft Paint or Adobe Photoshop (some artists write their own programmes to originate images). A scanner can be used to input drawings, paintings, collage or found materials, photographs, text or digitally printed images. A scanner with a backlit lid enables the artist to scan photographic negatives and transparencies into a programme for manipulation. Similarly images can be captured and input from the Internet, or with digital still and video cameras. Existing images can be separated to make reproductions or manipulated digitally to create new images. A conventional mouse or a pressure-sensitive pad and pen (stylus), such as a Wacom Tablet, can be used to make original drawings and paintings.

The Adobe Photoshop software provides virtual tools, including pencils, erasers, pastels, airbrush, different types of paintbrush, magic wand, lasso, crop tool and other specialist tools. The artist can control the size and spread of the tools, and the colour of mark made. A wide range of filters can be applied to the marks, such as Stylize (including emboss, halftone and solarize), Artistic (including fresco, cut out and rough pastels), Brush Strokes (including splatter, cross-hatch and angled strokes), Blur (including motion blur, radial blur and Gaussian blur) and Sketch (including reticulation, graphic pen and bas relief). This is only a small selection from the Filter menu. The Image menu can be used to alter contrast and tonality, and colour information can be changed to RGB, CMYK or grayscale. Artwork can be rotated, inverted, enlarged, reduced and built up in separate layers (in a similar way to assembling the positives of a screenprint).

Text can be generated with software such as Microsoft Office or AppleWorks. These applications offer a wide selection of fonts, styles, sizes, patterns and tones. Fine adjustments to text positioning and presentation is possible with desktop publishing software such as Adobe Pagemaker and QuarkXPress, and if these elements are imported into Adobe Photoshop, further adjustments are possible.

Outputting positives

Completed artwork up to A4 (29.7 x 21 cm/11⅝ x 8¼ in.) can be printed onto clear acetate using a home printer. Transparent grained acetates, which are suitable for positives, are available for inkjet printers. These are sold through office suppliers and are often labelled OHP (for use with overhead projectors). An image printed on a transparent substrate by an inkjet or laser printer is sufficiently opaque to work successfully as a positive. Larger-format images should be stored on a CD or a Zip or Jaz cartridge and taken to a bureau for output onto a transparent substrate using an image-setter or large photocopier. Before embarking on an image, it is a good idea to visit the bureau to find out what kind of substrates they will print on, the estimated cost, the file type (e.g. TIFF), the form of disk (e.g. CD), the format (e.g. PC or Mac) and to check that the emulsion side of the clear film can be up (rather than down).

Resolution of positives

A screenprinter has to consider the resolution of the artwork (usually expressed as dots per inch, or dpi) in terms of how the image is captured, created, output, exposed and screenprinted. The higher the resolution at which an image is captured, the greater the amount of detail that is stored. This resolution cannot subsequently be increased. However, storing and manipulating images at high resolutions requires more computer memory, thus slowing the process down. High resolutions will also diminish the number of grey tones which can be reproduced.

Different output devices produce printed images in varying resolutions, and the more sophisticated the machine, the more capable it will be of printing very fine detail. Image-setters will print up to 2400 dpi, standard inkjet printers offer resolutions up to 700 dpi and laser printers will normally print up to 1200 dpi.

The image will ultimately be printed out in some form of halftone, which imposes practical constraints on the amount of detail that will be reproduced. A balance needs to be struck between the halftone screen frequency (usually measured in lines per inch, or lpi) and the stored image resolution (dpi). As a broad guide, a specific halftone-screen frequency (in lpi) will work

best with an image resolution of twice this number (in dpi). For example, a halftone of 100 lpi will work best with an image resolution of 200 dpi. Working with these patterns and grids – including the structure and threads

per inch (tpi) of the screenprinting mesh – may result in unwanted moiré effects (see pp. 97-8).

Using digital positives with water-based screenprinting

It would be easy to allow the complexities of these issues to dominate the approach to making digital positives, and the answer to this is simply to experiment methodically, keeping careful notes and evaluating the results. In general, screenprinting has in the past been considered less able to reproduce fine detail than etching or lithography, and the rationale for this has been that even

1. (below) This drawing was made on an iMac computer, using a painting programme and a Wacom tablet and stylus.

2. (below) A simple map (drawn with waterproof marker pen on smooth PVC sheet) was made to help register the different layers.

fine meshes, by their nature, are crude instruments. However, it is more likely that the real problem was that volatile solvent-based inks dried fast in the tiny open dots in the photostencil, closing them and thus continually blocking the finest areas of detail. Fine meshes coated with dual-cure diazo-photopolymer emulsions, exposed and developed carefully, produce stencils which can hold very fine detail. The water-based screenprinting mixtures described in this book can be controlled so that every tiny dot will print reliably and accurately throughout an edition, allowing a much greater degree of detail to be achieved.

3. (opposite above) A photograph of a demolition site was scanned into Adobe Photoshop and altered before being printed out on OHP acetate. The resulting photostencil on a fine mesh was printed with water-based printing mixture onto cartridge paper. Note how strongly the marker pen used to draw a line around the cut-out area prints. A blue highlighter pen would not have affected the image in this way.

4. (opposite below) A collage made from found images and text was drawn on with black pen and painted on with white acrylic paint. It was then scanned into Adobe Photoshop and manipulated further.

5. (top right) The resulting image was made into a positive.

6. (right) The three positives were printed together in register on cartridge paper.

Collaborative community book project, *Where Are We Going?*, 1999 (detail). This is a section from a fold-out book which was printed using Lascaux Gouache and standard mix on Fabriano 4. The book was made as part of the King's Cross Festival, London.

above A photograph of a face was placed on top of the selected collage elements of netting and grass, and a scan was made. The image was imported into Adobe Photoshop, a detail was magnified and the contrast was altered. When the artist was happy with the image, it was printed out on OHP acetate using a standard domestic inkjet printer.

above This collage was made by an artist using digital equipment for the first time. Feathers, netting, thread and a range of fabrics were laid on a scanner and covered with a sheet of white paper. An initial scan was made and the artist was then able to evaluate the results. Further collages and scans were made and viewed on the computer screen.

above The resulting photostencil on a fairly coarse mesh was printed with water-based materials onto Hahnemuhle paper. Note the loss of detail and the parallel bars on the image generated by the inkjet printer, which was not adjusted to the highest possible quality. Using a fine mesh would have increased the quality of the reproduction.

above Karen Guthrie, *An Historic*, water-based screenprint, 1995 (detail). The positives were created and generated

below Grace Quintanilla, *Untitled*, water-based screenprint, 1995 (detail). The positives for this image were originated from still frames which were part of a

digital video film made by the artist. The images were printed out as four-colour separation positives. The artist deliberately used non-process colours

digitally, and the image was printed on Rives BFK paper using Lascaux Studio Acrylics and standard mix.

and manipulated the printing registration to create a sense of movement, which related to her other activity of film-making.

Colour Separation and Process Printing

An image can be divided by colour into a set of halftone separations. Each separation (positive) represents a different colour and, when these are screenprinted in perfect register, the image will be re-assembled.

This process was developed as a method of printed colour reproduction and separations were created using a photographic technique. This involved the use of a process camera with colour filters and a halftone screen. Nowadays most images are separated digitally. Artists can make basic separations with a colour photocopier.

The separated colours are usually the four translucent process colours: cyan, magenta, yellow and keyline black (CMYK). Other colour systems exist,

Sir Eduardo Paolozzi, *Study for Pearson Tapestry*, water-based screenprint, 34.5 x 48.5 cm (13½ x 19 in.), edition of 75, 1996. The artist made a collage on which a large tapestry and the screenprint edition were based. The screenprint positives were generated from the collage using digital and autographic processes. The separations were printed with standard mix and magenta, cyan and yellow Speedball process colours. The colour layers combined to create a range of other colours and tones. An autographic positive was printed with Verona green Lascaux Gouache, Screenprinting Paste and Acrylic Transparent Varnish.

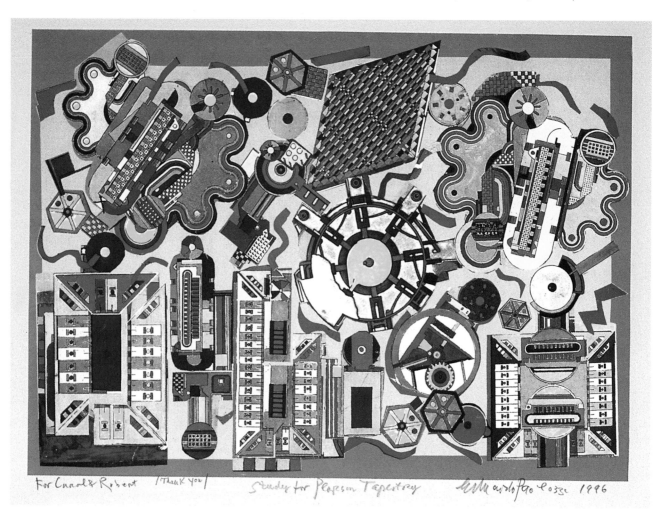

such as RGB (red, green and blue – the additive primaries) and the Lascaux Sirius Primary System (five primary colours plus black and white).

When photostencils are made from the halftone separations, they can be screenprinted. The translucent coloured dots will overlap and blend to form secondary colours in some areas. Process colours used in this way create an acceptable spectrum of colour for reproduction. To avoid moiré patterns, the separations should be exposed at slightly different angles to each other and to the grid of the mesh (see pp. 97-8).

The printing mix passes easily through the tiny open dots onto the paper below, without drying or blocking the mesh. Due to the thixotropic nature of these printing mixtures, the printed dots retain their form on the substrate, reducing the problem of dot gain. The technique of process printing can also be explored freely with different translucent colours on unusual substrates.

When fine halftone separations are to be printed accurately, certain factors have to be considered.

● A registration system needs to be decided upon (see pp. 181-4).

● A professionally stretched, properly prepared, fine, blemish-free mesh is necessary.

● The photo-emulsion must be of the best quality, fresh, applied with a smooth squeegee blade, dried correctly, exposed accurately and developed carefully. Inconsistencies in the emulsion coating will show as unwanted tonal changes within the image.

● Squeegee blades must be clean and even.

● The colours and printing mediums must be weighed with great accuracy.

● The registration sheet must be immaculately clean and well secured to allow perfect registration.

● Meshes and tools must be cleaned very thoroughly to prevent contamination of colours.

A detail of a water-based screenprinted proof of Sir Eduardo Paolozzi's image. This proof was the first layer and was printed with standard mix and magenta Speedball process colour.

A detail of a water-based screenprinted proof printed with standard mix and cyan Speedball process colour.

A detail of a water-based screenprinted proof printed with standard mix and magenta and cyan Speedball process colours. The mesh was overfilled with magenta printing mix and as a result this colour flooded on the print.

- Changing temperatures and humidity levels in the studio throughout the day will cause the paper to expand and contract, with consequent registration difficulties.
- Poor printing can blur the image or cause the printing mix to dry in the mesh.

- The behaviour of the dot structure on each printed layer will affect the balance of the finished image. A magnifying glass can be used to examine the dots.

A detail of a water-based screenprinted proof printed with standard mix and magenta and cyan Speedball process colours. Other colours are created when the translucent layers of halftone interact.

A detail of a water-based screenprinted proof printed with standard mix and magenta and yellow Speedball process colours.

A detail of a water-based screenprinted proof printed with standard mix and cyan and yellow Speedball process colours.

right A detail of a water-based screenprinted proof printed with standard mix and magenta, cyan, yellow and black Speedball process colours.

A Brief Guide to the Stages of the Photostencil Process

There are four main stages in making a photostencil.

1. Applying photo-emulsion to the mesh

Photo-emulsion is a light-sensitive liquid which is applied with a squeegee in a thin, even layer to a clean, dry, degreased, open mesh. The aim of this is to coat the entire mesh.

2. Drying the photo-emulsion

After the mesh has been coated, the screen is dried (in a horizontal position) and stored ready for exposure in a lightproof drying cabinet.

3. Exposing the photo-emulsion to UV light

The dry, coated screen is exposed in contact with a positive to UV light. The opaque areas of the positive will shield the dry photo-emulsion-coated mesh from the UV light. These unexposed areas will remain water-soluble and will wash away when the stencil is developed with water, leaving the mesh open.

The UV light will pass through the glass top of the UV exposure unit, and through the transparent areas of the positive, onto the dried, light-sensitive photo-emulsion. These exposed areas of photo-emulsion undergo a chemical change called crosslinking, which makes the emulsion water-resistant during development.

4. Developing the photo-emulsion

Water is used to develop the coated screen after it has been exposed to UV light. It is applied to the screen with a soft spray-type hose and a sponge. The unexposed areas of photo-emulsion remain water-soluble and wash away. The exposed areas have become water-resistant

and, although still delicate at this stage, they remain in place on the mesh, forming the photostencil. After developing, the screen is dried once again before being prepared for printing.

The Chemistry of Photo-Emulsion

Photo-emulsions consist of a water-based solution containing a polymer which crosslinks with bichromate salts when exposed to UV light. The most common components are polyvinyl acetate (PVA), sensitizer and dispersion agents. More complex photo-emulsions can include synthetic resins, polyacrylates, wetting agents, flow agents, defoamers, plasticizers and dyes.

Dual-cure diazo-photopolymer emulsions are combinations of pre-sensitized ingredients in the emulsion plus a diazo sensitizer. When the photo-emulsion dries on the mesh in the lightproof warm-air drying cabinet, the water evaporates and the remaining particles congregate. The coating is water-soluble at this stage. When the dried photo-emulsion-coated mesh is exposed to UV light, the sensitizer and the photo-reactive resins react with the polymers and make the emulsion water-resistant. The chemical reaction created by UV light causes the components of the emulsion to crosslink. Crosslinking is when one polymer molecule creates a link with the next one, forming a chain. To form a successful photostencil, crosslinking must occur evenly throughout the coating: this is why the sensitizer has to be stirred thoroughly into the emulsion with a clean, non-reactive (plastic) spatula. The process of crosslinking can also be affected by moisture, dust and grease on the mesh, which is why these conditions have to be controlled and contamination minimized in the studio stencil application area. If the photo-emulsion is underexposed, crosslinking will remain incomplete, with the result that the stencil will not be fully resistant to

A photo-emulsion workstation showing a screen-holder, a horizontal lightproof drying cabinet, a vertical drying cabinet and screen storage. This room also contains a UV exposure unit and a screen-developing sink.

water and may break down. In order to create a strong waterproof stencil, exposure must be sufficiently accurate for complete crosslinking to take place.

Developing

After printing, the photostencil is removed from the mesh using a solution of water and sodium meta periodate, which breaks the crosslinked chain and allows the coating to be washed away with water. If even a mist of the decoating solution is allowed to dry on a photostencil, crosslinking will continue further to a stage when the chain can no longer be broken and the photostencil becomes fixed on the mesh.

A useful metaphor for explaining the different stages of crosslinking is to describe the molecules of photo-emulsion when first applied to the mesh as a crowd of people standing close together. The action of the UV light encourages the crowd to link arms. The response of the crowd to the decoating solution is to let each other go. However, the effect of allowing the decoater to dry on the photostencil is equivalent to the crowd linking with one another in armlocks.

Mixing Photo-Emulsion

Dual-cure diazo-photopolymer emulsion is purchased as a container of emulsion with some pre-sensitized ingredients plus a separate bottle of diazo sensitizer. It has a shelf life of around one year, but once the sensitizer has been added the shelf life is reduced. The length of time the mixture will last is affected by the introduction of any contaminants and the temperature at which the emulsion is stored. In warm environments the emulsion will last longer if it is kept cool in a refrigerator. The emulsion should always be purchased in one-litre containers. When five-litre containers are used, it is almost inevitable that the quantity of light, dust and other contaminants introduced into the container will be sufficient to spoil the mixture before it has all been used, making this bulk-buying a false economy. The manufacturer's mixing and safety instructions should be followed. As the system described in this book uses a squeegee for application, this mix should be made a little thicker, with slightly less water added than recommended.

Equipment and materials required

Work in the photo-emulsion application workstation under yellow light (p. 133).

- 1-litre container of photo-emulsion plus sensitizer
- warm water
- particulate respirator
- gloves
- clean, strong, plastic mixing spatula, kept for this purpose only

- designated sponge and basin
- clean, dry rags

Principle: to achieve a homogenous mix.

Method of preparing photo-emulsion
- Wear a particulate respirator, gloves and an apron.
- Add a little warm water to the sensitizer powder in its bottle, leaving space in the bottle for the solution to be agitated. Close the lid tightly and shake thoroughly until no powder can be seen at the bottom of the bottle.
- Add this mixture to the emulsion and stir thoroughly for several minutes with a plastic spatula shaped for stirring.
- If working in yellow or red light, check the emulsion briefly under subdued white light as it will be easier to see if the different coloured components are mixed together properly.
- Wipe the neck and sides of the container with a damp sponge and replace the lid. This will minimize contamination and prevent the container from becoming sealed shut during storage.
- Write the date on the lid with a waterproof marker pen.
- The emulsion now has to de-gas (the gradual surfacing of bubbles caused by stirring) for fifteen minutes before use.

Problem solving
- If the sensitizer is not stirred into the emulsion very thoroughly, the photostencil will be weakened due to incomplete crosslinking during exposure.
- Dust and fluff in the mix, from a dusty studio or from dirty spatulas, will cause fisheyes and pinholes to appear in the photostencil.
- Plastic spatulas must be used, as metal ones will react with chemicals in the photo-emulsion.
- Pinholes in the stencil will be created if the photo-emulsion is applied to the screen immediately after stirring, without allowing time for de-gassing.

Applying Photo-Emulsion to the Mesh
Some manufacturers of photo-emulsion recommend that several coats be applied to both sides of the mesh, and that the coated screen be dried and re-coated in a darkroom to build up an even greater thickness of emulsion. However, the method of photo-emulsion application described below is suitable for fine artists who do not need a stencil with a commercial level of durability as print runs are usually less than two hundred.

This method of coating enables fine art screen-printers to make thin, very sensitive photostencils from a wide selection of materials. As a result artists are able to make successful positives from materials such as pencil drawings on tracing paper, tusches, photocopies and inkjet print-outs. These thin stencils are economic to apply and to remove from the mesh. Although the quality of the print relates to the thickness (EOM) or smoothness (Rz value) of the photo-emulsion coating in the mesh, diazo-photopolymer emulsions deliver such excellent edge definition and mesh structure equalization that manual coating – even by novice screenprinters – will generally produce successful stencils.

Using a squeegee to coat the mesh
A coating trough is the normal tool for the application of photo-emulsions but there are a number of reasons why the more familiar squeegee is a better choice for a fine art screenprinter.
- A squeegee is easy and familiar to handle, and artists quickly understand how different angles will affect the thickness and smoothness of the coating.

- A squeegee allows very thin and smooth stencils to be made.
- The soft blade makes sensitive contact with the mesh, making it easy to deliver exactly the right amount of emulsion.
- The angle is easy to vary, allowing fine control of the thickness of coating.
- There are no sharp edges and the soft blade will not damage the mesh.
- Emulsion is not wasted, as the excess can be lifted off the squeegee with a spatula and returned to the container. The remaining residue is easy to clean from the squeegee.
- Using squeegees for both printing and emulsion application is a sensible economy.
- Aluminium coating troughs may react chemically with some emulsions, resulting in contamination and shortening the shelf-life of the solution.
- The squeegee shown below is the correct length for this width of open area.

1. Positioning a screen in the screen-holder. Note the construction of this piece of equipment.

2. Pouring the photo-emulsion onto the squeegee blade. Note that the emulsion is applied to the flat side of the screen: the permanent margin is clearly visible.

3. The screenprinter has drawn the squeegee nearly to the top of the open area. Note the smooth coating of emulsion and the empty mesh.

4. The screenprinter has made four fills and is now skimming the excess emulsion off the mesh. Note the position of the screenprinter's hands. The excess emulsion which can be seen at the top on the permanent margin will be returned to the container with the soft plastic spatula.

Equipment and materials required for applying photo-emulsion

Work in the clean and dust-free photo-emulsion application workstation, using the equipment and materials provided there (see 'Equipping a Water-Based Screenprinting Studio', pp. 45-50).

● screen-holder with adjustable bar to hold the top edge of the screen so that this is supported a few degrees back from the vertical

● clean, degreased, dry screen

● wooden squeegee with a soft blade

● 1-litre container of dual-cure diazo-photopolymer emulsion and a storage bucket

● designated flexible plastic spatula, basin, sponge and three clean, dry rags

Principle: all the mesh should be evenly and consistently coated with photo-emulsion.

Application method

● Place the dry, dust-free, degreased screen, flat side facing out, on the vertical screen-holder and adjust the bar to hold the top edge of the screen securely.

● Select a squeegee with a soft unchipped blade which is slightly smaller than the open area to be filled. If the screen is large, a smaller and more easily handled squeegee may be used. Clean and dust the squeegee before use.

● Lay out the photo-emulsion container, squeegee, spatula, sponge and basin of warm water and drying cloths on a dust-free recycled PVC sheet or newspaper.

● Facing the screen's flat side, crouch down and position the squeegee in contact with the bottom of the open mesh.

● Pour the emulsion along the length of the blade where it is in contact with the mesh, except for a few centimetres at either end of the blade.

● Allow a little time for the emulsion to level out on the blade before making a gentle contact between the length of the blade and the mesh. Stand up and draw the squeegee steadily up the mesh, distributing the emulsion.

● At the top of the mesh, tip the squeegee back and lift it away from the mesh.

● Use the spatula to return excess emulsion from the squeegee blade to the container. If all the equipment is clean, no contamination of the emulsion will take place. The lid of the container of emulsion should be placed upside down on the container (as it is easier to clean the flat side of the lid) to protect the emulsion from unnecessary exposure to light and air.

● Step back and observe the coating, which should be quite wet and full looking. The aim is to fill the mesh evenly and consistently from bottom to top of the open area. Overfilled or empty areas of mesh can be corrected with a second or third pull. Stencil accuracy is related to the quality of the coating on the mesh which is affected by a number of variables including different mesh types, mesh sizes, room humidity, temperature, squeegee angle, speed of application, thickness of coating and drying procedure. By holding the squeegee in different positions the screenprinter can easily control the evenness and thickness of the coating. The best way to learn how to make a perfect coating is to experiment with different squeegee angles and body movements. Make a mental note of each approach and the coating on the screen, and compare this with the resulting photostencil and print. If possible, observe a skilled screenprinter coating a screen.

● Repeat the process of filling the mesh even if a perfect-looking pull has been made. This is because it is important to ensure that the photo-emulsion has been thoroughly distributed into all the spaces between

the threads. The tiny spaces in fine meshes require particular care. Coarser meshes will require a slightly different coating technique and a larger quantity of photo-emulsion.

● Large screens may have to be filled in sections with as many as six pulls. Stripes may appear where different pulls have overlapped. As long as these areas are not overfilled, overlaps do not create any problems.

● Check for overfilled areas by turning the screen around and examining the printing side of the mesh. The emulsion should look even and matt: shiny thick pools will cause stencil failure. To remedy this, replace the screen securely on the vertical screen-holder with the printing side facing out. Draw the empty squeegee steadily up the mesh, collecting the excess emulsion on the blade.

● Use the spatula to return the excess emulsion from the squeegee to the container, and gather up any excess around the outside of the filled area in the same way.

The squeegee is held vertically and a spatula is used to remove the excess emulsion from it. Note that the mesh needs to be skimmed: the emulsion has to be removed from the squeegee to do this.

● Follow the procedure for drying the photo-emulsion (see pp. 135-6).

● Wipe the container lid with a damp sponge and replace the lid firmly. Wash the outside of the whole container and its bucket, the squeegee, spatula, PVC sheet and gloves with soapy water and a dishwashing brush.

Problem solving

● Pinholes and fisheyes will appear in the photostencil if the working area is dusty. It is important to keep the area clean. A spray bottle of water can be used to spray the air in the area before application to settle any dust.

● Take time and if necessary lift excess emulsion off the blade and mesh with a spatula and start again if the application is going wrong.

● Chips in the squeegee can cause long, vertical, thread-like lines of emulsion reaching from bottom to top to appear.

● Photo-emulsion pooling in the centre of the mesh can be caused by a poorly tensioned mesh, incorrect application technique or a bulging squeegee blade (blade incorrectly bedded in the squeegee handle).

● If the emulsion coating is too thin, it will not bridge the mesh adequately, causing the print to show 'saw-toothing' (the printed edge looks like the teeth of a saw rather than a straight edge). The printing mix may also bleed underneath the stencil, causing the print edge to look soft.

● Prints which appear erratic, having areas which are free of ink or areas which are so full of ink that the print looks smudged, can result from too thick a coating of photo-emulsion. The resulting print 'shoulder' may make filling the open mesh evenly difficult.

● Varied thicknesses of emulsion coating will result in a stencil which deposits ink in different ways on the print, resulting in unwanted tonal or colour shifts.

1. Placing a screen which has just been coated with photo-emulsion in the horizontal drying cabinet. Note the spacing between the shelves.

2. Sliding the screen into the drying cabinet.

3. Closing and securing the cabinet door.

- A top quality emulsion is essential for four-colour process printing and other intricate stencils.
- If photo-emulsion is made up with too much water, or is applied to the full length of the squeegee, it may pour off the end of the blade.
- Pools of emulsion on the other side of the mesh will form if too much pressure is applied to the squeegee.

Photo-Emulsion Drying Procedure

It is important that the mesh coated with photo-emulsion is dried horizontally, with the flat side of the screen facing up. The best results are gained if a lightproof cabinet is used. This should have circulating warm air and an outlet to let damp air escape. A dehumidifier in the studio will also help to dry coated meshes correctly. The screen should be exposed as soon as possible after drying to prevent repeated overheating of the coating, which will make the stencil less effective. If the screen is not to be exposed immediately it should be stored in a lightproof vertical drying cabinet.

Equipment and materials required

- horizontal lightproof screen-drying cabinet positioned near the UV exposure unit

Principle: the removal of all moisture from the photo-emulsion coating.

Method of drying screens

- Place the coated screen flat side up in the lightproof horizontal drying cabinet, below any other screens in the cabinet.
- Make a note on the 'magic slate' attached to the outside of the cabinet to identify ownership of the screen.
- Turn on the electric fan heater to dry the coating.

- Check the coating to determine if it is dry. The screen can be rotated (with the flat side remaining up) to ensure even drying and to speed up the drying time.
- Once the coating is dry, switch off the fan heater. Allow a few minutes for aluminium screen frames to cool before exposure.
- Vertical screen storage which is lightproof, for storing photo-emulsion-coated screens which have been dried but not yet exposed, is useful.

Problem solving

- Water molecules in the emulsion coating will prevent essential crosslinking, resulting in poor resistance to the water-based inks and soapy water used. Only screens which have been dried completely with warm air will expose in the correct way.
- Stencils will take longer to dry if moist air cannot escape from the unit.
- Pale fingertip-sized spots in the dried photo-emulsion coating are sometimes caused by wet screens stored above dripping on the screen below. Degreased or cleaned screens should be dried in a vertical drying cabinet. Any newly coated or wet screens placed in the horizontal cabinet should be positioned below previously coated screens.
- Fisheyes and other imperfections in the photostencil are sometimes caused by dust in the drying cabinet or on the fan.

Exposing the Photo-Emulsion-Coated Screen to UV Light

The dry photo-emulsion-coated screen is positioned with a positive beneath it on a UV exposure unit with a vacuum lid. This machine is designed to create a close contact between the positive and the mesh while a controlled exposure to UV light is made.

The UV light passes through the glass top of the UV exposure unit and through the transparent areas of the positive onto the coated mesh. These exposed areas of photo-emulsion become water-resistant as they undergo a chemical change ('crosslinking', see pp. 129-30). The opaque areas of the positive shield the coated mesh from the UV light. These areas remain water-soluble, washing away when the stencil is developed, leaving the mesh open.

Equipment and materials required

- safe, self-contained UV exposure unit with vacuum lid, located in subdued light near the wash-out unit
- light integrator which measures the units of UV light released
- alternatively, an accurate minute/second timer to measure the length of the UV exposure
- dry photo-emulsion-coated screen
- clean positive made of suitable materials: avoid multi-layered positives
- screen landing pad (a duster folded into a square with its edges masking-taped together and a long cord attached to one corner)
- glass cleaner and cloth

Principle: to create a close contact between the positive and the dry photo-emulsion-coated screen, and expose them to an accurately measured quantity of UV light.

Method

- Switch on the safe light in the unit to illuminate the positive lying on the clear glass surface. Both the positive and the glass should be clean and free of dust, grease and scratches.
- Place the screen landing pad in the front right-hand corner of the glass, with the cord hanging down the front of the unit.

• Take the screen out of the lightproof drying cabinet and place this, printing side up, with its far right corner on the landing pad. The pad will allow the screen to be slid to the back of the unit without damaging the glass surface.

• Using the safe lights, position the screen and the positive in relation to each other so that the image will be easy to print. Some shapes such as long narrow solids are easier to print (with a one-arm) in landscape format, as opposed to portrait format. The image on the positive should read as it is to print ('right-reading'). When the unmarked side of the substrate lies in contact with the glass, the opaque marks are on top, touching the photo-emulsion-coated mesh which will flex around any impasto marks, creating a close contact and an accurate exposure. If the positive is in the wrong-reading' position when an exposure is made, the contact is less close, as the thickness of the substrate separates the marks from the photo-emulsion and an impasto mark is held between the two inflexible surfaces of the glass and the substrate. The light will bend fractionally as it passes the image before striking the emulsion and the photostencil may be marginally less accurate.

If a number of positives are being exposed, they should not overlap as the edges of each positive will expose as a dotted or open line.

• The screen s final position must leave room for the vacuum lid to be closed. Remove the landing pad from beneath the corner of the screen frame by lifting the screen slightly and pulling the end of the cord.

• Check the position of the positives again in relation to the screen and, if all is well, close the lid and switch off the safe lights.

• Switch on the vacuum, which will remove all the air from the unit. This will bring the rubber of the lid, the mesh, the positive and the glass into close contact.

• Set the light integrator to release a measured amount of UV light (this measurement can be judged from the results of previous test strips) and switch on the UV light source. If using a unit without an integrator, the exposure can be measured in seconds and minutes.

• After exposure the UV light and the vacuum pump should be switched off. The screen can be left safely for a few minutes under the lightproof lid while preparations are made for the next stage of the process.

Problem solving

• Saw-toothing, pinholing, poor stencil resistance to ink, image breakdown during printing, difficulties in removing emulsion and haze stains on the mesh may be caused by the under-exposure of the photo-emulsion.

• Scratches on the glass surface will cause the UV light to refract during exposure, and unwanted lines and geometric shapes will appear in the photostencil as a result. These lines are difficult to detect on the stencil by eye, but will print clearly. Screen filler is used before printing to stop these out. However, this is not always possible on complex images such as digital separations or delicate drawings. The use of a landing pad will help

A screenprinter using a landing pad when positioning a dry coated screen over two positives lying on the glass surface of the UV exposure unit. The safe lights are switched on to help with accurate positioning, and the integrator controls can be seen. Note the exposure examples on the wall beside the UV unit.

to prevent screen frames from scratching the glass surface of the UV unit.

- Grease and dust can shield the UV light from the photo-emulsion coating, creating pinholes and fisheyes.
- Multi-layered positives will not produce good results for a number of reasons. The edges of positives tend to expose as lines so collaged layers will create interference if this is not taken into consideration. A good contact between the image and the coated mesh is essential and, as layers build up, parts of the image become further removed from the emulsion, allowing the light to refract which can cause blurring and reduction in clarity. The practice of overlaying two oiled paper photocopies is unsatisfactory: a preferable alternative is to photocopy onto transparent acetate, increasing the contrast. The oil will be absorbed by the flexible rubber cover of the UV unit. This causes serious permanent damage to the lid as the rubber loses its elasticity. In addition absorbed oil will constantly be drawn from the rubber membrane onto degreased meshes by the vacuum. The presence of oil on mesh leads to all the technical problems associated with poor degreasing.

Maintenance

- Glass cleaner and a duster should be stored nearby so that the glass surface can be kept free of dust and grease.
- The UV light bulb of the exposure lamp will need to be replaced occasionally.

Determining exposure times

To get the best results from the exposure equipment, positives and photo-emulsion, a test photostencil can be made using an exposure calculator. The effort taken to make a test, document the results and store the notated prints in a visual aid folder will help to produce successful stencils, and will save time and materials in the future. As the UV bulb ages, the light emitted will become weaker and a new test may need to be made.

Exposure calculators are inexpensive, re-usable tools and are available with instruction booklets from screenprinting companies such as Autotype, Dirasol, Sericol and Ulano. There is detailed information on the Internet when 'exposure calculator' is used as the basis of a web search. Some of these exposure tools have to be manipulated manually whereas others have filters which simulate different exposures.

A filtered exposure calculator is a film supporting a repeated identical image made up of lines and spaces, text and ranges of halftone dots. Generally all but one segment is coated on the back with filters of successively increasing density, which are designed to produce the effect of different exposure times. When a single exposure of the sequence is made, the resulting stencil enables the user to select the particular segment which demonstrates the most accurate exposure, and from this result a calculation can be made to determine the length of the correct exposure.

Once these tests have been carried out, a positive made from different materials and translucent substrates commonly used in the studio can be designed as an exposure test strip. Marks can be made with different materials, which might include pencil, compressed charcoal, roll-on tusche, photocopies or digital printouts. These should be applied to the supporting substrates (which might include tracing paper, smooth PVC or grained sheets). The resulting photostencil may be printed and this print kept for comparison with the positive. This useful reference information can be notated and stored in a visual aid folder.

Double exposures

A photo-emulsion-coated screen may be exposed to the UV light two or more times before the stencil is developed. This procedure is fairly unusual but may be used for experimental work and to break up flat open areas into dots or other patterns. For example, a halftone dot screen or other patterned positive may be exposed to the photo-emulsion-coated mesh before the image positive is exposed. The most suitable length of time for the dot-screen exposure is often double the exposure given to the image.

Post-exposure

The practice of re-exposing the photostencil after drying to strengthen the emulsion provides at most 10% gain in the stencil strength. It is better practice to make good quality positives and a single correct exposure.

Photo-Emulsion Developing Procedure

Water is used to develop the photo-emulsion-coated screen after it has been exposed to UV light. The unexposed areas of dry photo-emulsion remain unchanged and are therefore still water-soluble and wash away easily, leaving the mesh open in the shape of the opaque marks on the positive. The areas of photo-emulsion which have been exposed to UV light are now water-resistant and will not wash away, closing areas of mesh and forming the photostencil.

Equipment and materials required

The screen is developed in the screen preparation and mesh-cleaning workstation (see 'Equipping a Water-Based Screenprinting Studio', pp. 45-50).
- clean, chemical-free, backlit screen wash-out unit
- gloves, eye protection and an apron should be worn

Principle: using water to wash away the shielded, unexposed areas of the photo-emulsion to create the photostencil.

Method

- Lift up the lid of the UV exposure unit and immediately take the screen to the wash-out bay. Leave the positive on the exposure unit until after the stencil has been developed, but glance at the image and take note of any delicate areas of tone or line.
- Taking care not to touch the fragile coating on the mesh, gently wet the screen on both sides with the soft hose.
- The image will start to appear as a slight change in colour, and may look more yellow than the surrounding

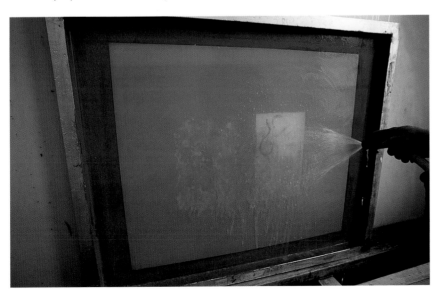

A screen is sprayed lightly with water immediately after exposure to the UV. The purple emulsion residue and the yellow mesh of the newly opened stencil areas can be clearly seen. Note the blue permanent margin and the aluminium frame.

violet exposed areas. This is more noticeable on a mesh that is white.

- As the photo-emulsion was applied on the flat side, it is more fragile and will rub off if this side is touched with fingers or sponge. The flat side should only be wetted with the hose, and if the stencil is delicate extra care should be taken.
- The printing side can be rubbed with a chamois leather, 'S' sponge or Ramer sponge used for this

purpose only. The emulsion will loosen and the image will dissolve and wash away, leaving the mesh open. The dissolved photo-emulsion will run down both sides of the mesh and will need to be rinsed away as even a dilute residue may dry and close the mesh, which may later interfere with printing. Thicker deposits of photo-emulsion, which have not been exposed to sufficient UV light to become fully water-resistant, may create a substantial residue. This will need to be loosened with gentle rubbing before being rinsed away. Once the mesh is clear of residue and all of the image area is open and clean-looking, return to the positive on the exposure unit. By comparing this with the photostencil, it should be possible to ascertain that the stencil has been developed correctly. A pressure hose operated on a light spray, or a garden spray hose, may be used carefully to open up the image a little more.

Robert Adam, *Landfall*, water-based screenprint, 1993 (detail). This image was made using photostencils. Photocopy positives generated from an etching by the artist and text from a book of ballads were combined with a number of positives made using charcoal pencil, and by splattering and sprinkling acrylic paint and ink on True-Grain. It was printed using Lascaux products on BFK Rives paper. Note the technique of printing with closely related colours (a blend) to create the soft colour changes.

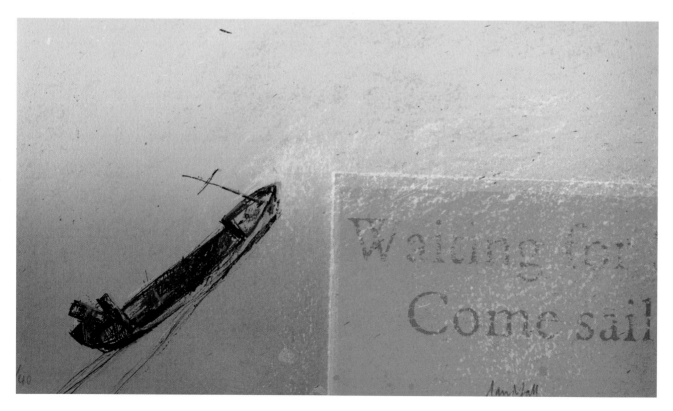

- The developed screen may now be taken into the daylight and dried in a vertical drying cabinet. The positive can be stored carefully. The exposure unit lid should be closed to protect the glass surface from dust.
- When the photostencil is dry, it should be checked on a lightbox and any fisheyes, pinholes or other unwanted open areas can be stopped out with Lascaux Screen Filler before printing.

Problem solving

- Creating a photostencil is a reasonably quick process, so if the result is not satisfactory it is usually better to analyse the problem, make adjustments to the process and start again. Changes may be needed to the coating procedure, exposure time or positive.
- Dust, fluff, air bubbles, splashes of water and grease which come into contact with the mesh at any stage of the process will cause the appearance of fisheyes, pinholes and open lines in the photostencil. These will all require stopping out, so it is better to take steps to avoid these problems. Some images are too complex for successful stopping out, and the process is time-consuming.
- Parts of the stencil may peel away from the mesh due to the presence of grease or because too thick a layer of emulsion has been applied.
- If all the dried photo-emulsion dissolves and washes away, this is usually due to insufficient exposure. Check that the UV bulb is working. If the sensitizer is not stirred into the emulsion thoroughly, the photostencil can fail in a similar way.
- If no areas of photo-emulsion wash away during development, the coated screen may have been exposed to UV light at some other stage of the process. Alternatively the positive may not have been

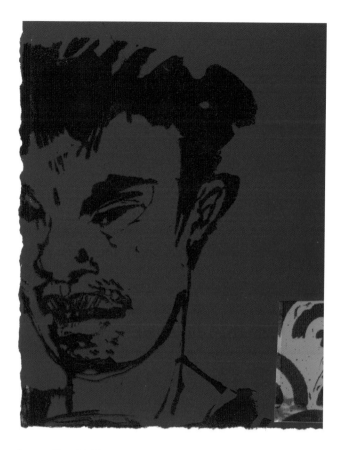

George Donald, *Blossom in Spring*, water-based screenprint, 1994 (detail). Photocopy positives were made from a range of drawn, painted and found elements. The resulting photostencils were printed on a variety of oriental papers, using Lascaux Studio Acrylics, painting aids, and Kremer Orotan and powder pigments. This printed material was then torn and cut up to create collages on which images were again screenprinted. Finally editions were made. This detail is from a print in George Donald's folio *Nine Translations from the Chinese*.

placed beneath the screen on the exposure unit, or the opaque areas of the positive may have allowed light to pass through.

- If areas of photo-emulsion dissolve in shapes unrelated to the image on the positive, this may be caused by the sponge being contaminated with stencil decoater. It is important that the wash-out unit and tools are free of chemicals.

SUBSTRATES

PAPER

Water-based screenprinting mixtures can be used on many types of paper. If an image is screenprinted on a range of different papers, the resulting prints will vary in the intensity of colour and the sharpness of line. For this reason the choice of paper is important.

Paper manufacture

Paper is made from a number of different materials, such as wood, cotton, linen and other vegetable matter, which are broken down into a mass of cellulose fibres. The pattern in which the fibres are laid down during manufacture will affect the way the paper expands during printing with water-based materials. For instance, if the fibres are randomly mixed, as in a handmade paper, expansion will be fairly consistent in every direction. When the fibres are predominantly parallel, as in most machine-made papers, such as cartridge or newsprint, expansion will be more directional. Mouldmade fine art papers fall between these extremes and are the most commonly used for water-based screenprinting.

Sizing and acidity

The extent to which a paper will absorb the printing mix depends on how it has been 'sized'. This refers to the addition of chemicals such as rosin, gelatin, starch, aquapel or polymers at the manufacturing stage. Watercolour paper and other papers which have greater water resistance are known as hard-sized; papers which are more absorbent, or unsized, are called waterleaf. The appearance of layers of printed colour will vary from one type of paper to another and the selection of a paper is a matter of experiment and choice.

Many papers will yellow or decay in time. This can be due to acidity, which can result from sizing with hide glue or alum. Artists who are concerned about the longevity of their work should use papers which are classified as acid-free or pH-neutral, together with Lascaux and Golden water-based screenprinting materials, which are also of archival quality. Most high quality artist's paper is of this standard.

Paper types

Art material shops and specialist paper merchants are able to supply swatches of different printmaking papers, and catalogues are available which provide detailed information. A search on the Internet for 'handmade papers', 'mouldmade papers' or 'printmaking papers' provides useful information from around the world.

Printmaking papers from Italy, France, Germany and England are readily available, and many other European countries have traditions of paper manufacture. A wide variety of papers are made in the Indian sub-continent, Japan and other countries in the Far East.

Papyruses from Egypt and bark papers have textured surfaces but accept water-based mixtures well. Papers which contain leaves, flower petals, silk and feathers can also be used, but sometimes particles can detach from the paper surface and adhere to the screen, thereafter acting like small paper stencils.

Graphic suppliers, art shops and gift shops sell decorative papers, including types which are patterned,

Lindsay Kirk, *Blue and Brown Cabbage Tree*, water-based screenprint, 28 x 23 cm (11 x 9 in.), 1993. Bark printed with Lascaux Studio Acrylic and standard mix.

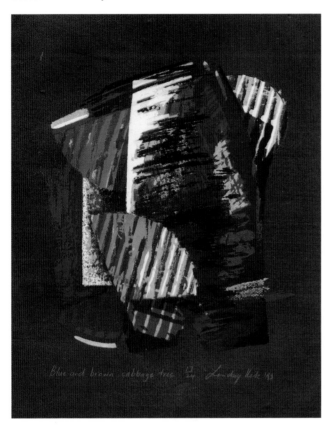

below left George Donald, a screenprinted collage element from a print in the folio *Nine Translations from the Chinese*, 1994. The photocopy positive was generated from found material (a Chinese plastic carrier bag). Printing mixtures made from Lascaux Studio Acrylics and standard mix were printed on both sides of delicate Japanese paper, which was then folded and used in the final printed collage edition.

far right A detail of a water-based screenprinted mark. This was printed with light gold Golden acrylic paint and Lascaux Thickener on black Japanese paper.

metallic, opalescent, gloss-coated and holographic. These papers may be used for screenprinting but are not acid-free, and their colours may be fugitive.

Paper dimensions

Papers are available in rolls or flat sheets. Flat sheets are more suitable for screenprinting and merchants generally stock a range of standard sizes. These vary from one country to another.

As a general rule it is practical to print on sheets of paper which fit easily on the press and on drying racks. The dimensions of the screens and the press bed need not necessarily limit the size of the print. However, large sheets and rolls of paper will have to be printed in sections and are consequently awkward to register. They are also unwieldy to manipulate and easily damaged. The storage and presentation of large prints should also be considered.

Weight

Paper is available in a variety of weights. This is measured in grams per square metre (gsm or gm^2), or in pounds where metric measurement is not used.

At the lightweight end of the scale, delicate Japanese, Chinese and Nepalese papers can be used

successfully for water-based screenprinting. The heavier papers (for example 300 gsm) are more stable and able to accept a greater deposit of water-based ink without warping or buckling. This makes them suitable for use when screenprinting with coarser meshes.

Surface

Smooth papers are classified as hot pressed ('HP'), referring to the process which created the surface. Papers with textured surfaces are called 'ROUGH' and medium-surfaced papers can be labelled 'CP' (cold pressed) or 'NOT' (not hot pressed). Screenprinters using solvent-based inks tend to prefer to work on smooth papers because of the way these inks perform. Screenprinters working with water-based printing mixtures can print effectively on some textured papers using a soft squeegee blade. A medium- or hard-grade squeegee blade will deposit ink only on the top of the textured surface and will not be sufficiently flexible to print into the contours. Extremely textured surfaces, such as canvas and some handmade papers, will require stencils to be held on coarse meshes of 49 T to 70 T (125 T to 180 T in the US). These meshes print a heavier

deposit of printing mix, which will be absorbed by the rough surface.

Deckled edges

Many of these watercolour and printmaking papers have beautiful surfaces and attractive feathered (deckled) edges. Screenprinters using fast-drying solvent-based inks generally prefer to print on papers with a straight, cut edge for speed of registration; for this reason deckled edges were often removed. Water-based screenprinting mixes are easily prevented from drying in the mesh, and therefore more time is available for registering papers with deckled edges. It is also simple to print over the edge of the paper, including the deckle, using a registration sheet (see p. 181). This type of print is known as a bleed print.

Handling

Heavier papers are better able to cope with the considerable handling involved in the printing process. A screenprint with twenty printings will have to be picked up and laid down forty times during the printing process alone. Sheets should always be lifted by

Handling a print correctly, by holding its opposite corners. This should avoid damaging the paper. The printer's chop and colour sequence swatches for this edition are on the press, which is being used as a signing bench. The water-based screenprint is *Trancas Pink* by Barbara Rae.

diagonally opposite corners to distribute the weight equally, and to minimize the risk of denting and creasing. This can be demonstrated by repeatedly lifting and laying down a perfect sheet of cartridge paper, using only one hand. When the paper is examined, half-moon-shaped dents (dinks) can clearly be seen. Any dinks in a print are permanent and will be visible when the print is framed.

Tearing paper

If the editioning paper is to be smaller than a standard sheet, it will need to be reduced in size. It is normal printmaking practice – for aesthetic reasons – to tear down paper rather than cut it. The paper is torn from the back of the sheet, using a steel straight-edge.

Printing on the paper

Many printmakers are concerned about the extent to which water-based screenprinting mixtures will warp or cockle the paper, making registration and presentation a problem. The mixes suggested in 'Printing Mixtures' (pp. 150-70) should not warp the paper when printed correctly. The addition of fast-drying Lascaux Acrylic Transparent Varnish to translucent printing mixes helps prevent cockling and allows numerous colours to be printed in a day. However, the addition of water to the mixture, or using an incorrect printing technique (see 'Printing Techniques' pp. 171-89), will warp or cockle even a heavyweight paper.

Printers making the transition from solvent-based to water-based screenprinting should start by using a fine mesh (120 T, or 305 T in the US) until they are confident with the new methods. Some screenprinters may need to adapt their printing technique and should practise on newsprint until they have overcome any problems. A good paper to learn on is Velin Arches Blanc

A printed piece of paper is torn using a steel straight-edge. The coloured paper was chosen to illustrate this action clearly. Note the position of the artist's hands. Paper should normally be torn from the back (it is easy to make pencilled marks on the back to act as tearing guides). This is in order to simulate a deckled edge, as the surface tends to break up more where the paper is pulled against the straight-edge. The blue (printed) sheet on the left has been torn and cut in different ways to demonstrate this: the left and near edges have been torn from the printed side of the paper; the right edge was torn when the paper was lying face down; and the far edge was cut with a scalpel on a cutting board.

300 gsm, which is 100% cotton, internally sized and buffered with calcium carbonate.

Expansion and contraction of paper due to variations in print-room humidity have always caused registration difficulties for screenprinters. For example, one colour of an image might be printed in the morning when the studio is relatively cool, but when a second colour has to be printed in the afternoon the registration is no longer accurate. This is due to the paper expanding as the studio has heated up and the humidity has altered. Humidity in a studio can be reduced if the screen wash-out area and screen-drying cabinets are kept separate from the printing area, and are vented to the outside. Water should not be left lying overnight in uncovered containers such as basins and buckets. Screenprinters working with finely detailed separations often use

dehumidifiers in their studios. Printing water-based screenprinting mixtures will cause the paper to expand, but when the printed image dries the paper should return to its previous form.

Artists using water-based printing mixtures for the first time may find that printing the entire paper surface with a flat open area before beginning to print the image helps to stabilize the paper. This coating practice can also increase the effectiveness of the press vacuum which holds the substrate in place. Its efficiency is reduced if the material being printed allows air to pass through easily. The network of holes in the press bed through which the air is extracted can create a pattern on very delicate substrates; for this reason certain papers and fabrics should be taped to and supported by a piece of gloss PVC sheet during editioning.

Paper stencils

Paper merchants sell newsprint and acid-free Archivart glassine paper, which is excellent for use as paper stencils (see p. 79).

Proofing paper

Newsprint for proofing varies in its specification. For water-based screenprinting, hard-sized is most suitable. This inexpensive paper is not acid-free and should be kept separate from pH-neutral papers and printed editions.

Tissue

Acid-free tissue should be used for interleaving editions and for packaging when mailing prints in tubes.

Documenting performance

Samples of papers and prints, with notes recording paper type and weight, mesh size, studio temperature, humidity and printing mixture recipe can be kept in a visual aid folder for future reference.

OTHER SUBSTRATES

Water-based printing mixtures can be controlled to print on a variety of different flat substrates.

A water-based screenprint printed on the crossword page of a newspaper. The photostencil was made from a photocopy positive and printed with gold Lascaux Gouache and Thickener.

A detail of a screenprint made from a child's painting of a tiger on smooth PVC sheet. The photostencil was screenprinted on iridescent fabric with metallic Lascaux Studio Acrylics and standard mix.

A detail of a screenprint made from a child's marker pen drawing of a tiger on smooth PVC sheet. The photostencil was screenprinted on unusual fabric with gold Lascaux Gouache and Thickener.

Fabric

These printing mixtures are not suitable for textiles which are to be worn or washed. They can be printed successfully on a range of fabrics used to create installations, paintings, banners and other indoor artworks. Some specialist fabrics have unusual surface qualities which are interesting to print on. All the ingredients of the printing mixes may also be used for painting, enabling multimedia works to be made.

Coarse meshes should be used for printing onto canvas and other roughly textured or open-weave cloth. Silks and fine fabric should be stretched and supported on thin boards for easier printing and drying.

Metals

Most thin sheets of metal are suitable for water-based screenprinting. Any sharp protrusions must be smoothed down or these will rip the mesh during printing. Similarly the edges of the sheet must be filed, sanded and covered by masking tape to protect the mesh. Gloves and steel-toecapped footwear are the recommended safety clothing for working with metal.

Metal surfaces should be thoroughly cleaned and degreased, and finally treated with CPS acidic degreaser before printing. To prevent the metal from oxidizing, it should be polished and degreased, and then painted or screenprinted with a coat of Lascaux Acrylic Transparent Varnish before printing. If the surface of the print is to be strong and scratch-resistant, Lascaux varnish should be added to the printing mix.

Etching plates

In an equivalent to the process of sugarlift in etching, an image can be screenprinted onto a prepared etching plate using Lascaux Screen Painting Fluid. An aquatint (acrylic-resist etching spray aquatint) is then applied over the plate, completely covering the screenprinted image. When the sprayed aquatint is dry, the plate is

above Jenny Hendra, *Moses 1*, etching plate, 23 x 20 cm (9 x 7⅞ in.), 2002. A zinc etching plate, which had been lightly sanded, degreased and dried, was screenprinted with Lascaux Screen Painting Fluid. This is visible as the blue image on the surface.

above right Jenny Hendra, *Moses 2*, collagraph plate, 23 x 20 cm (9 x 7⅞ in.), 2002. A collagraph was made on a lightly sanded, degreased zinc plate. First the plate was airbrushed with Lascaux Aquatint Resist. When this was dry, transparent Lascaux Hard Resist was painted over an area of the plate to create a lighter tone (its smooth dry surface will not hold the ink). The image of the horse and the Moses basket was screenprinted on, using a standard Lascaux screenprinting mixture. The horse was immediately dusted with carborundum powder, but the Moses basket was left untouched. The plate was left to dry before the excess carborundum was shaken off.

right An intaglio print was taken from the collagraph plate illustrated above. The mid-tones are created by the airbrushed resist. The Lascaux Hard Resist brushmarks can now clearly be seen as light tone. The carborundum areas print velvety black and the Moses basket, which was not dusted, is tonally similar to the aquatint and so is indistinct.

A patterned ceramic tile was photocopied on tracing paper to create a positive. This was used to make a photostencil, which was printed on a colour photograph using Lascaux painting aids mixed with gold pigment powder.

soaked in a tray of warm water until the screen painting fluid softens and starts to lift the aquatint in the image areas. As this happens, the metal is exposed in the form of the original screenprinted image and may subsequently be etched.

Collagraphs

Collagraphs are intaglio prints taken from specially designed collages. The marks and textures on a collagraph plate must have a low profile in order to pass through the etching press. The textured areas hold ink and create tone. Artists can incorporate screenprinted marks, including photographic imagery, on collagraph plates by dusting the wet printed image (on the plate) with carborundum powder immediately after printing. Once this is dry, the excess carborundum is shaken from the plate, and the plate is then inked up in intaglio, wiped and printed in the normal way. The carborundum-coated areas print with a dense, velvety appearance.

Plastics, PVC, Perspex (Plexiglas), photographs and laminates

Water-based screenprinting works well on most plastics and PVC sheets, as well as other non-absorbent materials. As an example, smooth clear PVC sheets are printed on for registration as part of the printing system. Some plastics may require degreasing before printing. Alkaline residues must be rinsed away as these may destabilize the screenprinted image. After rinsing, the final degrease should be with an acidic degreaser, which is then washed away.

Different printing mix recipes will perform in different ways. Varnish-rich mixes create durable marks. Dry printing marks on plastic sheets can be removed with a little abrasive household cream cleaner, such as Cif, or soaked for a few minutes with Mr Muscle Bathroom or Mystrol, and then rubbed with a non-abrasive scouring pad.

Installations made using this technique are illustrated on pp. 9, 29 and 199.

PRINTING MIXTURES

PREPARING ARTIST'S PAINTS FOR FINE ART WATER-BASED SCREENPRINTING

Lascaux, Golden and Speedball artist's paints can be used in conjunction with Lascaux painting aids to create a wide range of screenprinting mixtures and effects. The following system is based on the authors' extensive experimentation and professional experience, and differs from the recipes and technical suggestions provided by the manufacturers.

These water-based products are made without solvents, are toxicologically tested and have ASTM D 4236 ('no health labelling required') status. Kremer artist's pigments are also suitable for professional use, and each pigment has its own safety data sheet. An understanding of the normal uses of artist's paints and painting aids is useful, and printmakers should read the product information which is available from manufacturers, or visit the appropriate websites.

Screenprinters can make creative use of the different behaviours and drying times of the wide range of materials. Colours can be matt, satin or glossy, and the range of colours is infinite. Different types of metallic, iridescent and interference colours can be printed through a range of mesh sizes. Opaque colours can be printed to produce a rich, solid deposit. Translucent mixes dry to a pure, clear colour without any chalkiness, and transparent layers dry crystal clear, whether matt or glossy.

The viscosity of the mix can be controlled, which is useful for printing techniques such as blends. The mixtures are thixotropic, which means that as the mixture is moved on the mesh its viscosity is reduced and it becomes more fluid; the mixture thickens when it is still. The addition of Lascaux Acrylic Transparent Varnish to mixtures makes them thinner (similar to the feel of solvent-based inks). Surplus printing mixes can be stored in airtight jars and re-used, even years later.

Drying times on the mesh may be altered to suit both the climatic conditions of the studio and the skill of the printer. To find a mix that is perfect for the conditions of a particular studio, the recipes suggested below can be followed, and these can be slowed down or sped up as required. Until mixes can be made from memory, the ingredients should be weighed (a waterproof marker pen should be used to note the quantities on the storage jar).

 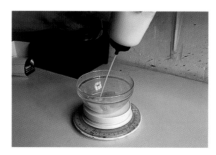

1. Weighing the Lascaux Screenprinting Paste. Note the clean glass surface of the bench.

2. Squirting the Lascaux Acrylic Transparent Varnish into the mixing bowl. Storing varnish in this type of container (a recycled bottle) allows the artist to add controllable quantities.

Selecting a paint from a basic workstation. Note the signs on the shelf below, which locate items of equipment.

This is useful if more of the mixture is required. Sections of the resulting print and notes recording paper type and weight, mesh size, studio temperature, humidity and ink performance can be kept in a visual aid folder. This way of working allows the artist to establish a 'feel' for the process of making a printing mix and, before long, to become proficient at this.

SELECTING AND MIXING COLOUR

If a pre-mixed colour needs to be altered, or a new colour mixed, the following procedure is efficient and economic:

Equipment and materials required
Work at the printing mixture workstation.

- gloves and apron
- scraps of paper or torn-up proofs measuring approximately 10 cm (4 in.) square for palettes (stored in container)
- range of firm acrylic paintbrushes (1 cm/³⁄₈ in.)
- selected colours
- 5-litre tub of Lascaux Screenprinting Paste
- 5-litre container of Lascaux Acrylic Transparent Varnish
- set of scales
- hand-held electric liquidizer or plastic spatulas
- basin of warm soapy water
- sponges and dry cloths
- household dishwashing liquid
- clean storage jars with lids
- waterproof marker pen for labels
- gumstrip tape

Method
- Look for a colour close to the desired colour in the printing mix storage area. If one appears to be suitable, it can be tested by spreading a little out with a brush on a scrap of paper or on a proof, simulating as far as possible the deposit that a particular mesh will make.
- Consult the appropriate recipe (see below), depending on which type of paint is being used and whether the printing mix is to be opaque, translucent, shiny, matt, etc.
- Lay four pieces of paper on the clean bench.

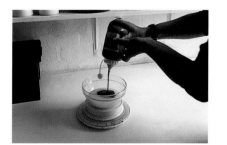

3. Adding and weighing blue Lascaux Gouache to the printing mixture in the bowl.

4. Stirring the mix vigorously with a clean plastic spatula.

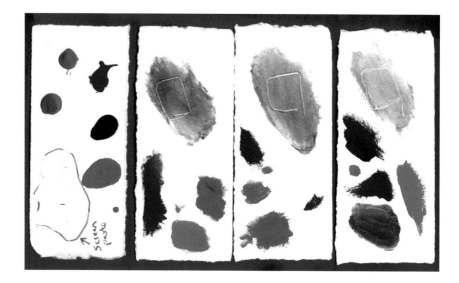

On the left is a paper palette with some Lascaux Screenprinting Paste and five spots of paint. Colours and paste from this palette were transferred to the other three palettes in order to work out colour mixtures. The spots of colour next to the mixed colour have been placed there as a reminder of the individual components in that colour. Note how clean the reservoir palette remains even after several test palettes have been made.

- Choose the larger scrap of paper, if applicable, to become the main palette. On this piece of paper spoon a small amount of Lascaux Screenprinting Paste. Squeeze dots of the selected colours around it, with spaces between them to prevent them mixing. This practice has the additional benefit that any dried paint in and around the paint bottle nozzle is forced out onto the paper, where it can be discarded. (If this dried ink finds its way into the printing mix, it will break up into countless tiny specks which print or can block the mesh.)
- Use gloved fingers or select a brush for each colour, and one for the paste.
- Take a clean scrap of paper, mix a little Lascaux Screenprinting Paste with some of the paints from the palette to find the correct colour. (The colours dry too quickly to mix together easily, which is why paste is an important component.)
- Repeat this procedure on fresh scraps of paper until the correct colour is blended. An advantage of this system is that it allows freedom to experiment with colour, as each little palette is quick and inexpensive to make, and disposable. Another benefit is that the artist has to consider how each layer of colour will interact,

and this method makes it possible to test potential colour combinations. In this way, time-consuming colour errors can be avoided.
- The colour should be tested for opacity on a proof, and also tested on a scrap of the editioning paper. Most paints alter slightly when they dry, making this method of working very accurate.
- When a correct colour has been decided on, the bench, brushes and gloves should be cleaned and dried. Bottles of colour which are not needed should be wiped, the nozzle caps firmly replaced and the containers returned to their shelves. Unwanted palettes should be discarded.
- Four new scraps of paper should be laid out on the bench. One of these should be laid out as a fresh palette with the constituent colours for the mix, together with some screenprinting paste.
- The selected colour should be remixed a few times on separate scraps of paper, with a mental note made of the approximate proportions of the component colours. If the colour is difficult to recapture, it is possible that some contamination has occurred, and it is best to start the process again.

- Following the basis of the main recipes (some will require as little as 2 gm of colour) and using the established proportions of colour, a bowl of the printing mixture can now be mixed. Add the colour cautiously, stirring and testing the mixture frequently on paper. When the colour matches the swatch, the mix is ready. As the colour is added, a running total of the weight should be noted.
- Draw the outline of the selected area of colour using the handle of a brush.

A BASIC PRINTING MIXTURE PREPARATION WORKSTATION

A well-designed workstation with teaching aids will make mixing paints a simple, economic and pleasant procedure. In educational systems this process can be related closely to painting and colour theory. In busy shared studios a selected basic system should be provided at the workstation to help avoid confusion, together with a visual aid folder of basic ink recipes.

A simple system can be based around Lascaux Gouaches, as these paints are uncomplicated to print with. The mixtures are easy to wash from the mesh, even

This paint preparation workstation uses both the Lascaux Sirius Primary System and Lascaux Gouaches.

when allowed to dry. Opaque colours are made by mixing Lascaux Gouache and a little Lascaux Thickener in a bowl, and then screenprinting in the normal way. If necessary, a little Lascaux Retarder may be used to slow down the drying speed of the printing mixture. Teachers in schools may wish to make up a quantity of standard transparent printing mix, to which students may add small amounts of gouache to create translucent colours. When the system is established, other suggested paints may be added to it.

Equipment and materials

The lowest shelf should hold:
- a set of easy-to-read weighing scales
- Pyrex (sturdy glass) mixing bowls
- a bottle of household dishwashing liquid
- some hooks for flexible plastic catering spatulas and other soft spoons
- a box containing scraps of editioning paper on which to make and test colour
- a jar of up to six firm acrylic paintbrushes (1 cm/ $^3/_8$ in. wide)
- a container of standard transparent printing mix, labelled 'Transparent printing mix', or Lascaux Screenprinting Paste, labelled 'Screenpaste (slow drying, 30% maximum)'
- 5-litre containers of Lascaux Acrylic Transparent Varnishes, labelled 'Gloss Varnish (fast drying)' and 'Matt Varnish (fast drying)'

Another shelf should hold:
- 500-ml bottles of Lascaux Gouache

A staff cupboard should contain:
- 1-litre bottle of Lascaux Thickener, labelled 'For opaque colours only'

Surplus printing mixes are added to the plastic container storing the most similar colour. This mixture is then stirred, the neck of the jar sponged clean and the container returned to the shelf for future use.

- 1-litre bottle of Lascaux Retarder
- a supply of clean plastic containers (available from wholesalers: many schools do not permit storage in glass containers)

A sink nearby with running hot water should be provided with:
- rectangular plastic dishwashing basins
- densely formulated sponges ('S' type or Ramer are suitable)
- Mystrol or similar household cleaner
- non-abrasive cleaning pads

Using a waterproof marker pen to identify equipment storage locations, and adding extra labelling to containers, will help screenprinters become confident and familiar with the system.

500-ml bottles of Lascaux Gouache and Studio Acrylic colours are an ideal size for general use and the colour can be squeezed out without contaminating the rest of the paint. Lascaux Decora and Lascaux Artist's Acrylic

bottles are slightly taller. Golden and Speedball paints are packaged in a variety of sizes of tub, requiring clean plastic spatulas to dispense the paint.

A PROFESSIONAL PRINTING MIXTURE PREPARATION WORKSTATION

A well-designed workstation with a good range of shelves and an easy-to-clean, white-surfaced bench covered with PVC or hardened glass will make the process of making printing mixtures for screenprinting simple and accurate. Screenprinters using this water-based system can choose to work with the best quality artist's materials, which are available in a comprehensive range of professional quality colours and archival quality painting aids. The colours are manufactured to consistent specifications and are completely reliable. Hand-painted colour swatches are available from Lascaux and Golden, and these can be held for accurate reference if full colour ranges cannot be purchased immediately. If the paints are stored and used correctly, they will have a very long shelf-life, so most studios will be able to build up a wide range of colours over the years. The use of painting aids allows the screenprinter to adapt mixes to facilitate printing and to alter the surface of the print.

The use of precise digital scales allows colour mixes to be recreated easily and quickly by any member of staff, which is cost-effective in publishing studios where time is at a premium.

Equipment and materials
The lowest shelf should hold:
- a set of easy-to-read, accurate digital weighing scales

- calibrated glass jugs
- some hooks for flexible plastic catering spatulas and other soft spoons
- scraps of editioning paper and proofs on which to make and test colour
- household dishwashing liquid
- a jar of up to six firm acrylic paintbrushes (1 cm/ $^3/_8$ in. wide)
- 5-litre container of Lascaux Screenprinting Paste
- three 5-litre containers of Lascaux Acrylic Transparent Varnish 575 (one container each of gloss, satin and matt)
- 1-litre container of Lascaux Thickener
- 1-litre container of Lascaux Retarder
- 1-litre Lascaux Impasto Gel gloss
- 1-litre Lascaux Impasto Gel matt
- 1-litre Lascaux Structura
- 1-litre Lascaux D496 Medium
- a hand-held electric liquidizer

A professional collaborative editioning studio.

- a particulate respirator for working with powder pigments (stored in an airtight container, such as a recycled Lascaux Screenprinting Paste bucket)
- several ceramic dishes for holding spoons and for mixing up small amounts of printing mixture

Shelves above should hold a range of:
- Lascaux Studio Acrylic - Artist's Acrylic Colours
- Lascaux Gouache
- Lascaux Decora
- Lascaux Sirius Primary System (watercolour)
- metallic pigment powders
- Lascaux Aquacryl
- Lascaux Resonance Gouache
- Lascaux Artist's Acrylic - Artist's Acrylic Colours
- Lascaux Studio Bronze (metallic acrylic colours)
- Lascaux Silver and Gold Gouaches
- Lascaux Perlacryl
- Golden Silkscreen Medium
- Golden Acrylics (artist's paints)
- Golden Metallic Acrylics

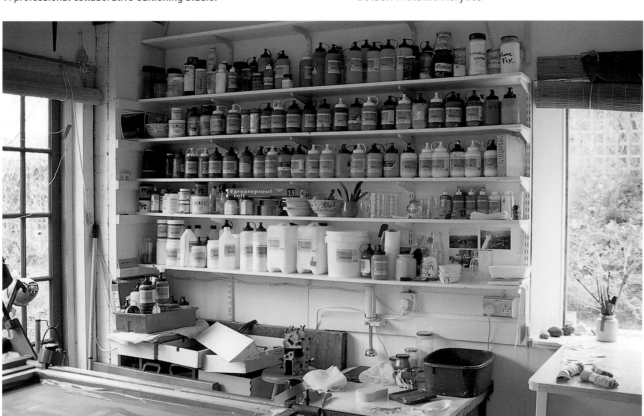

- Golden Airbrush Colours
- Golden Fluid Acrylics
- Golden Retarder
- Kremer powder pigments
- Kremer Orotan
- Kremer Organic Pigment Pastes
- Speedball process colours

- A sink with running hot water should be nearby
- Storage is required for rectangular plastic dishwashing basins, densely formulated sponges ('S' type or Ramer are suitable), Mystrol or similar household cleaner, rags and non-abrasive cleaning pads
- Shelving is required to store a variety of different-sized recycled glass or plastic jars (with lids) to accommodate stored printing mixtures.

W. Barns-Graham, *Millennium Series (Red)*, water-based screenprint, 24 x 31 cm (9½ x 12¼ in.), edition of 75, 2000. The opaque marks in this image were screenprinted with Lascaux Gouache mixed with a little Lascaux Thickener. The artist painted the positives using Golden acrylics to make opaque marks on True-Grain.

OPAQUE PRINTING MIXTURES

An opaque colour layer will obscure the printed marks beneath it. Some paints will dry to create velvety matt surfaces, while others will dry to a glossy, plastic-looking

layer. Coarse meshes deposit a thicker layer of printing mix than fine meshes, therefore these meshes are more suitable for printing opaque layers.

Opaque colours may play an important part in the design of an image, and some screenprints are entirely made up of opaque elements. Opaque layers can be used to alter an image radically or to disguise an error. For example, when an image has a very dark background, opaque white can be printed onto all the areas which are destined to be printed with bright colours. When the white layer is dry, translucent drifts of the bright colours can be printed across the image, covering both the dark and the white areas. The white areas become coloured, fresh-looking and luminous, and the drifts of colour subtly enrich and darken the background.

Paints and Recipes for Opaque Printing Mixtures

Screenprinters can make use of the natural opacity of certain paints and these should be selected for this type of screenprinting. Lascaux Gouache, Resonance and Decora are suitable. Other paints such as Lascaux Studio Acrylics, Lascaux Artist's Acrylics and Golden acrylic paints can be printed very densely if combined with a small quantity of Lascaux Thickener or Retarder.

Lascaux Gouache

Lascaux Gouache (31 hues) can be overpainted without dissolving and intermixing with previous layers. The colours are intense, brilliant and lightfast, and can be printed directly from the bottle.

Method

Work at the printing mixture workstation.
- Work out the colour as explained in 'Selecting and Mixing Colour' (see pp. 151-3).

- Weigh the Lascaux Gouache paints in a mixing bowl (the mix might weigh 10 to 500 gm), add 2 gm of Lascaux Thickener and stir vigorously. If the gouache does not thicken add another 2 gm, and so on. Adding this small amount will make the mixture less fluid and its printing performance will be improved. Excessive quantities of thickener will slow down the drying rate of the printing mix on the paper.
- If the mix is too fast-drying in the mesh, add a few drops of Lascaux Retarder.
- Dried mixture can be washed easily from the mesh with soapy water.

Lascaux Resonance Gouache

Lascaux Resonance Gouache (28 hues) is physiologically and toxicologically harmless. These aromatic paints are composed of an age-resistant synthetic binder, bioinformation, oil of sage and pure lightfast pigments.

Method

Work at the printing mixture workstation.
- Work out the colour as explained in 'Selecting and Mixing Colour' (see pp. 151-3).
- This gouache paint can be lifted from the container using a soft plastic spatula and can then be stirred in a small dish before being applied to the mesh and printed in the normal way. This paint can form a skin in the container.
- If the mix is too fast-drying in the mesh, add a few drops of Lascaux Retarder.
- Dried mixture can be washed easily from the mesh with soapy water.

Lascaux Decora

A slightly diluted economy alternative to the highly concentrated Lascaux Gouache (29 hues).

Method

Work at the printing mixture workstation.

● Work out the colour as explained in 'Selecting and Mixing Colour' (see pp. 151-3).

● Weigh the Lascaux Decora paints in a mixing bowl (the mix might weigh 10 to 500 gm), add 4 gm of Lascaux Thickener and stir. If this does not thicken the gouache, add another 4 gm, and so on. Large quantities of thickener will slow down the drying rate of the printing mix on the paper. The gouache can be printed on its own, but it is a little too fluid and the addition of some thickener makes it easier to print with.

● If the mix is too fast-drying in the mesh, add a few drops of Lascaux Retarder.

● Dried mixture can be washed easily from the mesh with soapy water.

Lascaux Studio Acrylics

Lascaux Studio Acrylic paints (36 hues) are formulated for high covering power, and have uniform luminosity

Barbara Rae, *Kilberry*, water-based screenprint, 56 x 76 cm (22 x 30 in.), edition of 40, 2002. The artist painted smooth PVC sheet using Lascaux Tusches to make a group of positives for this image. It was screenprinted on Fabriano Uno paper using a range of Lascaux paints and painting aids. Golden materials were used in combination with Lascaux Thickener. Kremer pearlescent and metallic pigments were also used.

and very good lightfastness. These paints are fast-drying and become waterproof when dry. For this reason care should be taken when screenprinting with opaque mixtures as dried acrylic paints cannot be removed from the mesh. Printing mixtures must include Lascaux Thickener and Retarder.

Method

Work at the printing mixture workstation.

● Work out the colour as explained in 'Selecting and Mixing Colour' (see pp. 151-3).

● Weigh the Lascaux Studio Acrylic paints in a mixing bowl (the mix might weigh 10 to 500 gm), add 4 gm of Lascaux Thickener and stir. If this does not thicken the paint, add another 4 gm, and so on. (The addition of Lascaux Thickener and Retarder is critical in this recipe, as it is required not just to thicken the acrylic paints, but also to slow down the drying time on the mesh.)

● Lascaux Retarder must be added to slow down the drying time (2 to 40 drops).

● Stir the mixture well in a bowl before application. This will avoid pockets of acrylic drying in the mesh.

Looking at the left section of *Kilberry* from a shallow angle, it is clear that most of these printed layers reflect light to a greater or lesser extent. Only the grey sky and the velvety purple black are behaving differently and absorbing the light.

The lower left corner of *Kilberry* showing (in order of layer) translucent pink, translucent turquoise, opaque silver, velvety purple black, satin black and gloss black.

Lascaux Artist's Acrylics

Lascaux Artist's Acrylic paints (46 hues) meet the most demanding artist requirements as they have excellent lightfastness, exceptional brilliance, intensity and depth of colour. Some colours in the Lascaux Artist's Acrylic range are translucent (these are labelled) and are not suitable for opaque layers.

The lower right corner of *Kilberry* showing (in order of layer) translucent turquoise, darker translucent turquoise, translucent yellow, translucent pink, opaque silver, opaque turquoise, translucent silvers, velvety purple black and shiny gloss black.

Method

Follow the method for Lascaux Studio Acrylics.

TRANSLUCENT PRINTING MIXTURES

The word translucent is defined as 'allowing light to pass through partially or diffusely', or 'semi-transparent'. Translucent printing layers are important in screenprinting as they enable complex colour and tonal structures to be assembled rapidly. Richly pigmented artist's paints are particularly suited to this way of working as they can be used to create pure, clear colour layers: often as little as a single gram will be sufficient to colour a substantial amount (e.g. a litre) of printing mix.

By printing layers of colours (such as cyan blue, ultramarine blue, red, magenta and yellow) so that they interact in a planned way, many additional tones and colours (including shades of light blues, deep blues, violets, purples, carmines, reds, oranges, greens and browns) can be created in few printed layers.

The density of the layers creates additional tone, so a brown which is made up of all the layers of colour will have a darker tone than the ultramarine blue which consists of a single layer printed on white paper. If these colours and tones were to be created using opaque layers, a screen would need to be prepared and printed for each of the shades and various colours.

Translucent colours can be rich and vibrant, but still allow the marks or colours below to interact. As each layer of translucent colour also makes the layer below more intense, the colours printed often have to be paler than might be expected. For example, an animated red (very different from a flat printing of opaque red) can be built up by printing several layers of a pink-looking mix (a few grams of a selected red added to a transparent printing mixture) through different textured stencils.

When an image has a colour balance problem, a printmaking technique which may help overcome this is to print a flat translucent layer of Bordeaux red over the image. Layers of translucent white can also be used to lighten and soften selected areas.

Bases for translucent printing mixtures

A range of translucent artist's materials can be used as a base in which colour can be suspended to make a coloured printing mixture. For example, if a litre of printing mix contains only 2 gm of colour, the other ingredients must be selected to print well and not alter the colour in any way.

The drying time of the printing mixture can be controlled by varying the base components and their proportions. A fast-drying mixture is used if many layers are to be printed in a single day. A slow-drying printing mix is useful if the process of registration is lengthy, as the mix will not dry in the mesh. Slow-drying mixes are also useful in hot, dry studio environments and will enable a novice screenprinter to print accurately.

Artist's painting aids and varnishes are used for these purposes. An understanding of the characteristics of painting aids and varnishes used in these printing mixes will help the screenprinter control both the handling of the mix on the screen and the surface quality of the print. Information about these materials is available from manufacturers' literature and websites.

The main painting aids needed for screenprinting are Lascaux Screenprinting Paste, Acrylic Transparent Varnish 575 (gloss, satin and matt), Thickener and Retarder. Lascaux Screenprinting Paste has been specially designed for adding to artist's colours so that these paints can be screenprinted. The other products have been developed for painters but are ideal for screenprinting mixtures.

Lascaux also manufacture a number of other products with which experienced screenprinters can experiment. These include Mediums (gloss, satin and matt), Modelling Pastes (A and B), Structura, Gesso, Uni-primer, Impasto Gel (gloss and matt), Matting Agent, Acryl Emulsion D 498-M and Acrylic Transparent Varnish 575-UV (gloss and matt). These products are labelled ASTM D 4236 'No health labelling required'.

An actual leaf was photocopied onto acetate and the photostencil of this was printed with three different turquoise translucent mixes. The printing mix with the greatest quantity of turquoise added looks almost black on this paper (which had been dyed previously with Kremer Organic Pigment Paste diluted in water).

above Three different printing mixtures have been screenprinted to build up this image. The two paler mixtures work together harmoniously. However, the single printing of the mixture with the most turquoise paint stands out tonally from the others.

below A repeat printing of the leaf, using a turquoise printing mix, shows that although strongly pigmented the mixture is not opaque.

Golden manufacture a useful range of painting aids, including silkscreen medium, mediums, varnishes and retarder. These fast-drying products should be used in conjunction with Lascaux Thickener, which gives the mixtures more body and slows down the drying time on the screen. As all these painting aids have different behaviours, the drying time and surface quality of the mix can be controlled to suit the printer's skill or the image.

Recipe for standard translucent printing mixture
This recipe can be altered to suit registration requirements, studio climatic conditions, the printer's

skill, the complexity of the image, the type of paint and the percentage of colour in the mix.

As a working rule, the ratio of screenpaste to varnish and pigments should be approximately 1 part screenpaste to 3 parts varnish + paint.

For example, a pale tint would be made as follows:
- 200 gm Lascaux Screenprinting Paste
- 600 gm Lascaux Acrylic Transparent Varnish (gloss, satin or matt)
- 2 gm of selected Lascaux, Golden or Speedball paints, or Kremer fine powder pigments, or Kremer Organic pigment pastes.

A rich translucent colour would be made as follows:
- 200 gm Lascaux Screenprinting Paste
- 400 gm Lascaux Acrylic Transparent Varnish (gloss, satin or matt)
- 200 gm of selected Lascaux, Golden or Speedball paints, or Kremer fine powder pigments, or Kremer organic pigment pastes.

- Lascaux Screenprinting Paste will slow the rate of drying in the mesh and will make printing controllable. An excess will make the mixture sticky, and the prints may warp and be slow to dry.
- Lascaux Acrylic Transparent Varnishes are very versatile and make excellent printing bases as they are not sticky, allowing the mesh to snap back cleanly from the substrate. The varnishes accelerate the drying time on the mesh and on the paper, and reduce the risk of the paper cockling. They store well, are very pure and do not make the colour cloudy, chalky or dirty-looking. Since they are fast-drying, they need to be mixed with slow-drying paste or thickener.
- The paints have a similar drying time to the varnish.

Equipment and materials required
Work at the printing mixture workstation, and follow the procedure for the type of paint and density of colour required.

Principle: to make a coloured printing mixture which will interact with the colours below and, with subsequent printings, create a wider range of colour and tone.

Method
- Select the type of paint, and follow the recipes given in 'Paints and Recipes for Translucent Printing Mixtures' (pp. 163-5)
- Follow the procedure described in 'Selecting and Mixing Colour' (pp. 151-3).
- Estimate how much mixture will be required, allowing sufficient for the squeegee to operate on the screen (there may well be a surplus of printing mix after editioning).
- Place the mixing bowl on the scales so that the ingredients can be weighed. Add the paste, varnish and paint, and mix these together thoroughly with a plastic spatula.
- Make a note of the proportions in the mixture.

Proofing the mix
If the mix is too fast-drying, the mesh will block and the proofs will look as though parts of the image are missing or fading. This can be remedied simply by lifting the printing mixture back into the mixing bowl and wetting the mesh with a slightly soapy sponge and water. Some paste can be added to the printing mix (and a note made of its weight). The new mixture should be stirred and then proofed at least five times on newsprint to shed the wet soapy mixture in the mesh and to check that the altered mix is printing well. If printing is still difficult, lift the printing mixture back into the mixing bowl, add

some Lascaux Retarder and proof again. Repeat this procedure until the stencil is printing correctly. If there are still problems, see 'Printing Techniques' (pp. 171-89).

- Store the excess printing mix in a container with a lid.
- Use a waterproof marker pen to note the proportions of the ingredients on the storage jar or on a gumstrip label.

Paints and Recipes
for Translucent Printing Mixtures

All Lascaux paints, Golden acrylic paints, Kremer fine powder pigments and Kremer organic pigment pastes make excellent translucent colours when mixed with the standard printing mix. Some paints are translucent by their nature. These include Lascaux Sirius Primary System (watercolour), Aquacryl, Kremer Organic Pigment Paste, Golden Airbrush Acrylic and Golden Fluid Acrylics.

These paints can be added to the standard mix recipe to make translucent printing mixtures. Printing mixes which include Studio Bronze metallic colours should be printed through a coarse mesh for best results.

Lascaux Sirius Primary System

Lascaux Sirius Primary System (watercolour) is suitable for screenprinting and can be used as part of an educational programme based around colour theory. The Lascaux Sirius Primary System is a unique balanced colour concept based on five primaries (magenta, red, yellow, cyan and ultramarine) rather than three. The set also includes black and white, which can be used to alter combinations of these colours. The colours are high quality and dry to a velvety-matt, water-soluble finish. These products are labelled ASTM D 4236 'No health labelling required'.

Ruth Pelzer-Montada, *Untitled* from the folio *Underwired*, water-based screenprint, 1995 (detail). Positives were drawn with conté crayon on grained film which was moistened with spray window-cleaner. Other dry drawings were made on tracing paper. The resulting photostencils were freely registered and printed using pale, translucent mixtures (tints). These were made from Lascaux Studio Acrylic colours mixed with the standard printing mix. Other examples of images constructed using these recipes and translucent layers are Victoria Crowe's *While in Venice* (see pp. 111-15) and the images made using horse-shaped PVC stencils (see pp. 82-4).

Making a dense translucent printing mix using Lascaux Sirius Primary System

Work at the printing mixture workstation.

- Work out the colour as explained in 'Selecting and Mixing Colour' (pp. 151-3).
- These paints are quite liquid, fast-drying and very translucent, so a little Lascaux Thickener is added to thicken the paint and slow down its drying time, making it suitable for screenprinting. (The method for adding Lascaux Thickener is as follows: add 4 gm of

thickener and stir vigorously. If the paint does not thicken, add another 4 gm, and so on. The mixture will become less fluid as it is stirred. Excessive quantities of thickener will slow down the drying rate of the printing mix on the paper.)

- A few drops of Lascaux Retarder may be added if the mix is drying too quickly in the mesh.

Method of making a pale translucent printing mix (tint) using Lascaux Sirius Primary System

Work at the printing mixture workstation.

- Work out the colour as explained in 'Selecting and Mixing Colour' (pp. 151-3).

Barbara Rae, *Hill Fort*, water-based screenprint, 76 cm (30 in.) in diameter, edition of 40, 1998. The positives for this screenprint were painted using Lascaux Tusches on smooth PVC sheet. The resulting photostencils were printed in many rich translucent colours and one opaque white printing. Lascaux Gouache, Studio Acrylics and standard mix were used. The paper was torn down into a circle before printing and was accurately registered using the PVC sheet method. Waterproof marker pen lines were drawn on the press bed to locate key points at the circumference of the image.

- For a tint, add a tiny drop of paint to the standard printing mix.
- Stir the mixture well in a bowl before printing.
- A few drops of Lascaux Retarder may be added if the mix is drying too quickly in the mesh.

Speedball process colours

Speedball process colours (cyan, magenta, yellow and black) are necessary for printing four-colour separations.

Method

Work at the professional printing mixture workstation.

- Refer to the section 'Colour Separation and Process Printing', pp. 126-8.
- Use accurate digital weighing scales to measure out the colours and other components for the printing mix, so that the colour balance of the image can be carefully controlled.
- The standard mix is usually appropriate for this type of printing mixture (see 'Recipe for standard translucent printing mixture', pp. 161-3).
- Stir the mixture thoroughly in a bowl before printing.
- Lascaux Sirius Primary System can be used for experimental colour separation printing.

Kremer Organic Pigment Pastes

These are solutions of pure, unmixed pigments in water with glycol derivatives and preservative. The colours are extremely dense, staining and powerful.

Method

Work at the professional printing mixture workstation.

- Suitable for professional printmakers requiring rich translucent colours. Wear gloves and work carefully as the colours will stain hands, worktops and spatulas.

- Work out the colour as explained in 'Selecting and Mixing Colour' (pp. 151-3).
- Add a tiny amount of the organic pigment paste to the standard mix (see 'Recipe for standard translucent printing mixture', pp. 161-3).
- Stir the mixture well in a bowl before printing.
- Note that these powerful pigments may stain the mesh.

Golden Airbrush Acrylics

These high quality colours are made with 100% acrylic polymer and lightfast pigments, and are available in around 30 hues. The paints are labelled ASTM D 4236 'No health labelling required'.

Method

Work at the professional printing mixture workstation.
- Suitable for professional printmakers requiring translucent colours.
- Work out the colour as explained in 'Selecting and Mixing Colour' (pp. 151-3).
- These are fast-drying and can stain the mesh.
- To create a tint, the paints may be used in conjunction with the standard printing mixture (see 'Recipe for standard translucent printing mixture', pp. 161-3).
- For a richer colour, the paints should be combined with Lascaux Thickener to thicken the paint and slow down its drying time. (The method for adding Lascaux Thickener is as follows: add 4 gm of thickener and stir vigorously. If the paint does not thicken, add another 4 gm, and so on. The mixture will become less fluid as it is stirred. Excessive quantities of thickener will slow down the drying rate of the printing mix on the paper.) Lascaux Retarder may be added as required to slow down the drying time further.
- Stir the mixture well in a bowl before printing.

Golden Fluid Acrylics

These paints have strong colours, a thin consistency and a glossy appearance, and they are available in around 40 hues. They are labelled ASTM D 4236 'No health labelling required'.

Method

Work at the professional printing mixture workstation.
- Suitable for professional printmakers requiring glossy translucent colours.
- Work out the colour as explained in 'Selecting and Mixing Colour' (pp. 151-3).
- These are fast-drying and can stain the mesh.
- To create a tint, the paints may be used in conjunction with the standard printing mixture (see 'Recipe for standard translucent printing mixture', pp. 161-3).
- For a richer, glossy colour, the paints should be combined with Lascaux Thickener to thicken the paint and slow down its drying time. (The method for adding Lascaux Thickener is as follows: add 4 gm of thickener and stir vigorously. If the paint does not thicken, add another 4 gm, and so on. The mixture will become less fluid as it is stirred. Excessive quantities of thickener will slow down the drying rate of the printing mix on the paper.) Lascaux Retarder may be added as required to slow down the drying time further.
- Stir the mixture well in a bowl before printing.

TRANSPARENT PRINTING MIXTURES AND RECIPES

Transparent is defined as 'clear' or 'permitting the uninterrupted passage of light'. Transparent, colourless printing mixes are useful for glazing and monoprinting techniques. Gloss, satin or matt mixtures can be made

and printed to seal or alter the surface quality of the print, or selected parts of it.

Materials and equipment required

Work in the printing mixture preparation workstation, using painting aids or varnishes which will dry clear.

Principle: to make a clear printing mixture (gloss, satin or matt) that will allow the layers below to be seen without any unwanted chalkiness, cloudiness or muddying of colours.

Recipe and method for a standard glaze

• Follow the recipe for standard translucent printing mixture (see pp. 161-3) but omit the colour. Although this mixture appears white, it will dry clear.
• Print as normal, ensuring that all equipment is very clean.
• The recipe may be altered by varying the proportions to suit the printer's level of skill, different climatic conditions or the complexity of the print. Lascaux Retarder can be used to slow down the drying time.

Recipe and method for a gloss transparent printing mixture

• 200 gm Lascaux Impasto Gel gloss
• 30 gm Lascaux Retarder
• 50 gm Lascaux Acrylic Transparent Varnish gloss

Follow method for a standard glaze.

Experienced printmakers can experiment with Golden gloss Mediums and Varnishes (non-toxic type), which may be used in conjunction with Lascaux Thickener to create glossy printing mixes. These painting aids are too liquid and fast-drying for screenprinting, so Lascaux

An artist is monoprinting by painting with a transparent printing mix (standard glaze) on an empty, i.e. unfilled, photostencil. This painted mark will fill the mesh where the brush has deposited the mix. The rest of the mesh is then filled with blue printing mix using the squeegee. The filled mesh, which contains both the transparent mix and the blue mix, is then printed.

Thickener is added to thicken and slow down the drying time. (The method for adding Lascaux Thickener is as follows: mix in a bowl, add 4 gm of thickener to the painting aid and stir vigorously. If the mix does not thicken, add another 4 gm, and so on. The mixture will become less fluid as it is stirred. Excessive quantities of thickener will slow down the drying rate of the printing mix on the paper.)

GOLDEN PRINTING MIXTURES AND RECIPES

Professional screenprinters can use the range of Golden acrylic paints to make glossy printing mixes, which are generally translucent. These fast-drying paints tend to stain the mesh, and the printing mixture may build up on the closed areas of the stencil. Golden printing mixtures may cockle the proofing newsprint and some papers. Within the Golden range we could find no additive to resolve these specific screenprinting issues. However, Lascaux Thickener can be added to thicken

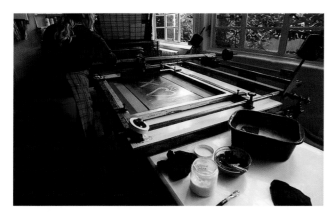

The screenprinter is about to print the monoprint onto paper. Note the quality of the fill (blue printing mix) and the clean-looking, sharp images of the painted shapes (transparent mix). Building an image with this monoprinting technique can involve printing any number of layers, and is controllable and economic. The blue printed areas will alter the colours below. The value of the transparent marks is that the unprinted paper (or any previously printed colours) in the shape of the painted image will be preserved. Unlike other monoprinting methods, any surplus printing mix will simply be a more translucent (and re-usable) version of the original printing colour.

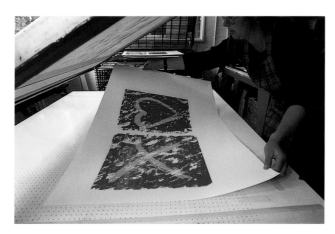

The screenprinter is lifting the monoprint by diagonally opposite corners to place it on the drying rack, where similar prints can be seen. The texture on the blue areas of the print was created by an autographic photostencil. Note that the photostencil on the mesh is now empty, and has not yet been refilled with blue printing mixture. Another transparent painting will be made before the screen is filled again. If the painting is made on a filled screen, this monoprinting method will not work.

the printing mixture and slow down the drying time to improve the printing performance (Golden Thickener is not non-toxic).

Principle: to make a glossy printing mixture which will create changes in surface quality or a wider range of colour and tone.

Method

Work at the professional printing mixture workstation.

- Follow the procedure described in 'Selecting and Mixing Colour' (pp. 151–3).
- Stir the mixture well in a bowl before printing.
- Add Lascaux Thickener if necessary.

Dense semi-opaque layer

- 100 gm Golden Acrylic colour
- 100 gm Golden Silkscreen medium
- 15 gm Golden Retarder

Rich translucent layer

- 70 gm Golden Silkscreen medium
- 70 gm Golden Polymer Varnish gloss
- 15 gm Golden Retarder
- 20 gm Golden Acrylic colour

Delicate layer of colour

- 70 gm Golden Silkscreen medium
- 70 gm Golden Medium gloss
- 15 gm Golden Retarder
- 3 gm Golden Acrylic colour

Method of adding Lascaux Thickener

Add 4 gm of thickener and stir vigorously. If the paint does not thicken, add another 4 gm, and so on. The mixture will become less fluid as it is stirred.

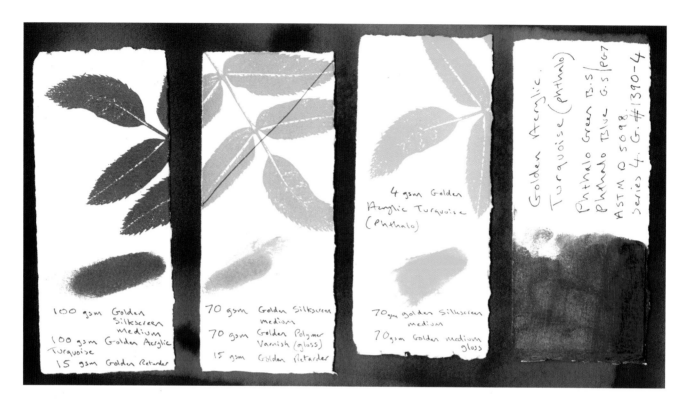

Excessive quantities of thickener will slow down the drying rate of the printing mix on the paper.

METALLIC, IRIDESCENT, PEARLESCENT, INTERFERENCE AND POWDER PIGMENT PRINTING MIXTURES

There are several methods of screenprinting with these materials. All the paints can be used to create dense layers if they are mixed with Lascaux Thickener or Lascaux Retarder (to control the drying time). Delicate tints can be achieved by adding a little metallic colour to the standard mix (see pp. 161-3). The colours are generally fast-drying so the proportion of Lascaux Screenprinting Paste should be increased and the proportion of Lascaux Acrylic Transparent Varnish decreased accordingly.

The swatch on the right shows and records the paint used (Golden turquoise); the other swatches show three different printing mixes made from this colour. The three mixes follow the recipes described on p. 167. These examples were also made to illustrate the correlation between brushed-on printing mixture colour swatches and the way in which these mixtures appear when printed. With some practice, an artist can learn to predict how a mix will print, on the basis of the swatch. The prints made with these mixtures are illustrated on pp. 160-61.

Types of paint

● Lascaux Gouache gold and silver can be printed using the methods for printing Lascaux Gouache (see p. 157). These printing mixes are effective and simple for any screenprinter to work with. Printing with a coarse mesh will lay down a heavy metallic deposit.

● Lascaux Perlacryl is formulated from synthetic mother-of-pearl and produces a distinctive lustrous effect. The sixteen colours in the range include two golds, pearl white and emerald green. These finely

Barbara Rae, *Zia Longhorns*, water-based screenprint, edition of 150, 2000 (detail). This image has several printings of different metallics, including Lascaux Gouache, Lascaux Studio Bronze, gold powder pigments and fine gold Golden acrylic paint. These paints were mixed with Lascaux Thickener, Acryl Emulsion D 498-M, Retarder, Screenprinting Paste and Kremer Orotan. Images printed with different gold recipes are illustrated on pp. 146, 147 and 149.

pigmented paints can be printed through delicate or coarse meshes. Follow the method for printing with Lascaux Studio Acrylic (p. 158).

● The Lascaux Studio Bronze range includes eight metallic colours, among them silver, aluminium, steel, copper and four golds. This range is fast-drying and requires the addition of Lascaux Retarder. Follow the method for printing with Lascaux Studio Acrylic (p. 158).

● Golden fine gold acrylic paint is suitable for printing with delicate or coarse meshes. Golden Iridescent Acrylics and Golden Interference Acrylics should be printed through very coarse meshes. Follow the method for printing with Golden paints (pp. 166-8).

● Professional printmakers can make use of powder pigments. Artists who wish to use them should consult

relevant literature, or the Kremer catalogue published by A. P. Fitzpatrick, for health and safety information and acrylic paint-making advice. Pigments must be stored in containers with lids and handled with care. Many are toxic, and all are fine dusts which may be inhaled. Gloves, an apron and a particulate respirator must always be worn when handling powder pigments. Once the powder has been totally combined, the printing mixture is safe to handle (unless toxic pigments have been used). Kremer offer a comprehensive range, from semi-precious minerals (such as lapis lazuli) to inexpensive modern synthetic colours. The range also includes metal powders (such as tin, stainless steel and copper) and pearlescent pigments (golds, silver, bronze and other colours). The pigments can be mixed with the standard mix or with painting aids

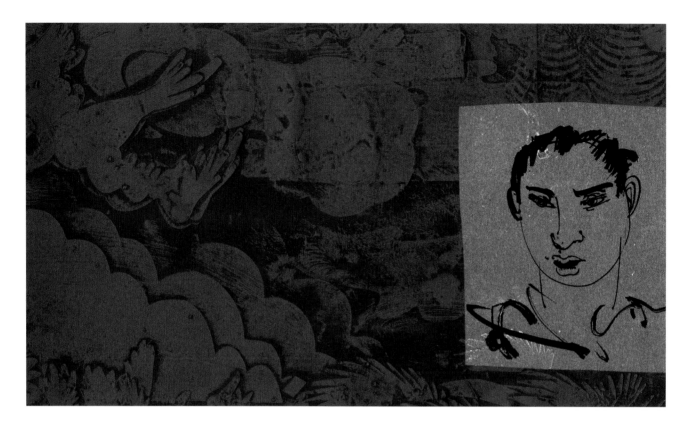

(Kremer Orotan and Lascaux Acryl Emulsion D 498-M).
Pigments can be mixed into the standard printing mix
using a hand-held catering liquidizer.

● All metallic printing mixes tend to separate in
storage. For this reason only small amounts of mixture
should be made.

● A hand-held catering liquidizer can be used to
reconstitute a stored printing mixture which has
separated and dried out. This should be carried out
in a mixing bowl.

George Donald, *The White Emperor* from *Nine Translations from
the Chinese*, 1994 (detail). The velvety black line drawing was
printed, using a coarse mesh, with Kremer Bone black pigment
combined with Lascaux products to create a special printing mix.
The resulting screenprinted line is light-absorbing and contrasts
with the other three surfaces of the print. These are the white
rectangle (screenprinted with Lascaux Gouache), the black relief
ink (which looks grey) and the black Arches paper. This mixed
media print was arrived at in the following way. The artist made
a collagraph plate from many layers of cut-out card glued to
a board. This collage was varnished and allowed to dry. The
collagraph plate was rolled up with black relief ink and printed
onto the black paper using an etching press. When the artist
saw the resulting print, he laid a tracing paper photocopy of
one of his drawings onto the image. This effect was very
beautiful and a plan was made to simulate it using water-
based screenprinting. First a paper stencil was used to print
a white rectangle. Then a photostencil was made from the
original tracing paper photocopy, and the face was printed
onto the rectangle.

PRINTING TECHNIQUES

SETTING UP A VACUUM PRESS

Basic sturdy screenprinting presses equipped with vacuum beds can be bought from specialist suppliers. The vacuum press illustrated in the following photographs is well suited for artists to use. The information below relates to this type of machine, but will also apply to most other hand-operated vacuum presses. A visit to a nearby print studio to examine working presses might be helpful when deciding what type of machine to buy.

These machines are often available second-hand. They are unlikely to be acquired with any installation or assembly instructions, but are usually simple enough to be set up and maintained by the owner. More complex machines may require the services of an engineer.

The screen press frame

The press consists of a sturdy table-like construction and a hinged press frame to hold the screen in register. The screen is wedged between the two moveable bars of the press frame. Once the screen is firmly in place, small clamps can be attached to the press frame to hold the screen firmly in position. These clamps should ideally not have any sharp edges in case they are dropped on the mesh. The type shown is ideal.

The printer can lift the press frame up to register paper and remove prints. A simple adjustable bolt, attached to the hinge mechanism at the back of the press, controls how high the press frame can be raised. (To identify this bolt, stand clear of the moving parts of the press and ask a friend to move the press frame

slowly up and down. The bolt can be seen stopping the movement of the frame.) If the bolt is incorrectly adjusted, the press frame is either too high or too low to be practical. If the front bar of the frame, when raised, is hard to reach and the squeegee falls off, the press frame is set too high. A press frame that cannot be raised high enough to register prints and clean the vacuum bed is set too low.

The vacuum pump

The paper is held in place on the press bed by means of a vacuum pump which is positioned under the press. The flat press bed is perforated to allow air to be sucked through. Good quality presses have quiet and powerful vacuum pumps. The most convenient switching mechanism is a foot pedal which artists can use to turn the air flow on and off. On some presses the vacuum switch is controlled by the movement of the press frame. This offers less flexibility and registration can be more awkward.

When the air flow is switched on, the paper lying in register on the press bed will be sucked down and held firmly in position. The vacuum also helps prevent the paper sticking to the wet mesh, thus improving the 'snap'. After printing the piece of paper, the vacuum is switched off, releasing the print, which can then be lifted and placed on a drying rack.

Snap

The action of the mesh lifting away from the wet print is called 'snap'. This is determined by the height of the gap

between the mesh and the press bed (when the press frame is down). The snap should always be checked before proofing. (The screenprinter can press the centre and sides of the mesh down gently, making contact with the press bed, to feel the height of the gap.) If the snap is too great the mesh can be damaged.

There are four points on the press that can be used to set the snap. The most frequently adjusted are the two rubber-footed bolts at the front corners of the press frame. These should rest on the surface of the bed when the press frame is down. These bolts can be adjusted to alter the height of the mesh from the press bed. The snap is also controlled by the height the press frame is set at the back of the machine. The back bar of the press frame (when this is down) should be several millimetres (one or two eighths of an inch) clear of the press bed. Two large bolts below the hinges can be adjusted (an allen key is used to lock and unlock these). Some machines can be raised by up to 10 cm (4 in.) to accommodate a thick substrate.

The counterbalances

Counterbalances are the weights at the back of the press frame which are used to balance the combined weight of the screen and the squeegee. This weight varies depending on the size of screen, the squeegee and whether the one-arm is in use. The weights can be altered by moving them up or down the bolts.

When the weights are adjusted correctly, the press frame feels light. This takes the strain from the printer and prevents the weight of the squeegee on the mesh being too great. One way to think about this aspect of balancing the press is to imagine the printing frame as a seesaw, with the printer's weight affecting one end and the counterbalances affecting the other.

Care should be taken that the weights remain on their bolts and that threaded counterbalances do not jam together.

The one-arm and squeegee clamp

Most good presses will have a one-arm and a squeegee clamp and, although they all vary slightly, the principle is the same. The squeegee is held parallel to the mesh across its width and the counter-balanced moveable bar allows the assembly to be moved easily by the printer along the length of the screen, drawing the squeegee across the mesh.

The squeegee is secured to the one-arm using a specially designed clamp. Once the squeegee is in the clamp, the assembly can be slid into place along

A screenprinter is registering a piece of paper (the registration clips are pale and barely visible). The screen frame is up. It is self-supporting (due to the action of the counterbalances, seen on the right) and is at the correct height. This allows the artist to work under the mesh easily and safely. Note the underside of the screen, which has been filled correctly and is ready for printing. Masking tape is close at hand, hung on the bolt which secures the front bar to the round side-bar. The printing table is correctly laid out.

The press frame is down and the screenprinter (moving backwards) is printing a filled photostencil onto a registration sheet at the beginning of the printing process. This is a Kippax press, and the solidity of it is evident. The vacuum pump is just visible below the press. The screen frame and screen are held away from direct contact with the press bed by the snap legs. Two clamps can be seen securing the screen to the press frame. The one-arm and its counterbalance are being moved along the back bar of the press frame. The centre of the squeegee has been placed in the middle of the open area and is being pressed into contact with the substrate and the press bed as the printer moves backwards.

the one-arm until the centre of the squeegee is over the centre of the open area to be printed. The exact printing position of the squeegee blade in relation to the mesh can then be adjusted with the bolts on the squeegee clamp.

The use of the one-arm mechanism makes printing large images less physically demanding. Lightweight screenprinters should use a one-arm to print even small editions. It is often easier to teach correct hand-printing angles if the one-arm printing technique is learned first,

as students can easily be shown how the squeegee position affects the appearance of the print.

Safety

A clear space should surround the vacuum press to allow safe printing. Sufficient access will be required to use and alter the press. The moving press frame and one-arm counterbalances at the back of the press should not project into a thoroughfare and are safer if positioned near a wall. The power point for the machine should be

A close-up of a squeegee held in the squeegee clamp which is attached to the one-arm bar. The top four wing nuts release to allow the clamp to be slid onto the bar, which, in section, is diamond-shaped. The squeegee has been slid into the clamp and the bolts tightened to hold it firmly in place. The lowest middle bolt that can be seen controls the blade angle for printing. The bolts that control how parallel the blade is to the mesh are on the other side of the clamp and cannot be seen. A perfect fill has been made but chips in the squeegee blade have left tiny streaks. The yellow area at the far end of the screen is where a gumstrip stencil has been applied to the underside of the mesh.

positioned so that there are no trailing electric flexes that could get caught in the moving parts of the machine or cause a printer to trip up.

Materials and equipment for maintenance of the vacuum press, one-arm and squeegee clamp:

- Mystrol
- engine grease and a rag
- clean rags
- sandpaper or wire wool
- electric drill
- dust mask

Method

The press bed should be clean and free of any dried ink or tapes. The perforations in the press bed should be clear and air should be able to pass through all of them.

- An electric drill can be used to re-drill any blocked perforations. Wear a dust mask.
- Moving parts such as joints, bars and bolts should be clear of dried printing mix or screen filler, and should always be well greased. Dried ink should be cleaned or sanded from the press frame bars.
- The vacuum pump should be serviced regularly.
- The bar along which the one-arm travels at the back of the press must be well greased.
- The bar of the one-arm itself must be clean and free of dried ink, otherwise the squeegee clamp will jam when it is being slid onto the one-arm. The squeegee clamp must be free of wet or dry printing mixtures. It will require a little cleaning at the end of every editioning run. The bolts of the clamp should be well greased.
- If wooden squeegees are used in conjunction with the one-arm clamp, they can be damaged by the bolts digging into the wood. A piece of card folded around the squeegee handle will help prevent this.

- A bicycle handlebar grip can be purchased and fitted onto the end of the one-arm bar.

PREPARING THE PRESS FOR PRINTING

These procedures can be followed when learning to use the vacuum press.

Preparing to print

- The screenprinter should wear an apron, comfortable clothes and shoes with a good grip. Printers should avoid skin contact with the printing mix. This is easily possible using standard printing technique. If the printing mixture does transfer to hands or arms, it should be washed off immediately. The mix can also transfer to hair when working under the screen. Bangles, rings, necklaces, flexes for personal audio equipment, scarves, loose clothing and long hair can become caught in the press, which is dangerous.
- The printer must realize that the moving parts of the press could injure a bystander and should take responsibility for being in control of the machine.
- The printing mix should be prepared. In the case of translucent colours, an extra bowl of standard mix may be useful in case the colour needs to be made more translucent.
- Editioning paper should be prepared and stored within easy reach. Paper can be stacked on a nearby bench or smaller printing papers can be stored in a plastic bag on the printing table.
- A single stack of editioning paper is too heavy to place on a drying-rack shelf and will stretch the springs that hold the shelf up (thereafter the damaged shelf will continually fall down during editioning). Sheets of paper may be laid out singly on drying-rack shelves.

When all the paper is laid out, each shelf should be raised carefully so that the first sheet of paper to print is at the bottom of the rack. During editioning the printer should work up the rack.

● Other substrates to be printed on should be prepared and stored close by.

Fitting the screen on the press

● The screen should be clean and dry, with a defined open area or stencil, taped edges and a margin.

● The press frame is raised to its highest point (where it should remain, balanced by the counterbalance). The printer is then able to use both hands to lift the screen onto the flat, clean press bed. The screen should lie on the press with the printing side facing up (the flat side will be in contact with the press bed).

● The screen can be rotated on the press bed so that the stencil on the mesh is in the optimum place for printing. Points to be considered are how easy it will be for the printer to reach the open area, and the orientation of the paper on the press bed.

● Once the screen is in the most suitable position, the press frame is brought down and the screen placed between the moveable bars. These are then pulled towards each other, wedging the screen frame in place. Once the screen is firmly wedged, the screw handles on either side are tightened to hold the screen in place.

● Screen clamps can then be attached to hold the screen frame firmly in place.

Setting up the one-arm

If the one-arm is to be used, it should be assembled at this stage. The squeegee clamp would rip a mesh if it were to be laid on the screen. The following procedure avoids that possibility:

● The correct size of squeegee is selected and rested on the screen frame (left or right side).

● All bolts on the clamp are screwed out so that there is plenty of room for the squeegee and one-arm bar to be manoeuvred. The clamp is then slid onto the one-arm bar and moved along until the squeegee is reached. The printer holds up the one-arm bar (which now supports the clamp) with one hand and uses the other hand to slide the clamp over the squeegee handle until this reaches the mid-point of the squeegee.

● The bolts are tightened to secure the clamp to the squeegee.

● The clamp (and squeegee) can then be slid safely along the one-arm bar until the centre of the clamp is over the centre of the stencil. The wing nuts on the clamp can then be tightened to secure the clamp to the bar.

● The printer should test that the clamp and squeegee are secure, and re-tighten the bolts if necessary.

● The squeegee should be secured so that neither end of the blade is pressing down too severely into the mesh. Its entire length should be in close, even contact with the mesh. Fine alterations can be made after proofing, when the squeegee will generally be set to press down more at the back of the image.

● The printer should decide on the direction of printing, and set the filling and printing angles of the squeegee accordingly. These estimated positions can be adjusted after the first proofs are made. All the counterbalances should now be adjusted so that the press may be operated comfortably and the weight of the squeegee on the mesh (when the press frame is raised) is not too great. The press frame holding the screen should lie on the press bed without flying up. At the same time, the assembly should not be too heavy, as it has to be supported above the screen bed when filling the mesh.

(To work this out the printer should stand and face the press and hold the front bar between two fingers of one hand. If this is uncomfortable the counterbalances will need to be altered until the frame is balanced.)

Setting up for hand-printing

- Usually only smaller stencils are printed by hand. A wooden squeegee handle is comfortable to hold. The use of a squeegee support means that the printer does not have to stretch to the back of the screen to lay the squeegee down safely (a mesh may be ripped if a squeegee is dropped on it).
- If there are other stencils close to the printing area, these should be covered with recycled PVC sheet parcel-taped to the printing side of the mesh. The squeegee should not run over the tape or the PVC sheet. The most suitable types of parcel tape peel away easily in a single piece and do not leave a sticky residue.
- The squeegee support should be parcel-taped to the mesh 15 to 20 cm (6 to 8 in.) behind the image. This allows space both for the printing mix reservoir and for the squeegee to rest.
- Once the squeegee and support are on the screen, all the counterbalances should be adjusted so that the press may be operated comfortably. The counterbalance

for the one-arm (which is not in use) should be adjusted so that the one-arm remains in a raised position. The press frame holding the screen should lie on the press bed without flying up. At the same time, the assembly should not be too heavy, as it has to be supported above the screen bed when filling the mesh. (To work this out the printer should stand and face the press and hold the front bar between two fingers of one hand. If this is uncomfortable, the counterbalances will need to be altered until the frame is balanced.)

Preparing to print

- The snap should be checked.
- A clean registration sheet of the correct size should be laid on the press bed.
- The printing table should be laid out with some waterproof gloves, a basin of warm soapy water, a sponge, three drying cloths, the printing mix and a soft plastic spatula resting in a china or glass bowl.
- A roll of masking tape and a roll of parcel tape can be hung on the handles of most presses or hung up nearby.
- A roll of gumstrip should be hung nearby to keep it dry. This is easily spoiled if handled with wet hands.
- The plan should be checked before printing starts.

1. A screenprinter has set up the printing table and press with the squeegee on the one-arm and is about to apply printing mix.

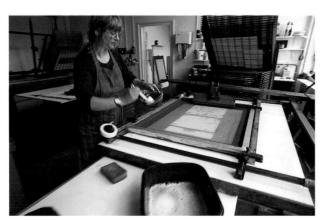

2. Spooning on the printing mix. Note the blue permanent margin, the brown photostencil and the yellow open mesh.

SCREENPRINTING TECHNIQUES

To create one printed image, two strokes of the mesh are made. The screen is first held up from the press bed (to prevent the mesh touching the surface). The squeegee is used to draw all the printing mixture across the mesh, maintaining continuous close contact and filling the open areas. This is referred to as filling the mesh and the quality of each print will depend on how well this is done.

For the second stage of the printing process the frame is brought down so that the snap legs are in contact with the press bed. The printer can now let go of the press frame and move into the printing position. The squeegee is pulled in the opposite direction and this time the screenprinter applies pressure to the squeegee, which forces the mesh downwards into contact with the substrate on the press bed. As the squeegee is pulled across the mesh with continuous pressure, the printing mix is forced out of the spaces between the threads of the mesh onto the paper or substrate, creating a print. The accuracy of the print is dependent on the quality of the fill.

The angle of the squeegee and the weight applied by the printmaker affect the print both during filling and

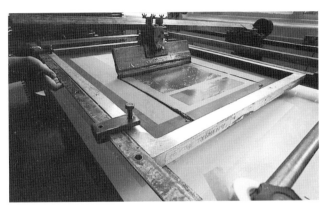

3. The screen is filled as the screenprinter moves the squeegee in close contact with the mesh, from right to left. Note the outstretched arm of the printmaker supporting the press frame.

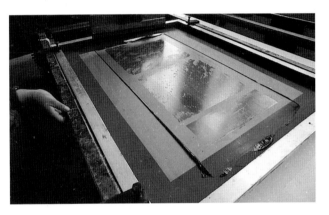

4. The entire stencil has now been filled. By looking at the fill, the printer can judge whether a good print will result. If the fill is poor, a proof rather than one of the edition should be printed.

5. The screenprinter is moving backwards and steadily forcing the printing mix out of the mesh and onto the substrate, which is held in register by the vacuum. Note that the artist is printing a monoprint.

6. After printing, the mesh should be empty of printing mixture.

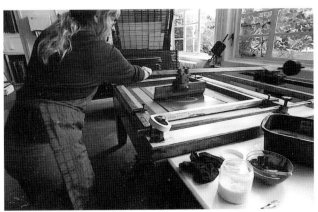

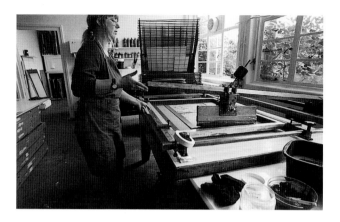

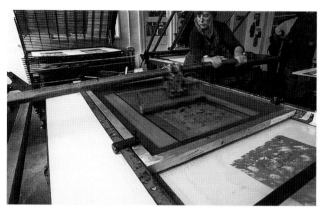

7. **(above)** The screenprinter preparing to fill the mesh once more.

8. **(above right)** The screenprinter is monitoring the angle of the squeegee and the effect of the pressure she is applying to it. She is also watching for the mesh to snap away from the print as she moves. The registration sheet can be seen clearly, flipped out of the way over the side of the press. Any printing mix which offsets from this onto the press can be washed away after editioning. The screen frame on the press in the background has no screen in place and is in the raised position, which is set too high.

9. **(below)** The squeegee clamp adjustment had been set incorrectly and so a strip of the image was not printing. The printing mixture left in this non-printing area can be seen clearly at the back of the open area. The clamp and squeegee were then adjusted so that the blade made a better contact at its far end. The screenprinter is reprinting the mesh (without refilling it) to check that the adjustment will force the printing mix from this area.

below right This screenprinter is moving backwards as she prints the image.

printing. The apertures between the mesh fibres are so tiny that they cannot readily be seen by the naked eye, therefore the quantity of printing mixture required to fill them would be measured in microns.

After filling, the screenprinter should look at the mesh to observe the quality of the fill. When the screen is overfilled, it can be described as 'flooded' and the printed mark looks smudged (often described as having 'bled'). Stencils flooded in this way can also lose detail, as some areas will dry up and block the mesh. If the fill looks streaked or patchy, this is usually caused by poor filling and a lack of printing mixture. A proof (test print) should be taken onto some newsprint. By looking at the mesh in this way before printing, editioning errors can be greatly reduced.

Good filling technique is particularly important in water-based screenprinting. If the mesh is filled unevenly – for instance, with a greater loading of printing mix in

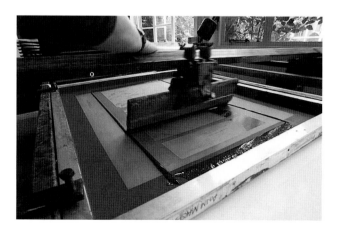

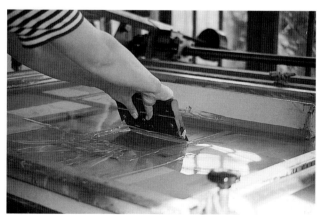

some areas – the resulting print will be unevenly saturated. The wetter areas of the paper will expand more and set up tensions which will warp the paper. Solid geometric printed shapes can set up similar tensions in the paper and require particular care in terms of filling technique.

As each sheet of paper is printed, the printer should look at the mesh to check that the whole stencil is empty and clean-looking. The ideal is to fill the mesh and then to empty it by printing. Using this technique an artist can soon become a skilled printer.

One way of developing this skill is to print many newsprint proofs, using a different amount of body weight or moving in various ways until a perfect print can be taken and repeated consistently. Newsprint behaves differently to a mouldmade printmaking paper so when learning to print it is worth practising on editioning paper, too, to become familiar with its characteristics.

The one-arm squeegee clamp can be adjusted to maintain the correct filling and printing angles. For this reason learning to print using the one-arm can make it easier to achieve consistent results, and also builds confidence. When hand-printing, the screenprinter has to maintain both a consistent pressure and the correct angle between the squeegee blade and the mesh. In order to achieve this, the printer has to have a good understanding of this theory until the position becomes automatic.

Whether printing with the one-arm or by hand, the printer's body movement has to be fluid. Any hesitation, change in pressure or change in the angle of the blade while printing will show up as lines and tonal changes on

below left The screenprinter is supporting the frame with his body while filling the mesh carefully.

below right The screenprinter taking a print.

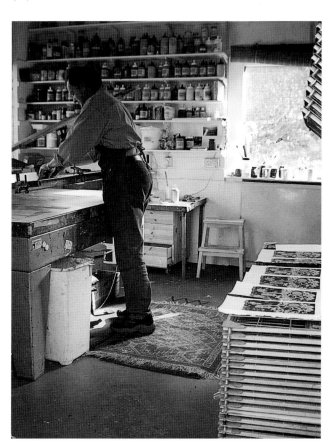

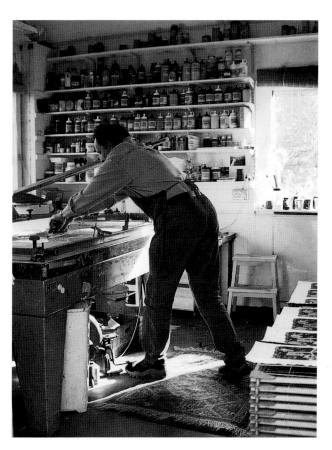

These proofs were printed on a selection of papers with a range of different water-based printing mixtures. They were made to illustrate some common printing problems. The original lith film positive is illustrated on p. 118.

above This proof of an image of doves was done on newsprint with the snap too high on the right hand side. The resulting print has areas missing.

above A proof on brown paper. Areas on the left and right side of the image are missing, as the snap was too great on both sides of the press.

right The image was printed on a hard, rough-surfaced paper. A coarse mesh would have printed the stencil more accurately. Alternatively, some water added to the mixture might have helped to print the image more completely.

above Areas of the image are missing as the mesh was insufficiently filled.

above As a test the photostencil of the doves was filled three times and left untouched for 45 minutes. It was then printed to produce this proof, which looks blurred and has lost detail. However, subsequent prints were perfect. The printing mixture was made with 80 gm indigo Lascaux Studio Acrylic + 200 gm Acrylic Transparent Varnish satin + 80 gm Thickener.

the print. Other unwanted lines on the print can be caused by chips or bulges in the squeegee blade, which prevent a perfect contact being made between the blade and the mesh.

When hand-printing, a certain amount of experiment will be necessary to determine the correct angles, which vary depending on the printing mix, the substrate and the printer's technique. The squeegee should be lifted vertically (at the printing angle) after each print, as the mesh snaps up. This should not be done with a flick of the wrist, as this will cause the printing mix to climb the squeegee handle onto the printer's hands.

The proofs opposite were printed to illustrate some common printing problems. A photographic lith film (see p. 118) was used to make a photostencil on a 120 T mesh (305 T in US), then printed with a variety of mixtures. Slightly odd printing mixtures were made: these were all easy to use and it was surprisingly difficult to make these faulty prints.

REGISTRATION TECHNIQUES

Screenprints may require a single element to be placed accurately on a substrate or may be constructed of many complex layers. For these reasons a registration system is essential to enable consistent correct positioning of the elements that make up the image.

The most accurate and reliable method is to make a registration sheet. This way of registering enables the artist to work quickly and easily, and also allows the colour, translucency and printing quality of the image to be checked before proofing.

An advantage of using this system in a shared studio is that, at any point during editioning, screens can be moved on or off presses, and the registration re-established each time, simply and precisely.

Equipment and materials
- a clear smooth 300 gsm PVC sheet, generally larger than the editioning paper and cut with straight edges
- map
- editioning paper or other prepared substrate
- masking tape (the type which can be removed easily within 14 days)
- a basin of warm soapy water, a sponge and three drying cloths

Method
- The PVC registration sheet is laid on the clean, dry vacuum press bed and is positioned beneath the image area on the mesh. The vacuum is switched on to hold the registration sheet in place while it is being printed.
- The printing mix is applied to the screen, the image is printed onto the registration sheet, and its position is assessed. The entire image should be centrally placed on the sheet. The resulting clean margin is useful for clean and easy manoeuvring of the registration sheet.
- If the image is not well positioned on the registration sheet, the printed image is simply sponged away. The sheet is dried and moved to a better position. The image is then printed onto the repositioned registration sheet. The newly printed image should now be centrally placed on the sheet. A generous clean margin allows space for sponging printing mix off the sheet without any water reaching the edges and running under the sheet.
- When the registration sheet is correctly positioned, its left or right edge should be attached to the bed with a single length of masking tape, forming a hinge. The tape should be rubbed down firmly, as the registration sheet will now remain hinged to the press. When not lying on the press bed, it is flipped over the side. (Any printing mix which offsets onto the sides of the press can be removed easily with household cleaner when dry.)

- The vacuum is switched on, and the hinged registration sheet (in position on the press bed) is cleaned, dried and printed in order to check both the accuracy of the image and its positioning. The vacuum should then be switched off.

- The next stage is to attach the map (see p. 64) to the print or editioning paper, using small pieces of masking tape. These can be slid under the registration sheet and manoeuvred until the printed image on the registration sheet fits the map. (If a target registration system – see below – has been used on the positives, the resulting printed crosses should be aligned.) When the printed registration sheet fits the map below perfectly, the image is in register and the vacuum should be switched on to hold everything in place.

- By looking at the print on the registration sheet, the artist can see how the newly printed layer will affect the print.

- If the image on the registration sheet will not fit with the marks on the paper, or does not seem to work aesthetically, the image may be edited by wiping away areas of colour from the registration sheet to see if the image can be improved. If the wiped away areas improve the image, the artist can alter the stencil so that it prints in a similar way. A paper stencil can be added to the screen, or if the alterations are complex, screen filler can be used. In this latter case, the screen must be cleaned, dried and degreased before the filler can be applied (to the image areas which were wiped away on the registration sheet). The altered stencil will now print an image comparable to the edited registration sheet.

- If the printed image on the registration sheet looks satisfactory, the vacuum can be switched on to hold the paper (and map) in register and the hinged registration sheet (with the image printed on it) can be flipped out of the way, over the side of the press.

- Registration clips are now positioned around the paper (and map). Once the clips are in position the paper may be removed and stored on the drying rack. Some proofs should be made on newsprint to keep the mesh printing freely. The map should then be carefully detached from the piece of editioning paper, which can serve as a paper proof. More newsprint proofs should be taken before editioning is started.

Registration clips

Registration clips act as a guide so that the printer can position the paper in the correct place each time a print is made. Three registration clips are generally used and are positioned around the editioning paper in preparation

left The artist is registering this repeat print (monoprint), using the PVC registration sheet. Note the hinge attaching the registration sheet to the press bed.

opposite A piece of paper is being placed on the press bed. The registration clips are pale and difficult to see in this photograph, but the screenprinter is using the clips to position the paper in register.

for printing. The clips should be positioned so that the printer can see them clearly and so that the paper is easy to place against them. The paper should touch against the clips gently so that the edge is not softened. Ideally, the placing of the clips in relation to the sides of the printing paper should remain consistent throughout the edition. The function of the registration clips is not to hold the printing paper in position but to mark its location accurately. The action of the vacuum holds the paper firmly in place.

● Registration marks (arrows) can be drawn on the press bed with a waterproof marker pen (these marks can be removed with some Cif household cleaner after editioning).

● Registration clips can be made from masking tape strips or small rectangles of card masking-taped to the press bed. More sophisticated clips can be fashioned from small rectangles of card to which PVC rectangles are glued, leaving an overhanging lip (of a few millimetres or one or two eighths of an inch). Each clip is taped to the press bed and the lip fits over the paper as it is moved into register, holding this securely in position. Clips are ideally the same thickness as the paper and should be positioned carefully and masking-taped down.

● Papers with soft deckled edges can be roughly positioned, using simple registration clips, and then moved into perfect position (the image fitting the map, or all four targets matching, as outlined below), using the printed image on the registration sheet.

● For large editions of images (with unprinted margins), three filing cards can be attached (with removable masking tape) to the backs of each sheet in the edition, to provide a hard edge from which to register. These record cards can be purchased in packs from office stationery shops.

Target registration marks

Some positives are constructed with target-type registration marks on them, which will print.

● The system for precision registration should be followed (see below).

● Before editioning, smooth papers can have masking fluid painted on the four areas of paper where the registration targets will print. The masking fluid will accept the printed registration targets and protect the paper beneath. The masking fluid (together with the registration targets) is rubbed away after the edition is printed, leaving the paper clean. This method cannot be used with soft or rough papers.

● Alternatively, thin PVC window-type stencils can be cut to protect the paper margins around the image area. These stencils should be attached with low-tack masking tape to the back of each print. The registration targets print on the PVC stencil.

● Some printmakers enjoy seeing the printed registration targets and feel them to be a part of the work.

● If the marks are printed, but unwanted, the print can be window-mounted or torn down from the back.

Precision registration

The printed registration sheet can be used on its own as a registration method. This is useful for very precise alignment, for when the paper has a pronounced deckle, for monoprinting, for awkward substrates and for free repeat printing (for instance, of a particular motif). This method involves manoeuvring the substrate under the registration sheet until it is in perfect register, then flipping the registration sheet back and printing the substrate. This process is repeated for each printing.

PROOFING AND EDITIONING

Proofing is carried out to check that the stencil and mesh are printing without fault, and that the colour and its translucency are correct. To keep the mesh printing well, many proofs should be taken on newsprint throughout the processes of balancing the press and registration. The printer assesses these proofs to see if there has been any stencil change and to check that the printing technique is producing consistent results.

Proofing can also be used in a creative way to explore an image or concept. By printing the layers in slightly different ways on, for example, ten sheets of editioning paper, the varied results provide a great deal of information which can be used to advantage when the final edition (of perhaps seventy prints) is produced.

After proofing and registration, the artist is ready to print the artwork. This may be an element of an installation, a piece of fabric, a stage in an etching or collagraph process, a stage in a mixed media piece, a one-off or a small varied group of prints. Proofing is important in these cases as the substrate may be precious or unique, or may have required considerable preparation.

Proofing is equally important when numbers of identical prints are being made. Artists generally need to print editions if they are making a book or folio. Editions of prints are made as it is more practical to print a number of screenprints, and making at least ten allows the chance to experiment. Producing screenprints in editions also enables artists to exhibit their images widely and to enter international print competitions.

Equipment

- stopped-out screen with margin
- correctly set-up press, squeegee and printing table
- registered image and registration clips in place
- print-drying rack, emptied of unwanted prints and set up for editioning

The wet print is lifted by diagonally opposite corners. The printed registration sheet can be seen in the flipped back position.

The wet print is placed flat on the drying rack. The remains of parcel tape can be seen on the press bed. This is often mistakenly used for registration and is difficult to remove.

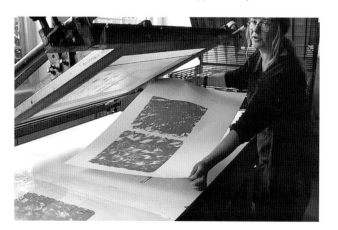

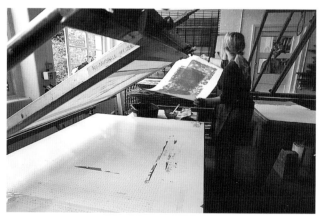

- editioning paper or prepared printing substrates (stored in a plastic bag on the printing table, on a nearby bench or laid out on separate shelves of the rack).

Method for proofing
- The mesh is filled and the image is printed on the registration sheet and registered.
- The printed image is checked for errors, stencil accuracy, colour and translucency. This checking process prior to editioning is known as proofing. Some editioning paper should be used for proofs so that accurate comparisons can be established. Each colour is printed on these proofs so that judgments about the colour layers are easier to make.
- Errors such as unwanted small lines, spots or fisheyes can be blocked with little pieces of gumstrip stuck to the underside of the mesh. The registration sheet is then cleaned, dried and reprinted to check that the gumstrip pieces have closed all the unwanted areas.
- The colour can be checked by printing the image onto paper or, in the case of subsequent printings, a proof.
- The proof can be laid on the drying rack to dry a little, and should be looked at in good light. In this way a decision can be made regarding the correct colour and translucency.
- The processes of registering and determining whether the image is aesthetically correct can take time (in some cases a screenprinter may decide to stop at this point and create a better stencil).
- When the screenprinter is satisfied, some proofs should be taken on newsprint before editioning begins. This enables the printer to check that the image can be printed easily and without strain. The printing mix, the balance of the press frame and one-arm, the snap, the squeegee size and angles, blade quality and position of the squeegee support will affect the comfort of the printer and the quality of the image.
- Any necessary adjustments should be made and, when the proofs are printing consistently and well, editioning can begin.

Method for editioning
- A perfect proof on editioning paper (referred to as the 'BAT', or in the US as the 'RTP') is clipped up on a wall beside the press. Throughout editioning prints may be compared with this print. This is because most changes in the image, or deterioration of the stencil, occur gradually and may go undetected by the printer unless constant reference to the BAT or RTP is made.
- The mesh is filled with the printing mix and examined. If the fill looks faulty, a proof should be taken.
- If the fill looks fine, a sheet of the editioning paper is lifted carefully by its opposite corners and registered to the clips or marks on the press bed (while the vacuum is off).
- The vacuum is switched on, the press frame is lowered and a print is pulled.
- The vacuum is switched off and the print is carefully picked up by its opposite corners and taken to the drying rack.
- The drying-rack shelf being used should be low down and in the horizontal (i.e. lowered) position. The wet prints should be stacked flat, working from the bottom of the rack upwards. (A good way to set out the rack is to store on the bottom shelf a pile of unused newsprint, projecting slightly for easy availability; the map on the next shelf up; some shelves reserved for proofs; and the remainder of the rack allocated for the edition.)
- The wet print is carefully laid on the drying-rack shelf so that the grid supports the print evenly, particularly at the corners, allowing it to dry flat.

above A blend of yellow, red, magenta and ultramarine printed through an open area onto white paper.

below A monoprint made by painting with green and blue printing mix, and drawing with white and yellow Caran d'Ache crayons on an open area. Instead of transparent printing mix, a red-brown colour was chosen and printed on white paper.

• The next sheet of editioning paper is registered on the press bed and the sequence repeated until the entire edition is printed. If any problems are encountered, proofs should be taken until the difficulty is resolved.

• After printing the final print, the mesh should not be filled, as an empty mesh is quicker to clean.

• If the screen is not being used immediately, it should be taken to the screen preparation and mesh-cleaning workstation and cleaned using the standard procedures (see p. 192). The one-arm, the squeegee, screen clamps and squeegee supports should all be removed before the screen is taken off the press frame. The press frame, in the horizontal position, is loosened to allow the screen to be dropped gently from the frame onto the press bed. The press frame will now be unbalanced and will have to be held down. The printer should re-tighten the screw handles (for safety both to mesh and printer) and then hold the press frame firmly and carefully, raising it to the furthest point where it can be left safely. The screen can now be lifted from the press bed and taken to be cleaned.

• The press, printing table and registration sheet should have all tapes removed, be cleaned and dried, and the printing area tidied.

• Once the prints are dry, they should be removed from the rack, starting with the highest shelf (this means that they will be stacked in the correct printing order). They can be collated (prints with errors may be put aside to become proofs) and stored together with the map, BAT and related proofs in a plan chest.

BLENDS AND MONOPRINTING
Blends
Bands of colours (closely related or contrasting) can be printed simultaneously through a single stencil to produce a print with different coloured stripes: this is

called a blend. These water-based printing mixtures are particularly suited to this technique as they are thixotropic.

- Several colours (fairly thick printing mixtures) are laid out on the screen, in pools which are just touching. The open mesh is filled and, after several proofs have been printed, the artist should see parallel bands of colour filling the mesh. It should be possible to maintain these strips of colour throughout editioning: each print will vary slightly depending on the skill of the printer.

- If the chosen colours blend to make browns or greys, these may eventually dominate the mix and produce muddy-looking prints. It is generally more effective (and less wasteful of paint) to use closely related colours or those which mix to produce a useful colour. For example, yellows and reds create oranges, and the surplus can be stored and used for other prints.

- If a variety of browns and greys are needed for an image, these can be achieved by layering the appropriate blends on top of each other.

- Several layers of printed blends can produce either subtle or spectacular effects.

- Blends, in combination with other marks, can be used cleverly to save time and create complexity when building an image (see illustrations on pp. 75 and 140).

Monoprinting

A monoprint is a unique image made using a printmaking method. There are several ways of making marks when screen monoprinting.

- The paper should be prepared in the same way as for editioning.

- A screen with an open area is set up on the press ready for printing. Slow-drying transparent printing mix is applied to the screen. This is printed onto the registration sheet and registered, then the clips are positioned. If all the substrates are of different

Turquoise printing mix marks were painted on an open area and a translucent pink printing mix was used to fill the mesh. This was printed on white cartridge paper. A photostencil made from photocopy positives was printed over this, using a rich translucent red. Where the red was printed over the turquoise, the marks became purple.

dimensions, the registration sheet should be used to register each monoprint.

- Artists should experiment with some test marks to familiarize themselves with the process.

- Monoprints can be made by painting an image on the mesh, using slow-drying printing mixes. A plastic spoon is used to lift small amounts of selected coloured printing mixes onto a PVC palette. The artist paints the

image on an empty open area. A single brush mark will fill the mesh it touches and this will be the colour that prints. When the painting is finished, transparent printing mix is squeegeed over the image to fill the mesh. After several minutes a print may be pulled. If the printed marks have bled, too much printing mix has been painted on the mesh. If areas of the image have not printed, the transparent mix or the painted colours have been too fast-drying and have blocked the mesh.

● Marks can be made by drawing on the empty open area with soft Caran d'Ache water-soluble crayons. The drawn image should be filled with transparent printing mix and left for a minute before printing. The resulting print has a characteristic drawn appearance. Painted marks can be added to the image. Sometimes, rather than printing, the crayons block the mesh and do not print for a few pulls.

● These monoprinting techniques can be used to build up an image in layers, and varied editions can be made.

● Monoprinting techniques can be used in conjunction with other stencils. For example, in an editioned screenprint made of twenty conventional layers, the tenth layer might be a photostencil with monoprinted marks. Alternatively, monoprinted marks might be laid down and a photostencil printed on top in a translucent colour to create a varied edition.

SQUEEGEE SUPPORT

A squeegee support is used to lay the squeegee against during hand-printing. It is parcel-taped just behind the open area which is being printed. These supports cannot be purchased but are simple to make out of card and adhesive-backed plastic film.

Making a squeegee support

The support is an extended cardboard wedge, which in section consists of an isosceles triangle measuring approximately 15 cm (6 in.) on the long sides, with a short side of 10 cm (4 in.). A set of squeegee supports of varying lengths is useful, but the most commonly required size tends to be around 40 cm (16 in.) in length. The support should be lightweight and made of five pieces of framer's mounting card, parcel-taped together to form a wedge. The wedge is then covered with self-adhesive vinyl sheeting to make it waterproof and able to withstand daily use for five years or more.

The squeegee support is parcel-taped to the mesh with one long side in contact with the mesh to provide a stable base. (The parcel tape used to secure the support should detach from it without causing damage.) The short side should face the printer, and is the side the squeegee is rested on. The squeegee handle will project above the support, making it easier to grasp and, because of the shallower angle of rest, the squeegee will be less likely to slide down onto the mesh. A photograph of a squeegee support being used is illustrated on p. 88.

PROBLEM SOLVING WHEN SCREENPRINTING

● Dust attracted by static electricity to the underside of the mesh will print like fisheyes. A clean damp artist's sponge can be used to remove dust from the mesh.

● If flaws in the stencil are numerous or impinge on the image, the mesh will have to be cleaned and degreased, and these flaws stopped out with screen filler before proofing.

● Prints with unwanted bubbles, streaky colour and missing areas, and prints which are fuzzy or smudged, are usually caused by faulty printing mixtures.

• When an image completely fails to print, the printing mixture may have started drying in the mesh. The mix may be too fast-drying for the studio conditions or the skill of the printer. Too small a quantity of printing mix on the mesh in a hot dry studio will dry quickly and close the mesh. Dishwashing liquid (in some cases Mystrol may be needed) should be applied to the mesh. The printing mix should be removed and slowed down before being returned to the screen. The printer (wearing gloves) should use a sponge to rub the soapy mixture through the mesh onto the registration sheet. This should then be cleaned and dried, and the screen filled and proofed onto newsprint until it is printing correctly and reliably.

• Prints which have streaks, speckles, marks, missing or flooded areas, and prints which are smudged, fuzzy or offset, are usually the result of poor printing technique.

• If the prints have strips or areas missing, spotted areas, one corner flooded or unwanted marks and patterns, the press may be set up incorrectly and the snap in particular should be altered.

• If the paper is too textured for the squeegee blade (which is too hard) and the mix (which is too viscous), the prints will look spotted and areas of the mesh will dry up and block.

• If the editioning paper sticks to the underside of the mesh during printing, the snap may be insufficient, the mesh may be slack, the printing mix may be too sticky, or the printer may be trying to print too fast, or may not have allowed the mesh to release from the paper after printing. The amount of suction provided by the vacuum is unlikely to be the main problem, as these printing mixes, in combination with correct printing technique, can in fact be printed successfully without any vacuum.

• Areas of the image may not print, or unwanted images (ghosts) may appear if the mesh has not been properly cleaned before the stencil was applied.

• During printing, a thick build-up of printing mix may appear on the photostencil. This is caused by incorrect filling technique, when the contact between the squeegee and the stencil on the mesh during filling is not sufficiently close. A sharper, more flexible squeegee will help.

• If an image prints out of register, there may be a number of causes. The screen may have moved, the registration may be faulty, the registration sheet may have moved or been crumpled, creased or incorrectly hinged, the paper may have moved because the vacuum was not switched on, or the vacuum perforations may be blocked with dried ink.

• If a masking-tape hinge for a registration sheet will not adhere to the clean press bed, this is usually because a dry residue of cleaner has been left on the bed. This can be rinsed away and the press bed dried.

• When a successful image (paper stencil or screen filler) slowly begins to disintegrate during printing, it is possible to preserve the image for future use in the form of a screenprinted positive. An opaque black printing mix is applied to the screen and proofed on newsprint until the image is printing solidly and sharply. A print can now be taken on a clean piece of smooth PVC sheet. This may be stored for use as a positive.

• Printers who are learning the process may need to stop printing from time to time in order to wash and dry their hands. Printing mix can easily be transferred to prints, other equipment and the shelves of the drying rack.

• Prints which dry warped are the result of faulty printing mixes (with water added), poor filling technique, unsuitable paper or too coarse a mesh for the substrate.

• Unwanted lines and marks on prints may be caused by the underside of rack shelves if the correct stacking procedure (from bottom to top) is not followed.

RECLAIMING THE SCREEN

SCREEN PREPARATION AND MESH-CLEANING WORKSTATION

The screen preparation and mesh-cleaning workstation is used for a variety of purposes. These include screen preparation processes, such as developing photostencils and degreasing. Screen-cleaning and reclamation processes, such as removing printing mixtures, screen fillers, photostencils and unwanted stains (haze) from the mesh, are also carried out in this area. A system of coloured brushes and clearly labelled containers will help prevent problems due to cross-contamination.

Relevant safety and procedural information should be clearly displayed. All chemical storage containers must be labelled to identify their contents and any hazard. Appropriate MSDSs should be stored in a visual aid folder in the area.

If the high-pressure hose is used while chemicals or pigments are still on the mesh, these substances will be suspended in a fine water vapour and may be breathed in by artists working in the studio. Even when using chemicals which are labelled non-toxic, the safe practice of rinsing with a soft hose should be followed.

Equipment and materials

- high-backed, back-lit screen wash-out unit
- clearly displayed process and safety information
- high-pressure hose with safety information and instructions for use
- soft hose with adjustable hot and cold water
- non-slip, draining floor
- waterproof safety switches for all electrical equipment
- simple extraction fan to remove moisture
- safety equipment cupboard (clearly labelled on the outside with a list of contents) containing a waterproof apron, chemical-resistant gloves, eye protection, ear defenders, glass cleaner and duster for cleaning goggles or visor after use
- floor-cleaning mop and bucket
- warning light attached to fire alarm (in case fire alarm is not heard)
- waste container

System

- A shelf with a backboard divided into four different coloured sections, each clearly displaying written information relating to the procedure and safety. The shelf accommodates (in the appropriate sections) four one-litre, colour-coded, clearly labelled (chemical name and hazard), flexible containers with nozzles (such as recycled dishwashing liquid bottles or Lascaux acrylic paint containers).
- From a hook in the shelf below each coloured section, an appropriately coloured (specialist, large, soft) screen-cleaning brush should be hung, e.g.
- blue colour code for degreaser
- green colour code for dishwashing liquid to remove printing mix
- red colour code for photostencil remover
- yellow colour code for Mystrol screen filler remover
- Acrylic paint can be used for the colour code, then

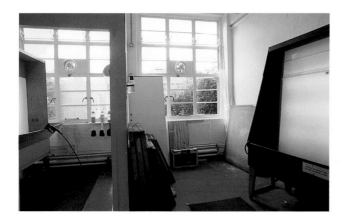

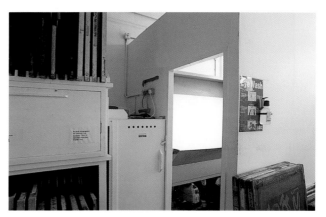

inkjet labels can be printed, and self-adhesive clear vinyl used to cover and protect the labels and painted surfaces.

Maintenance

The wash-out unit and brush should be rinsed after each process, and should be thoroughly cleaned periodically.

Screen refill bay (suitable for large workshops or for staff use)

This refill bay can save time and makes the procedure of mixing up chemicals safer. In self-regulating studios, artists can use this bay; in colleges or schools it may be part of the store room.

- A shelf with four different coloured sections to accommodate four five-litre, colour-coded, clearly labelled containers for pre-mixed screen-cleaning

chemicals (recycled detergent containers are suitable; household detergent can be purchased from industrial suppliers more economically in five-litre containers).

- Clearly displayed information in each coloured section relating to the procedure and safety.
- blue colour code for degreaser
- green colour code for dishwashing liquid to remove printing mix
- red colour code for photostencil remover
- yellow colour code for Mystrol screen filler remover
- Acrylic paint can be used for the colour code, then inkjet labels can be printed, and self-adhesive clear vinyl used to cover and protect the labels and painted surfaces.
- Eye protection, gloves and waterproof apron.
- Funnel (labelled with waterproof marker pen 'Rinse after use').

top left A view of the screen wash-out area, showing the screen-cleaning wash-out unit, the pressure hose lance, four cleaning brushes and a set of colour-coded screen-cleaning materials. Note the extraction fans in the windows and the separate photostencil wash-out unit (back-lit on the right).

top right Screen wash-out area with a view of the pressure hose pump, eye-wash station and screen-drying cabinets. The door to the wash-out area is shut when any photostencils are being removed from screens.

right Screen-cleaning materials and brushes. Note the large, soft brushes and the colour-coded system.

REMOVAL OF PRINTING MIXTURES AND PAPER STENCILS FROM THE MESH

Screens can be cleaned on the press if printing is continuing immediately. However, if printing has finished, the printing mixture must be cleaned thoroughly from the mesh in the screen preparation and mesh-cleaning workstation. Printing mixture must be removed from the screen to prevent this drying and causing damage to the mesh.

Although the dishwashing liquid used to remove the printing mixture is considered safe to use for washing dishes, it should be handled with care and never blasted into a mist with the high-pressure hose. Similarly any paint or pigment residue (even if labelled non-toxic) should be rinsed from the mesh using a soft hose.

Equipment and materials required

- screen preparation and mesh-cleaning workstation
- gloves, suitable footwear, apron, and eye and ear protection
- colour-coded (green), soft, specialist screen-cleaning brush
- container of dishwashing liquid to remove the printing mix (environmentally friendly products are available)
- printing mixture storage jar with lid
- soft, flexible plastic spatula
- basin of warm water, sponges and clean, dry cloths
- waste container
- scissors (for trimming tape from used PVC)

Principle: complete removal of all printing mix, paper stencils and tape, leaving no areas of the mesh blocked or stained.

Method

Work in the screen preparation and mesh-cleaning workstation.

- The mesh should be left empty of printing mixture after the last print has been pulled.
- Wear non-slip footwear, chemical-resistant gloves and a waterproof apron.
- Flexible plastic spatulas make it possible to lift all the printing mixture from the mesh, sides of the screen, squeegee and other tools. The left-over printing mix can be stored in a jar with a lid. This is economical as the mixture can be used again, even years later, and this practice cuts down on landfill waste.
- The mesh should be filled with dishwashing liquid using a sponge (this starts the cleaning process).
- Remove the screen clamps, squeegee, squeegee support, squeegee clamp, protective PVC sheets and parcel tape from the printing side of the screen and lay these on the printing table for cleaning later (the open areas of the mesh should be cleaned first).
- The sides and closed areas of the mesh should be soaped to soften the printing mix. These areas can be wiped up later.
- After a few minutes, the sponge can be used to lift up the soapy residue and some can be pushed through the mesh onto the registration sheet below. The registration sheet can then be wiped clean with the sponge and the process repeated until the mesh is clear. Alternatively, the soap-filled mesh can be printed onto newsprint several times to shed the soapy mix and to leave the mesh clear of printing mix.
- Any paper stencils, PVC stencils or gumstrip repair patches must be removed at this stage to avoid the risk of the printing mix drying between the mesh and the stencil. If these stencils or patches are dampened (from the underside of the mesh), they are easier to

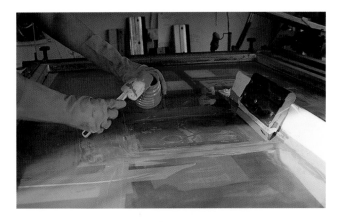

1. **(left)** A soft flexible spatula is used to lift all the left-over printing mixture from the mesh and the squeegee.

2. **(below left)** The printed image on the registration sheet has softened and is now easy to wipe away with a damp sponge.

3. **(bottom left)** After a few minutes the soapy mixture is loosened and lifted away with a sponge.

4. **(below)** After the mesh has been dampened for a few minutes, the paper stencils (or in this case several strips of gumstrip) can be removed easily from the underside.

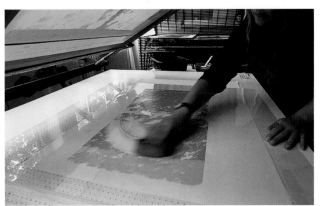

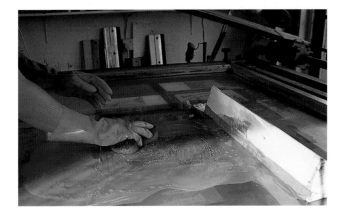

detach. The stencils can be pushed from the mesh onto the registration sheet either with a squeegee or a sponge. PVC stencils may be washed, dried and retained for future use, but paper stencils will have to be discarded.

5. **(above)** After cleaning, a cloth is used to dry the registration sheet.

- The mesh and squeegee should be wiped and rinsed with water until they are clean.

- If printing is to continue, check that the underside of the mesh is clean and dry, particularly the closed stencil areas. A new colour can then be applied to the mesh and proofing begun again.

- The PVC registration sheet should be dried and any registration marks or clips removed from the press bed. Any masking tape should also be removed and thrown away, as it quickly becomes brittle and difficult to remove. The printing table should be tidied up and re-arranged for the next print run.

Cleaning the screen thoroughly in the mesh-cleaning workstation

- If no more printing is planned, or the image is large, the screen should be taken off the press and carried to the mesh-cleaning workstation where it can be cleaned with dishwashing liquid. The screen is placed in the wash-out unit and the dishwashing liquid is applied to the mesh and frame with the colour-coded (green) brush.

- The soft hose (for safety reasons) is used to rinse the mesh and frame.

- After the soapy mixture is washed away, the high-pressure hose is used to blast any residue from the mesh. Ear protection and eye protection must be worn when using the high-pressure hose.

- Wash gloves (as if they were hands) to free them of soap and printing mix.

- Screens should not be left in the screen preparation and mesh-cleaning workstation, where they may become contaminated. They should be dried in the vertical drying cabinet or returned to storage slots.

- The wash-out unit should be rinsed, the draining outlet cleared of any debris, and any gumstrip or paper stencils removed.

Problem solving

- Stain (haze) in the mesh can be caused by incorrect cleaning or by faulty printing mixes (some pigments are very staining). These stains ('ghosts') may block the mesh (like a faint stencil), showing up on the print as pale images. Haze caused by printing mixtures can be identified by recognizing the printing image ghost on the mesh (see 'Haze Removal', p. 197).

- If a photostencil on the mesh starts to dissolve in 'brush-stroke' marks, this may be caused by the brush being contaminated with photostencil remover.

- Clean up any dried paint or painting aids on the printing table and press bed with household cleaners such as Mystrol or Mr Muscle Bathroom. Cleaning dried ink from surfaces and tools is easier with a non-scratch cleaning pad.

- The mesh of screens left in the wash-out area can be damaged by mists of photostencil remover. The remover will dry on the mesh and cause the photo-emulsion to crosslink in such a way that the stencil becomes fixed and impossible to remove.

REMOVAL OF PHOTOSTENCILS FROM THE MESH

After printing, the photostencil is removed from the mesh so that the screen may be used again. Filler reversal technique also requires that the photostencil is removed.

The photostencil remover is a chemical which should be handled with care, even though the solution is dilute.

Equipment and materials required

- screen preparation and mesh-cleaning workstation
- chemical-resistant gloves, visor, waterproof apron and ear protection

- colour-coded (red), large, soft, specialist screen-cleaning brush and colour-coded container of diluted photostencil remover (Folex CL 14)

Principle: complete removal of entire photostencil, leaving no areas of the mesh blocked or stained.

Method

Work in the screen preparation and mesh-cleaning workstation.

- Wear chemical-resistant gloves, visor, waterproof apron and ear protection.
- Screens which have not been used for a long time will be easier to clean if they are thoroughly degreased before the application of photostencil remover. This is an effective and economic practice as less photostencil remover will be required.
- The screen is placed in the wash-out unit and the photostencil remover is generously applied to both sides of the mesh with the red brush.

The diluted photostencil remover is applied to a photostencil and moved around with a specialist screen-cleaning brush (which has a colour code painted on its handle). Shortly after the remover has been applied to both sides of the screen, the nature of the photo-emulsion seems to change and the stencil collapses.

- The brush should be kept moving across the entire surface of the mesh (including areas near the frame) as the photostencil starts to dissolve and wash away. More remover is added to the mesh, and this is also moved around, and should not be allowed to dry.
- The soft hose (for safety reasons) is used to rinse the loose photostencil from the mesh.
- After the dissolved stencil is washed away, the high-pressure hose is used to blast any residue from the mesh. Ear protection and eye protection must be worn when using the high-pressure hose.
- Start by spraying from the printing side, as the photo-emulsion was applied from the flat side. Work across the screen on both sides in regular vertical lines from top to bottom to remove any traces of stencil. Repeat this to ensure a very clean mesh. (When this process is being followed to remove a photostencil as part of a filler reversal technique, the force of the high-pressure hose may weaken or damage the screen filler. The pressure hose should be used with caution, and from the printing side only.)
- The wash-out unit and brush should be rinsed.
- The mesh should be degreased if the screen is to be used immediately.
- Wash gloves (as if they were hands) to free them of photostencil remover.
- Screens should not be left in the screen preparation and mesh-cleaning workstation, where they may become contaminated. They should be dried in the vertical drying cabinet or returned to storage slots.

Problem solving

- A photostencil which will not dissolve quickly may be covered by a layer of grease. The grease shields the photostencil from the remover. The mesh should be degreased before removal of the stencil.

- If after degreasing and applying photostencil remover, the photostencil will not dissolve at all, it may have been previously contaminated by a mist of photostencil remover which has dried and crosslinked, permanently damaging the mesh.
- Stencil-shaped stains ('haze') in the mesh can be caused by underexposing the photo-emulsion or by using an incorrect chemical to remove photostencil. It is important to establish the correct exposure time and to choose the correct chemical partner for the photo-emulsion in use.
- The soft hose should be used, as mists of these chemicals can damage the health of other artists working in the area (see p. 33).
- The bristles on the cleaning brush will harden if the brush is not rinsed after use.

REMOVAL OF SCREEN FILLER STENCILS FROM THE MESH

Screen filler is removed from the mesh using a household cleaner which is classified as safe to use in the home. However, care should be taken, and the

Some small areas of screen filler can be seen on this mesh. The brush has a colour code painted on its handle.

cleaner should never be sprayed into a mist. An MSDS should be sought for the product used.

Equipment and materials required
- screen preparation and mesh-cleaning workstation
- gloves, suitable footwear, apron, eye and ear protection
- colour-coded (yellow), soft, specialist, screen-cleaning brush and colour-coded container of Mr Muscle Bathroom or Mystrol

Principle: complete removal of entire filler stencil, leaving no staining on the mesh.

Method

Work in the screen preparation and mesh-cleaning workstation.
- Wear chemical-resistant gloves, visor, waterproof apron and ear protection.
- Place the screen in the wash-out unit and apply the selected filler remover with the yellow brush to both sides of the mesh.
- The filler will remain on the mesh, but may slowly start to feel as though it is becoming a little sticky and catching on the brush.
- Keep moving the brush and adding more chemical all over the mesh, taking care to work on both sides and on the areas near the frame. Do not allow the chemical to dry. Use the correct brush to prevent contamination and to avoid the risk of dissolving any photostencil.
- Warm water will make the removal of filler easier.
- Most or all of the filler will remain on the mesh. However, the filler has been weakened by the cleaner and can now be blasted easily from the mesh using the high-pressure hose.
- Using the pressure hose, work across the screen on both sides in regular vertical lines from top to bottom to

remove any traces of stencil. Repeat this to ensure a very clean mesh.

- A repeat application of filler remover may be required if the layers of filler have been applied by paintbrush and have become thick.
- When the mesh is free of the filler stencil, it should be degreased if it is to be used immediately.
- The wash-out unit and brush should be rinsed.
- Wash gloves (as if they were hands) to free them of filler remover.
- Screens should not be left in the screen preparation and mesh-cleaning workstation, where they may become contaminated. They should be dried in the vertical drying cabinet or returned to storage slots.

Problem solving

- If a mesh has both a screen filler and a photostencil to be removed, it is often quicker to remove the photostencil first.

HAZE REMOVAL

Photostencils, screen fillers, printing colours and varnishes can all cause staining of the mesh. This is known as 'haze'. Correct and thorough cleaning of the mesh after all procedures will help prevent this. These stains may block the mesh (like a faint stencil), showing up on the print as pale images ('ghosts'). The original cause of hazes can often be identified, as they will appear in the form of the printed area or in the form of a stencil.

Mild hazes caused by printing mixtures can be removed using household cleaners such as Mystrol or Mr Muscle Bathroom. These cleaners can be applied to the mesh using a screen-cleaning brush, and should be moved around for five minutes or so before rinsing away with warm water and a soft hose. The pressure hose can then be used to remove any remaining haze from the mesh.

Once every few years, a heavily used mesh may start to print poorly and may require the use of a screen haze-removing product. As these types of product are caustic and corrosive, this screenprinting process should only be carried out with care and by professional screenprinters. Work in the screen preparation and mesh-cleaning workstation and wear gloves, suitable footwear, apron and eye protection. The products can damage meshes if used incorrectly, so manufacturers' process instructions should be carefully followed, and MSDSs obtained, read and kept on file. However, any suggestion that this process should be part of an everyday screen-cleaning routine should be ignored. Haze remover will shorten the life of the mesh fibres and haze removal is an unpleasant process. If the screen prints well but is so stained that it is difficult to see through, this presents no difficulties if the PVC registration system is used.

COLLATING AND PRESENTING SCREENPRINTS

COLLATING SCREENPRINTS

When the prints are finished, they should be taken with the proofs and the BAT to a clean, dry work area. There they should be collated before signing and embossing with the screenprinter's stamp (the chop). Prints on unusual substrates should be prepared for exhibition according to their particular characteristics.

Collating

Collating an edition printed on paper involves examining and comparing the prints, and determining the final number of the edition. Any dented, damaged, badly printed or out-of-register prints should be put to one side as proofs. These can be used in the future for collage, painting or printing on. Minor blemishes can be cleaned from margins using a scalpel or a soft eraser. Fluff and dust can be removed with a large, soft, dry brush. The prints should be handled with the care used when handling painted works on paper. Each sheet should be picked up by opposite corners to prevent denting. The perfect prints should then be counted and a note made of this number.

From this group the following proofs are selected:

- When an artist has worked in collaboration with a publishing studio, a printer's proof (PP) is given to the screenprinter who printed the edition.
- A proof is also retained for the studio archive, and this is used for display purposes when promoting and selling the edition. This proof is marked HC, which originates from the French *hors de commerce*, meaning 'not for sale'.
- Up to 10% of the remaining prints may be designated artist's proofs (APs). These belong to the artist or may be shared with the publishing studio. If a BAT proof has been used as a working guide when printing, it may have been annotated by the artist or may have become marked during the printing process. Some collectors have an interest in these prints, so they should not necessarily be discarded.
- The remaining prints are counted and form the edition. These and the proofs are signed in a soft graphite pencil. If the print is a bleed print, it should be signed within the image. A soft coloured pencil may be used if necessary. The signature is usually placed in the lower right corner of the print. The edition is numbered,

right A print which has been chopped with the name of the studio.

far right A Chinese stamp on a water-based screenprint.

usually in the lower left corner. Conventionally the total edition number is preceded by the number of the print, for example 6/30. The artist may write the title of the work in the centre, level with the number and signature.

In the case of a collaborative print, the studio chop is used to emboss or stamp the prints to identify their origin. The chop is usually applied to the lower right corner of the print, close to (or on top of) the signature. Some artists have their own personal chop.

The prints should then be interleaved with sheets of acid-free tissue and stored in a plastic bag in a plan chest.

A document of authenticity for the edition should be drawn up for the use of galleries or purchasers. The document may specify the artist's name, the title of the work, the date, the medium, the paper size and image size, the number of prints and proofs in the edition, and the selling price. The document can also briefly describe how the print was made (for example, 'Three tusche paintings on PVC and one digital positive created using Adobe Photoshop were hand-printed in four layers using Lascaux Gouache on Banks Creme 200 gsm acid-free paper'). This information is also essential for the artist's own records and should be stored in a notebook or computer, together with details of the location and sales of each print in the edition. The artist's records should be updated as sales are made.

PRESENTING SCREENPRINTS

The artist should judge the most appropriate way in which the work should be presented. Prints have been made which were designed to be turned into paper boats and floated on a river; artists have pinned up entire editions outside and then set fire to them so that they burned as a performance piece; and layers of editioned prints have been pasted to a wall as an interactive artwork, in which spectators were invited to tear sections off, revealing parts of prints below. The screenprint may be a single element in an installation or sculptural piece, or a layer in a painting or a mixed media work.

Elizabeth Ogilvie, *Into the Oceanic 1*, water-based screenprinted installation, Taigh Chearsabhagh, Scotland, 1998. The installation consisted of trays of dyed salt water, an electric fan and a water-based screenprinted text on Perspex. The text was created and output digitally on clear acetate and was screenprinted using Lascaux Studio Acrylic, Retarder and standard mix. The artwork was created by Ogilvie in collaboration with the poet Douglas Dunn. Slender Perspex panels suspended over shallow, aluminium-held pools of water formed a block, fragmented by gentle, undulating movement, dancing light and overlapping reflections. The dyed black pools of water alluded further to the open sea and its infinite expanse. Grey salt crystals were left behind as the water gradually evaporated – a reference to the salt-making site which was once situated close to Taigh Chearsabhagh.

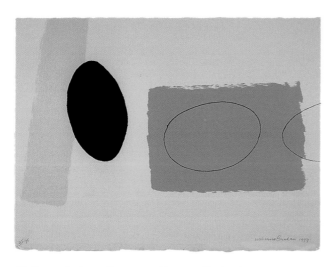

W. Barns-Graham, *Oranges and Lemons Playing Games*, water-based screenprint, 29.5 x 40 cm (11½ x 15¾ in.), edition of 75, 1999. The artist's positives were painted and drawn on True-Grain using Golden acrylic paint and pen, then screenprinted using standard mix, Lascaux Acryl Emulsion D 498-M, Gouache, Artist's Acrylic and Kremer organic pigment pastes, pigment powders and Orotan.

Works on paper should be framed according to the style of the work, not the general perception of how prints should be framed. Some images will suit a black lacquered frame but others will look much better in an entirely transparent Plexiglas or Perspex frame, a lime-waxed wooden frame or the kind of gilded and specially treated finish which is normally reserved for paintings. Artists who do not frame their own prints should seek out a good framer who is used to dealing with fine art work.

Prints may be float-mounted, window-mounted or float-mounted within a window-mount. Heavy

Mary Newcomb, *Little Lighthouse Town*, water-based screenprint, 59 x 57 cm (23¼ x 22½ in.), 1997. This image was made from a series of positives which the artist painted with tusches. It was screenprinted using Lascaux Screenprinting Paste, a range of Lascaux products and Kremer pigments including whites, ultramarines, vine, bone and Spinel black.

prints can be suspended from the mounting board using self-adhesive Velcro (plastic hook-and-loop fastener), which allows fine adjustments to be made.

To frame a print to conservation standard, the appropriate materials should be used, including acid-free mount board, tapes and backing board. The print surface should not be in contact with the glass, which should filter out UV light.

Prints to be mailed or transported in cardboard or plastic tubes should not be rolled too tightly. The print should be laid on a large sheet of tissue which overlaps its edges. Another sheet of tissue should then be laid over the surface of the print, and these should all be rolled together to form a cylinder. The overlapping tissue should be tucked into the ends in order to secure the print and prevent it from unrolling. A ball of crumpled tissue should be placed at the bottom of the tube. The print should then be inserted, together with a sheet with the sender's address (in case the tube becomes lost). Finally, another ball of tissue should be placed on top of the print and the lids should be sealed at each end with parcel tape.

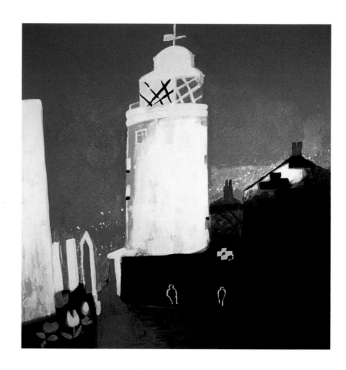

INTERNATIONAL SUPPLIERS OF MATERIALS SUITABLE FOR WATER-BASED SCREENPRINTING

ARTIST'S MATERIALS

Broad range of artist's materials including brushes and other tools

A. P. Fitzpatrick
Fine Art Materials
142 Cambridge Heath Road
London E1 5QJ
UK
Tel: +44 (0)20 7790 0884
Fax: +44 (0)20 7790 0885

T. N. Lawrence & Son Ltd
208 Portland Road
Hove
E. Sussex BN3 5QT
UK
Tel: +44 (0)1273 260260
Fax: +44 (0)1273 260270
Website: www.lawrence.co.uk

Dick Blick Art Materials
PO Box 1267
Galesburg, IL 61402-1267
USA
Website: www.dickblick.com

Pearl Paint
308 Canal Street
New York, NY 10013
USA
Website: www.pearlpaint.com

Golden paints

Golden Artist Colors, Inc.
188 Bell Road
New Berlin, NY 13411-9527
USA
Tel: +1 607 847 6154
Fax: +1 607 847 6767
Website: www.goldenpaints.com

Kremer pigments

Dr Georg F. Kremer
Farbmühle, Hauptstr. 41-47
D-88317 Aichstetten
Germany
Tel: +49 7565 91120
Fax: +49 7565 1606
Website: www.kremer-pigmente.de

Retailers

A. P. Fitzpatrick
(as before)

Kremer Pigments Inc.
228 Elizabeth Street
New York, NY 10012
USA
Tel: +1 212 219 2394
Fax: +1 212 219 2395
E-mail: kremerinc@aol.com

Art Stretchers Co.
104 John St
Brunswick East
Victoria 3053
Australia
Tel: +61 3 9387 9799

Kirjopiiska
Helsinki
Finland
Tel: +358 9 685 1902

Lejeune
Paris
France
Tel: +33 1 4307 5762

Künstler Magazin
Kastanienallee 13/14
D-10435 Berlin
Germany
Tel: +49 30 4 48 44 47

E & S Art International Inc.
Seoul
South Korea
Tel: +82 2 312 5335

Lascaux paints, painting aids, tusches, screen filler and screen painting fluid

Lascaux Colours & Restauro
Alois K Diethelm AG
CH-8306 Brüttisellen
Switzerland
Tel: +41 1 807 41 41
Fax: +41 1 807 41 40
Website: www.lascaux.ch

Retailers

A. P. Fitzpatrick
(as before)

Savoir Faire
40 Leveroni Court
Novato, CA 94949
USA
Tel: +1 415 884 8090
Fax: +1 415 884 8091
Website: www.savoir-faire.com

Art Basics
916 Victoria Road
West Ryde
2114 NSW
Australia
Tel: +61 2 9807 2222
Fax: +61 2 9809 6548

Holland Gwabo
Nishijin, PO Box 65602
Kyoto
Japan
Tel: +81 75 414 10 76
Fax: +81 75 431 89 58

Printmaking materials

Intaglio Printmaker
62 Southwark Bridge Rd
London SE1 0AS
UK
Tel: +44 (0)20 7928 2633
Fax: +44 (0)20 7928 2711

Speedball products, papers, art and printmaking materials

Daniel Smith Inc.
4150 First Avenue South
PO Box 84268
Seattle, WA 98124-5568
USA
Tel: +1 800 426 7923
International tel: +1 206 223 9599
Fax: +1 800 238 4065
International fax: +1 206 224 0404
Website: www.danielsmith.com

Speedball Art Products Company
2226 Speedball Rd
Statesville, NC 28677
USA
Tel: +1 800 898 7224
Fax: +1 704 838 1472
Website: www.speedballart.com

PAPER AND OTHER SUBSTRATES

R. K. Burt
57 Union Street
London SE1 1SG
UK
Tel: +44 (0)20 7407 6474
Website: www.rkburt.co.uk

John Purcell Paper
15 Rumsey Rd
London SW9 0TR
UK
Tel: +44 (0)20 7737 5199
Fax: +44 (0)20 7737 6765
Website: www.johnpurcell.net

Hiromi Paper International Inc.
2525 Michegan Avenue, # G-9
Santa Monica, CA 90404
USA
Tel: +1 310 998 0098
Fax: +1 310 998 0028
Website: www.hiromipaper.com

Twinrocker Handmade Paper Inc.
100 East Third Street/PO Box 413
Brookston, IN 47923
USA
Tel: +1 765 563 3119/+1 800 757 8946
Fax: +1 765 563 8946
Website: www.twinrocker.com

Synthetic paper

Astech Plastics Distributors Ltd
134 Sunrise Avenue
Toronto
Ontario
Canada M4A 1B3
Tel: +1 416 755 7286 /+1 416 755 3319
Fax: +1 416 755 9437
Website: www.AstechPlastics.com

Overhead projector film

Office stationery stores

Drafting film and Clear-lay

Grafix Plastics
19499 Miles Rd
Cleveland, OH 44128
USA
Website: www.grafixplastics.com

Genotherm gloss clear rigid PVC sheet

Advantage Supply
1454 West County Road
Roseville, MN 55113-3159
USA
Tel: +1 651 636 8668
Fax: +1 651 636 8675
Website: www.advantagesupply.net

Pentaclear (gloss clear) rigid PVC sheet

ADP
Refuge House
9-10 Riverfront
Enfield EN1 3SZ
UK
Tel: +44 (0)20 8884 7080
Fax: +44 (0)20 8366 3495

Pentaclear (gloss clear) rigid PVC sheet 700 x 1000 cm, 240 microns

Robert Horne
Huntsman House
Mansion Close, Moulton Park
Northampton
Northants NN3 6LA
UK
Tel: +44 (0)1604 495 333
Website: www.RHG.UK.com

CLEANING MATERIALS, SAFETY EQUIPMENT, JANITORIAL AND OTHER GENERAL STUDIO EQUIPMENT

Basins, sponges, spatulas, jugs, mixing bowls, drying cloths, shelving, storage units, filing systems

Household stores such as IKEA

Dishwashing liquid, Mr Muscle, Flash and other household cleaners

Household stores

Mystrol

Evans Vanodine International plc
Brierley Road
Walton Summit
Lancs PR5 8AH
UK
Tel : +44 (0)1772 322 200
Fax : +44 (0)1772 626 000
Website: www.evansvanodine.co.uk

**Ramer sponges,
Neptune (oval sponge)**
Ramer Sponges
Suite 30, Craven Court
Glebeland Road
Camberley
Surrey GU15 3BU
UK
Tel: +44 (0)1276 63192
Fax: +44 (0)1276 62902
Website: www.ramersponges.com

Spontex handy sponge
Mapa Spontex UK Ltd
Berkeley Business Park
Wainwright Road
Worcester
Worcs WR4 9ZS
UK
Tel: +44 (0)1905 450 300
Fax: +44 (0)1905 450 350
Website: www.spontex.co.uk

**Particulate respirators,
eye protection, aprons,
gloves, waste containers
and janitorial supplies**
Home improvement stores, agricultural
stores, laboratory equipment wholesalers

Northern Safety Co., Inc.
PO Box 4250
Utica, NY 13504-4250
USA
Tel: +1 800 631 1246
Fax: +1 800 635 1591
Website: www.northernsafety.com

3M Health Information Systems
Worldwide Service
Website: www.3mhis.com

**Plastic storage jars capacity 750m
'lPET 1150CYL p/code CA 3007
clear with white lids'**
Audus Noble Ltd
Blyth Industrial Estate
Cowpen Rd
Blyth
Northumberland NE24 5TD
UK
Tel: +44 (0)1670 543 100
Fax: +44 (0)1670 364 800

**Polythene bags
32 x 55 inches, 250 g**
A. L. King and Sons
Unit B
Sands Industrial Estate
Hillbottom
High Wycombe
Bucks HP12 4HJ
UK
Tel: +44 (0)1494 461 876
Fax: +44 (0)1494 451 881

Printer's wipes
Ultrawipe
Unit 7/8
Spring Mill Industrial Estate
Avening Road
Nailsworth
Glos GL6 0BS
UK
Tel: +44 (0)1453 832 266
Fax: +44 (0)1453 836 620
Website: www.bustex.co.uk

**Masking tape
and parcel tape**
Home improvement stores

SCREENPRINTING EQUIPMENT AND SUPPLIES

**Broad range of screenprinting
equipment and supplies, including
drying racks, squeegees, frames and
meshes, Folex products,
CPS products, drafting films**
Gibbon Colourcentres
25 Deer Park Rd
Wimbledon
London SW19 3UE
UK
Tel: +44 (0)20 8540 0304
Fax: +44 (0)20 8542 5256

Screenchem
5 Telford Place
East Lenziemill
Cumbernauld
Glasgow G67 2NH
Scotland
Tel: +44 (0)1236 733276
Fax: +44 (0)1236 733276

**CPS degreaser, Haze Remover HV and
other screenprinting products**
Autotype Americas Inc.
2050 Hammond Drive
Schaumburg, IL 60173-3810
USA
Tel: +1 847 303 5900
Fax: +1 847 303 5225
Website: www.cps-canada.com

CPS-Chemical Products & Services A/S
Hejreskovvej 22
DK-3490 Kvistgaard
Denmark
Tel: +45 49 13 81 10
Fax: +45 49 13 80 77
Website: www.cps.dk

Drying racks for prints

Mel-Ray Industries, Inc.
2167 South US Highway 17
Crescent City, FL 32112
USA
Tel: +1 800 367 8834
Fax: +1 800 201 3884
Website: www.melray.com

Exposure units
(self-contained)

Amergraph Corporation
520 Lafayette Road
Sparta, NJ 07871
USA
Tel: +1 973 383 8700/+1 800 526 2852
Fax: +1 973 383 9225
Website: www.amergraph.com

Exposure units (self-contained), presses, print-drying racks

Natgraph
Dabell Avenue
Blenheim Industrial Estate
Nottingham NG6 8WA
UK
Tel: +44 (0)115 979 5800
Fax: +44 (0)115 979 5700
Website: www.natgraph.co.uk

Frames

Coates Screen
1182 Quaker Court
Dallas, TX 75207
USA
Tel: +1 214 6388311/+1 800 888 4657
Website: www.coates-screen.com

Screen frames with adjustable tensioning system (The Roller Chase™)

Dimensional Products Corporation
2201 15th Ave. W
Seattle, WA 98119
USA
Tel: +1 800 782 3801/+1 206 352 9065
Fax: +1 206 352 8042
Website: www.dimensionalproducts.com

Meshes

Sericol
1101 W. Cambridge Drive
Kansas City, KS 66103
USA
Tel: +1 913 342 4060
Fax: +1 913 342 4761
Website: www.sericol.com

Photo-emulsions
Folex (Folascreen) dual-cure photo-emulsion DC 200 and CL 14 Remover

Folex Ltd
18-19 Monkspath Business Park
Solihull
West Midlands B90 4NY
UK
Tel: +44 (0)121 733 3833
Fax: +44 (0)121 733 3222
Website: www.folex.co.uk

Murakami dual-cure direct emulsion

Murakami Screen USA, Inc.
745 Monterey Pass Rd
Monterey Park, CA 91754
USA
Tel: +1 323 980 0662/+1 800 562 3534
Fax: +1 323 980 0659

Presses

H. G. Kippax & Sons
Upper Bankfield Mills
Almondbury Bank
Huddersfield HD5 8HF
UK
Tel: +44 (0)1484 426789/515112
Fax: +44 (0)1484 541799
Website: www.hgkippax.co.uk

Squeegees

Lawson Screen Products
5110 Penrose Street
Saint Louis, MO 63115
USA
Tel: +1 314 382 9300/+1 800 325 8317
Fax: +1 314 382 3012
Website: www.lawsonsp.com

Northeast Supply & Maintenance, Inc.
Lake Grove, NY 11755
USA
Tel: +1 631 981 1620
Fax: +1 631 738 1369
Website: northeastsupply.com
Manufacturer's webpage: www.jnj-industries.com/sque2a.htm

Pleiger Plastics
PO Box 1271
Crile Road
Washington, PA 15301-1271
USA
Tel: +1 724 228 2244/+1 800 753 4437
Fax: +1 724 228 2253
Website: www.pleiger.com

WATER-BASED SCREENPRINTING SPECIALISTS

Graal Press
Eskhill Cottage
Roslin
Midlothian
EH25 9QW
Scotland
Website: www.graalpress.com

GLOSSARY

autographic mark made by hand

autographic positive positive made by painting or drawing opaque marks on a transparent or translucent substrate

BAT perfect proof ('*bon à tirer*' – good to pull, or print) passed by the artist as a standard against which prints in an edition will be compared: cf. RTP

blanket sheet of felted wool used to distribute pressure evenly on the printing paper when the 'sandwich' of press bed, inked plate, printing paper and three blankets passes between the etching press rollers

bridging the ability of a coating to span the gaps between the threads of the mesh to form a stencil; over-heavy coatings of screen filler applied during a reversal process can also be described as 'bridging' when they form an impenetrable film over the screen painting fluid

chop embossing or printing stamp applied by hand to finished prints; normally specific to the printer or studio, they identify the provenance of the print

cockling warping of printing paper

creep effect when a printed mark spreads on the substrate

crosslink change which alters the form of a polymer chain

deckled edge feathered edge of a handmade (or sometimes mouldmade) paper caused during manufacture by pulp seeping between the mould and the removable frame (deckle) which defines the sheet edge

degreasing removing any traces of oil or grease from the mesh or other surface

dermatitis inflammation of the skin

digital positive positive created and output using a computer

dink half-moon-shaped dent in a paper sheet caused by careless handling

durometer measure of hardness or softness (e.g. of a squeegee blade), also referred to as 'shore'

edition group of identical (or sometimes varied) prints, signed and numbered by the artist

fisheye unwanted open area in a photostencil which prints with the appearance of the eye of a fish

flat side side of the screen frame on which the mesh is glued

flooding overfilling the mesh with printing mixture, usually leading to imperfect printing

foul bite an etching term which describes the speckles and dots created by unwanted corrosion of the etching plate

found material any objects or materials, such as feathers, leaves, fabric, paper, printed material or ephemera which can be incorporated in the image-making process

frottage taking a rubbing from an embossed or textured surface, such as wood or stone, using hard chalk, crayon, pastel or other medium on paper

ghost faint stain (often relating to image forms) in screen mesh caused by incorrect cleaning or by certain printing mixtures: cf. haze

halftone tonal image which has been broken into a structure of different-sized dots, which print to give the optical illusion of continuous tonal change

haze generalized faint staining of screen mesh caused by photostencils, screen fillers, printing mixtures and varnishes: cf. ghost

internal sizing part of the papermaking process which describes the addition of glue (size) to the paper pulp so that the resulting paper contains a homogenous mix of size within each sheet, increasing its strength and impermeability to water

landscape format image format in which the width is greater than the height: cf. portrait format

margin perimeter of mesh adjacent to the frame of the screen: this non-printing area is closed during printing, either temporarily or permanently, to protect the mesh and to be used as a printing mix reservoir

misting causing a vapour of droplets which can easily be inhaled, especially when using a high-pressure hose

moiré wave-like pattern sometimes seen when two geometric grids (such as a halftone image and a screen mesh) are superimposed

monofilament mesh woven from single smooth strands of synthetic thread: cf. multifilament

monoprint single image printed from an individually painted matrix (such as a screen mesh) which usually has unique elements

MSDS Material Safety Data Sheet: an international standardized form (which manufacturers are legally obliged to provide) containing information about materials and chemicals

multifilament mesh woven from threads which themselves are a composite structure of smaller filaments twisted together, so that each thread has a textured surface: cf. monofilament

offsetting the process by which an area of wet printing mixture or other substance (such as screen filler) is

applied to a surface, then lifted from it by contacting it with another flat surface (e.g. a sheet of glossy paper), and then printed (offset) onto a third surface (or into another position on the first surface)

particulate respirator close-fitting, high-grade breathing mask designed to filter very fine dust particles

photo positive positive made photographically on lith film using darkroom techniques

photocopy positive positive made on acetate or tracing paper using a photocopier

pinhole unwanted small open area on a photostencil that prints as a dot or spot

polymer chemical, made of long molecules, which is a component in acrylic paints, some acrylic painting aids and photo-emulsion

portrait format image format in which the height is greater than the width: cf. landscape format

positive transparent or translucent substrate supporting opaque marks which can be translated into a photostencil and then screenprinted

process printing separating a colour image into a set of halftone positives, each representing a translucent colour (normally cyan, magenta, yellow or black). When these separations are screenprinted in perfect register, the colour image will be reassembled: cf. halftone

proof test print (often on newsprint or cartridge, but sometimes on editioning paper) which may consist of one or more, or all, stages of a printed image

PVC sheet genotherm, rigid, gloss, clear sheet: a transparent substrate manufactured for the printing industry

reduction printing screen filler stencil process using a single open area: a series of stencils are made (and printed) which progressively reduce the printing area

registration the process of aligning the disparate elements which make up a print – positives, map, printed image, registration sheet – so that they are positioned exactly on top of each other as required

retarder additive to a water-based printing mix to slow the drying time

reversal term used in screenprinting to describe how all the areas which are open (and which print) become closed (non-printing), and vice versa

RTP perfect proof ('right to print'): cf. BAT

saw toothing the result when photo-emulsion is applied too thinly to mesh and does not bridge it adequately: this causes printed edges of photostencils to 'step', resembling the teeth of a saw rather than a straight line

screen filler liquid applied to a degreased mesh which dries to close areas of the mesh, forming a stencil: cf. stopping out

screen landing pad small pad of soft material (a household duster folded in four and taped at the edges), with a length of cord attached for retrieval. It is placed on one of the front corners of the horizontal glass surface of a UV exposure unit. When a screen is placed on the unit, one corner is 'touched down' on the pad, allowing the screen to be slid to the back of the unit in a controlled fashion and protecting the glass surface from scratches

serigraph fine art print made by painting stencils on silk meshes and printing through these: cf. silkscreen

shoulder raised edge of a stencil (particularly a paper stencil or thickly applied photo-emulsion)

silkscreen another term for serigraph, now more correctly referred to as screenprint: cf. serigraph

snap the action of the mesh lifting away from the wet print, determined by the height of the gap between the mesh and the press bed (when the press frame is down)

squeegee flexible-bladed tool (with a wooden or metal handle) used to fill the mesh and print the image

squeegee support waterproofed cardboard wedge which is parcel-taped to the mesh behind the image area and used to rest the squeegee on during hand-printing

stopping out painting screen filler onto the mesh to alter or edit (or create) an image: cf. screen filler

substrate sheet of material (such as paper, plastic or clear PVC) which may be screenprinted, or which may be used for making positives

sugarlift traditional etching process which results in a characteristic bold, broken, painted mark

thixotropic descriptive of a mixture which, as it is agitated or moved around, becomes more fluid; when left still, it thickens

tusche traditionally a greasy solution used in lithography for painting washes on stones or plates. In water-based screenprinting and acrylic-resist etching, tusches are specially formulated painting and printmaking media containing opaque particles, which are used to make autographic positives. Many types of mark can be created, from reticulated washes to soft-ground effects

UV-curable ink ink used in commercial screenprinting which is hardened by exposure to UV light

vacuum press screenprinting press with a perforated bed through which air is sucked by a vacuum pump, holding the printing paper (or other substrate) in position during printing

VOC volatile organic compound

INDEX